RUSSIAN
PAINTING

Parkstone
PARKSTONE PRESS

Publishing director: Jean-Paul Manzo
Texts by: Peter Leek
Coordination: Anja Vierkant
Designed by: Oliver Hickey
Typesetting by: Oliver Hickey

Printed and bound in Europe

ISBN 1 85995 355 7

© Parkstone Press Limited,
Bournemouth, England, 1999

Detail from:
Mikhail Vrubel
111 *Still Life with Plaster Mask and Sconce.* 1885.

CONTENTS

INTRODUCTION

The sublime imagery of the great icon painters, the portraiture of the eighteenth and nineteenth centuries, the paintings of sea, snow and forest, the scenes of peasant life and the historical works of the Itinerants, the stylishness of the World of Art movement, the bold experimentation of the artists of the early twentieth century . . . To anyone unfamiliar with Russian painting, its richness and diversity may well come as a surprise or at least as an exciting revelation. Indeed, the creative energy of Russian artists over the past two and a half centuries has been such that a book of this size cannot hope to offer a comprehensive overview of their output. Its aim is therefore to provide a representative selection of Russian painting from the eighteenth century to the start of the post-Revolutionary period (plus some glimpses of more recent work), but without attempting to do more than briefly allude to Russia's rich heritage of icon painting or to give in-depth coverage of the art of the Soviet era.

Icon painting

Although icon painting rapidly became an integral part of Russian culture, initially it was an imported art form, brought to Russia from Constantinople. The name "icon" is itself indicative of its Byzantine origin, being a transliteration of the Greek word for a "likeness" or image. In 988, after sending out envoys to report on the various religious options available, Prince Vladimir of Kiev Rus (the first Russian state) adopted Christianity both for himself and his subjects, staging a mass baptism in the River Dnieper. In order to build and embellish Christian places of worship, he invited Byzantine architects and artists to Kiev. As a result, the grander stone churches in Kiev were endowed with magnificent frescoes and mosaics. However, many of the early Kievan churches were built of wood, which made mural decoration impractical. Instead, religious images were painted on wooden panels. And these were often displayed on a screen separating the sanctuary from the body of the church – which eventually evolved into the iconostasis, an elaborate tiered partition adorned with icons.

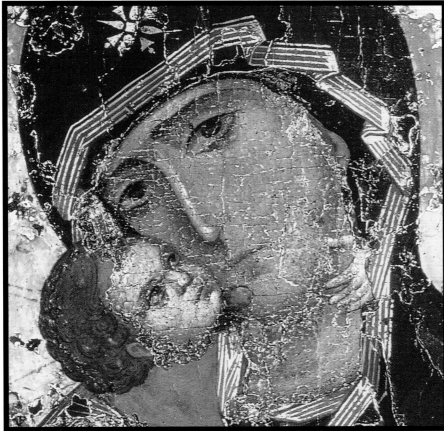

Detail from:
1 *The Virgin of Vladimir.* 11th - early 12th century.

The most famous of these early icons, *The Virgin of Vladimir* [1], (now in the Tretyakov Gallery, in Moscow), is thought to have been painted in Constantinople during the first quarter of the twelfth century. Between then and the time of Simon Ushakov (1626–86), arguably the last icon painter of stature, a great variety of schools and styles of icon painting developed, most notably those of Vladimir-Suzdal, Yaroslavl, Pskov, Novgorod and Moscow. The earliest icon painters remain anonymous. However, it is known that they were not all monks, and before long workshops specializing in icons and other forms of church decoration were common in many parts of Russia.

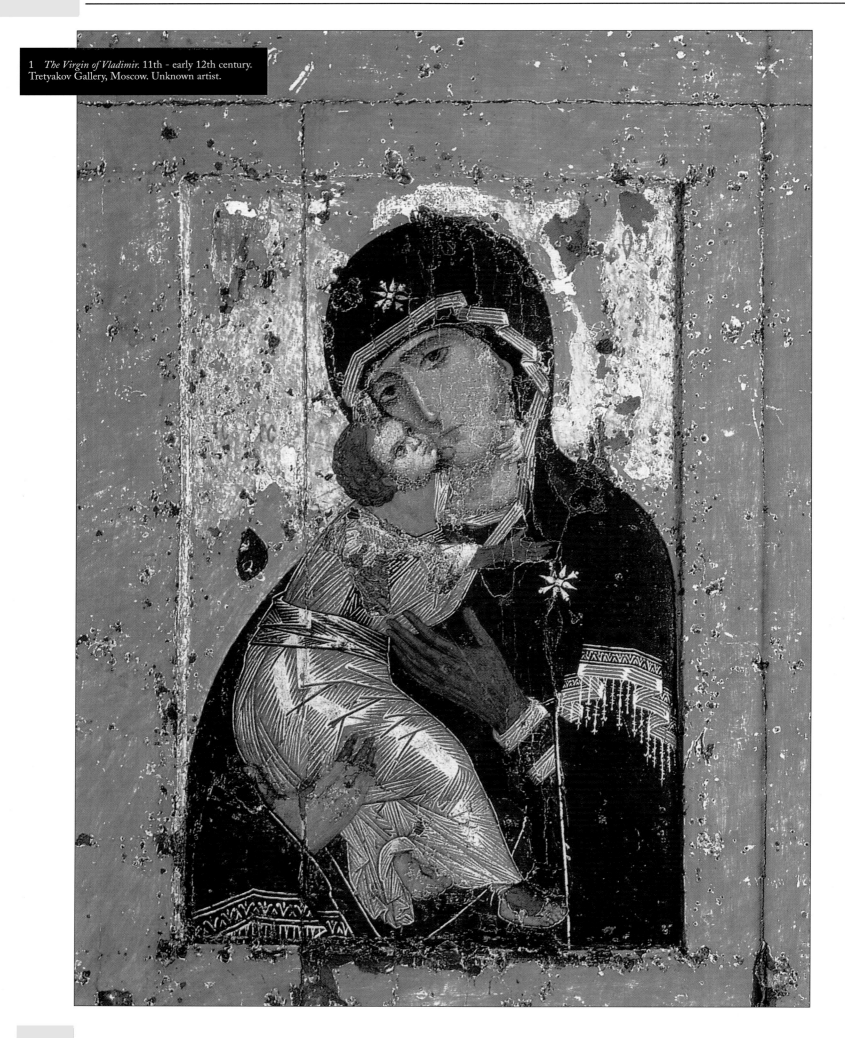

1 *The Virgin of Vladimir*. 11th - early 12th century.
Tretyakov Gallery, Moscow. Unknown artist.

Of the masters of icon painting, Theophanes the Greek (c. 1340–1405) came from Constantinople to Russia and greatly influenced both the Novgorod and Moscow schools. Other well-known masters include Andrei Rublev (approximate dates 1370–1430), whose most famous work, the *Old Testament Trinity* [2], is in the Tretyakov Gallery; his friend and collaborator Daniel Cherniy (a monk, as was Rublev); and Dionysius (c. 1440–1508), one of the first laymen to become a leading icon painter. At the time when Dionysius and his sons were active, ownership of icons became increasingly common. Previously nobles and merchants had begun the practice of displaying them in a place of honour in their homes, sometimes even in a special room, but now peasant families who could afford it began to hang icons in a *krasny ugol*, or "beautiful corner", too.

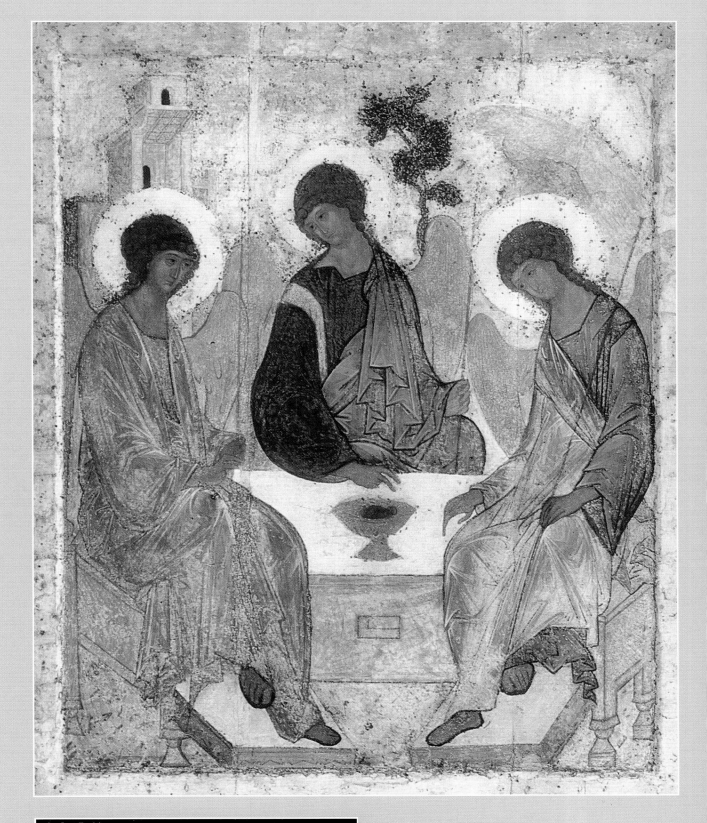

Andrei Rublev
2 *Old Testament Trinity.* 1422-1427.
Tempera with eggs on lime-panel. 142 x 114 cm.
Tretyakov Gallery, Moscow.

Parsunas

In addition to Christ, the Virgin Mary and saints or angels, up to the middle of the sixteenth century icon painters generally restricted their imagery to figures from the Old and New Testaments. Then in 1551 Ivan the Terrible convened a Stoglav (ecclesiastical council) to settle a variety of issues, including the question of whether the depiction of living people in icons was sacrilegious. The council's somewhat cryptic ruling was interpreted as sanctioning the inclusion of tsars and historical or legendary figures alongside those culled from the Bible. As a result, icon painting gradually widened its ambit, both in terms of style and content – until, during the schism that split the Russian Orthodox Church in the mid-seventeenth century, Nikon (the reforming patriarch) and Avvakum (the leader of the conservative Old Believers) vied with one another in their attempts to restore iconic purity. Nikon smashed, burned or poked out the eyes of icons that departed from the Byzantine tradition, especially those that included secular figures. And Avvakum railed against innovations and foreign influences in language scarcely less violent than Nikon's.

But the ruling of Ivan's Stoglav had unwittingly paved the way for the spread of non-religious art. To escape the attentions of Nikon and Avvakum and their henchmen, painters turned to portraiture and other varieties of artistic endeavour. One result was a vogue for *parsunas* (from the Latin *persona*), pictures of living people similar in style to icons, but of a non-religious nature. These were usually painted on wooden panels, rather than on canvas. At first they were extremely stylized, and the emphasis was not so much on capturing character as on conveying the sitter's place in society. But before long the *parsuna* gave way to a more realistic type of portraiture. For example, the portrait of Peter the Great's jester Jacob Turgenev [3], painted by an unknown artist some time before 1696, has a psychological depth and an irony absent from most *parsunas*. The quizzical shrewdness of the jester's expression and the way his powerful figure fills the canvas may have been meant to suggest that wisdom is not exclusive to princes, nor folly to fools.

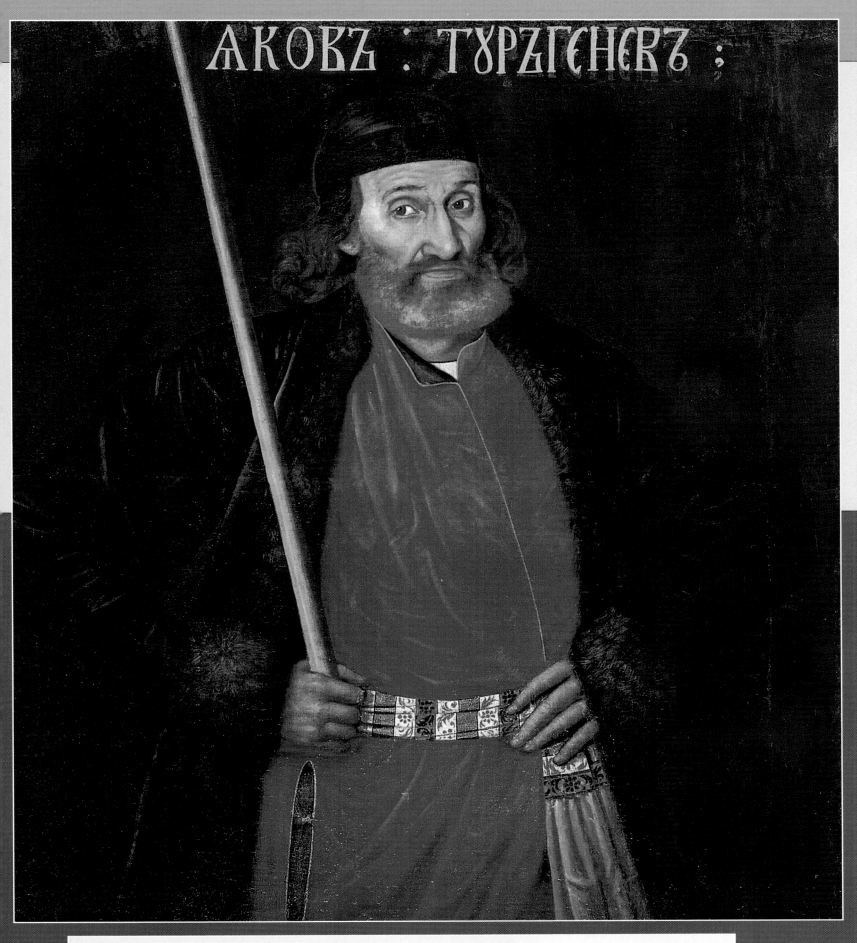

ѦКОВЪ : ТУРѮГЕНЕВЪ :

3 *Portrait of Jacob Turgenev.* Before 1696. Oil on canvas. 105 x 97,5 cm. Russian Museum, St Petersburg. Unknown artist.

The Academy

Peter the Great's decision to build a capital that would be "a window on Europe" had a considerable significance for Russian painting. First, he [4] lured architects, craftsmen and artists to Russia from various parts of Europe, both to design and decorate the buildings of St Petersburg and to train their Russian contemporaries in the skills needed to give effect to his plans for modernizing the whole country. With similar aims in mind, he paid for Russian artists to study abroad and planned to establish an art department in the newly created Academy of Sciences.

After Peter's death, these plans reached fruition with the founding in 1757 of the Imperial Academy of the Arts, which opened in earnest six years later. For more than a hundred years the Academy exerted a powerful influence on Russian art. It was augmented by a preparatory school, where budding artists were sent at six or ten. It was rigidly hierarchical, with titles ranging from "artist without rank" to academician, professor and councillor. Students who had the stamina to do so, toiled at their studies for fifteen years. And, until the last quarter of the nineteenth century, it was dominated by unquestioning acceptance of classical ideas. Russian artists frequently found the Academy's regulations and attitudes frustrating, but it did have the merit of making a comprehensive and rigorous artistic education available to those who showed signs of talent.

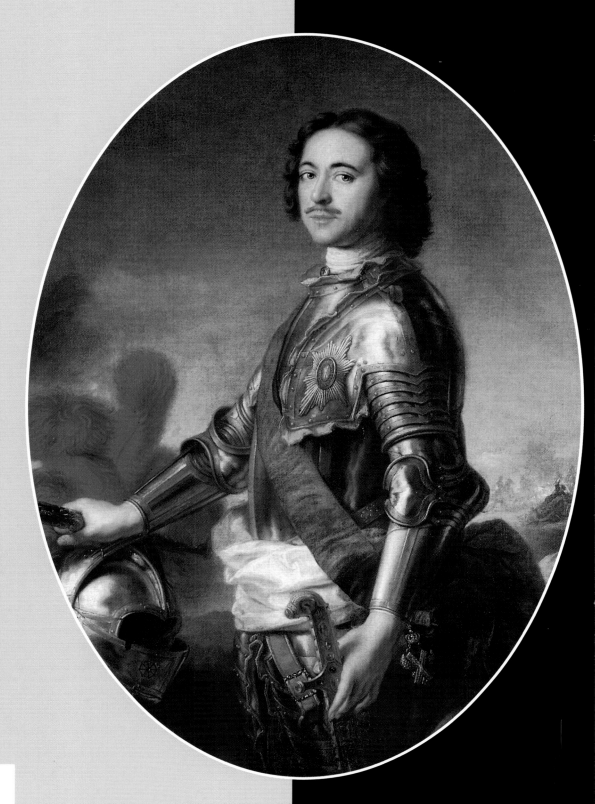

Jean-Marc Nattier
4 *Portrait of Peter the Great.* 1717.

Cross-currents in art

Initially the staff of the Academy included a preponderance of foreign – mainly French and Italian – teachers. As a result, Russian painting during the second half of the eighteenth and first half of the nineteenth centuries owed a great deal to the fashions prevalent in other parts of Europe, which tended to reach Russia slightly in arrears. Given the distance from St Petersburg and Moscow to the Western European capitals, this lag is hardly surprising. But Russian painters did have considerable opportunities to familiarize themselves with Russian and non-Russian art, both thanks to the circulation of reproductions (often in the form of engravings and lithographs) and due to the art-buying habits of the ruling class. As well as funding the Academy (including travel scholarships for graduates), Catherine the Great bought masterpieces of French, Italian and Dutch art for the Hermitage [5]. During the French Revolution, her agents – and Russian visitors to Paris generally – were able to pick up some handy bargains, as the contents of châteaux were looted and sold off.

5 *Room in the Hermitage.*

A hundred years or so later, Sergei Shchukin and the brothers Mikhail and Ivan Morozov purchased numerous Impressionist paintings and brought them back to Russia. In 1892 the merchant and industrialist Pavel Tretyakov [6] gave his huge collection of paintings (including more than a thousand by Russian artists) to the city of Moscow. Six years later, the Russian Museum [7] opened in the Mikhailovsky Palace in St Petersburg (today it houses more than 300,000 items, including some 14,000 paintings).

Ivan Kramskoi
6 *Portrait of Pavel Tretyakov*. 1876. Oil on canvas. 59 x 49 cm. Treyakov Gallery, Moscow.

Exhibitions also played an important role in the development of Russian art. At the end of the nineteenth century, the artistic status of icons had been in eclipse for approximately two hundred years, even though they were cherished as objects of religious veneration. During that time many of them had been damaged, inappropriately repainted or obscured by grime. In 1904 Rublev's *Old Testament Trinity* [2] was restored to its full glory, and in 1913 a splendid exhibition of restored and cleaned icons was held in Moscow to mark the millennium of the Romanov dynasty. As a result, the rediscovered colours and stylistic idiosyncrasies of icon painting were explored and exploited by a number of painters in the first decade or two of the twentieth century. Similarly, when Diaghilev mounted a huge exhibition of eighteenth-century portrait painting at the Tauride Palace in St Petersburg in 1905, the result was a noticeable revival of interest in portraiture and in Russia's artistic heritage as a whole. International exhibitions (like the ones organized by the *Golden Fleece* magazine in 1908 and 1909), together with foreign travel and visits by foreign artists to Russia, allowed Russian painters to become acquainted with movements such as Impressionism, Symbolism, Futurism and Cubism. What is particularly fascinating is to see how artists as diverse as Grabar, Vrubel, Chagall, and Larionov and Goncharova adapted these influences and used them in creating their own art – often incorporating Russian elements in the process.

7 *The Mikhailovsky Palace (The Russian Museum)*

From the Eighteenth Century to the 1860s

Ivan Nikitin
8 *Portrait of a leader.* 1720s.
Oil on canvas. 76 x 60 cm.
Russian Museum, St Petersburg.

Portraiture

In Russia, the eighteenth century was the century of the portrait. Other than icon painting, the patronage of the tsars or wealthy nobles or merchants was virtually the only source of income available to Russian painters. Perfecting their skills as portraitists was therefore high on the agenda of the five painters sent to study abroad, in 1716, by Peter the Great.

One of the five was Ivan Nikitin (c. 1688–1742). The son of a priest, he began his artistic career by studying drawing and arithmetic at an artillery college. Noticed by the tsar, he was dispatched to Italy, together with his brother Roman, an able though more conventional painter. In the portrait of Peter the Great that Ivan painted in 1721 the emperor is shown without attributes of power and with a degree of intimacy rarely encountered in royal portraits. Four years later, he painted an emotionally charged portrait of the tsar on his deathbed. Ivan's last years were overshadowed by tragedy. After the death of Peter the Great, he opposed the regime of Anna Ivanovna and in 1736 was deported to Siberia, together with his brother. By the time they were pardoned, Ivan was critically ill. He died on the way back from Siberia.

Another of the artists sponsored by Peter the Great was Andrei Matveyev (1701–39), who was sent to study in Holland. Obliged to paint battle scenes and ceilings and panels for the palaces of the tsars, he lacked freedom to fully develop the talent for portraiture evident in works such as *The Allegory of Painting* (1725) and the portrait that he painted of himself and his wife [9] in 1729. Matveyev was a fine colourist, and his works are full of pleasing nuances. They also hint at his desire to break new ground, to bring to portraiture a more psychological approach.

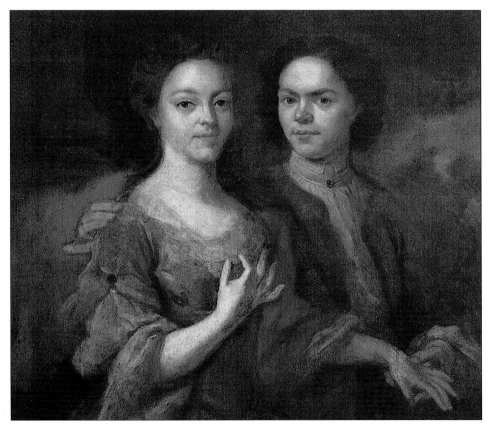

Andrei Matveyev
9 *Self-Portrait of the Artist with his Wife.* 1729.
Oil on canvas. 75.5 x 90.5 cm.
Russian Museum, St Petersburg.

The 1730s saw appreciable changes in Russian society. Intent on strengthening their position vis à vis the State, the aristocracy strove to show their standing by displaying the superiority and sophistication of their tastes and lifestyle, especially through the embellishment of the interiors of their homes. Portraits offered a means of self-aggrandisement, of conveying status, and by the 1760s they were in evidence everywhere – not only at the court in St Petersburg but in remote parts of Russia too.

Some of the most accomplished portraits from the mid-eighteenth century were produced by Ivan Vishnyakov (1699–1761). Continuing Matveyev's tendency towards lyricism, they possess the decorative qualities typical of the Rococo style then prevalent in Russia, without the frivolity generally associated with it. Instead, their static poses and facial expressions have an air of seriousness, focusing attention on the subject's face. Vishnyakov was at his most sensitive when portraying children [10]; their elaborate clothes and frozen poses underline the innocence and vulnerability of these diminutive lords and ladies. Despite the formality of his portraits, relatively few of them were commissioned by the Imperial court.

During the reign of Elizabeth Petrovna, Russia enjoyed a blossoming of the arts and sciences and an expansion of education – largely thanks to the influence of Mikhail Lomonosov (1711–65), a man of immense learning and wide cultural interests who became Professor of Chemistry at the Academy of Sciences in St Petersburg in 1745. Russian sculpture in particular benefited from these stimuli – and so did portraiture, which developed in two ways. Although there was a greater demand for elaborate formal portraits, there was also an increased realism in the way people were portrayed.

Alexei Antropov (1716–95) studied with Matveyev and then worked for nearly twenty years under the direction of Vishnyakov, concentrating primarily on learning to paint formal portraits. Flags, columns and other decorative accessories tended to feature in these portraits, along with luxuriant robes and drapery, all painted in lively colours. In deference to convention, they were normally full-length. Despite the inhibiting nature of official portraiture, Antropov managed to achieve a remarkable degree of veracity. The portraits, both formal and informal, that he painted during the 1750s and 1760s show him at his best [11].

Antropov's contemporary Ivan Argunov (1727–1802) painted numerous portraits of artists and their families. By the middle of the eighteenth century he was already considered a leading portrait painter, and he received a great variety of commissions – probably greater than any other Russian artist of his time. His portraits range from the Empress and members of the court to the serfs and ancestors of his wealthy patron, Count Sheremetyev. Whereas Antropov's style – with its rather static quality and feeling of detachment – is sometimes reminiscent of the *parsunas*, Argunov's work is generally more immediate and less austere.

Among the portrait painters of the second half of the eighteenth century, three stand out for the brilliance of their work: Rokotov, Levitsky and Borovikovsky. Their styles, however, are very different. Surprisingly, although highly regarded by his contemporaries, Fyodor Rokotov (c. 1735–1808) was completely forgotten during the period following his death and only rediscovered at the start of the twentieth century. Initially he worked as a court painter in St Petersburg, where he produced portraits remarkable for their individuality and vivacity, among them his portrait of the young Alexei Bobrinsky [12]. In 1767 Rokotov moved to Moscow, where he became the portraitist most sought after by Muscovite society. Once he was freed from the constraints of court painting, his portraits – especially those intended for the interiors of private houses – became more intimate. Particularly in his later works, he increasingly made use of *sfumato* (almost imperceptible colour transitions), and a silvery tonal range to reproduce the delicate sheen of his sitters' satins, silks and velvets.

Ivan Vishnyakov
10 *Portrait of William Fermore.* Late 1750s.
Oil on canvas. 135 x 109 cm
Russian Museum, St Petersburg.

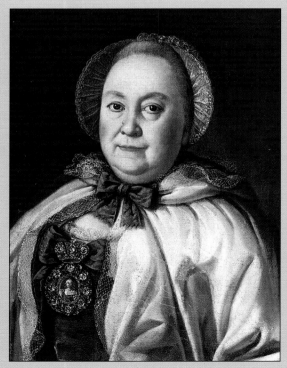

Alexei Antropov
11 *Portrait of Maria Rumyantseva.* 1764.
Oil on canvas. 62.5 x 48 cm.
Russian Museum, St Petersburg.

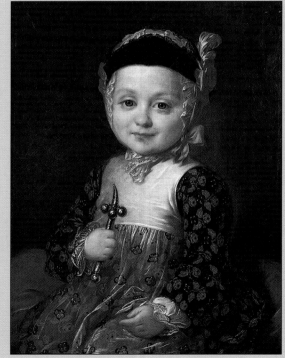

Fyodor Rokotov
12 *Portrait of Alexei Bobrinsky as a Child.* c.1763.
Oil on canvas. 59.5 x 47 cm.
Russian Museum, St Petersburg.

Dmitri Levitsky
13 *Portrait of Ursula Mniszech.* 1782. Oil on canvas. 72 x 57 cm (oval). Tretyakov Gallery, Moscow.

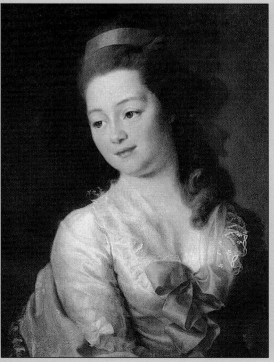

Dmitri Levitsky (1735–1822) possessed a marvellous ability to interpret and express personality. Every detail is painted with care, yet a feeling of spontaneity is never absent from his work. The son of a priest who was a gifted engraver, Levitsky was born in the Ukraine. After studying with Antropov, he spent a few years producing icons for churches in Moscow, then taught portrait painting at the Academy from 1771 to 1788. Levitsky excelled at female portraiture, as can be seen from his paintings of the aristocratic Ursula Mniszech [13] and Maria Diakova [14], the wife of architect, painter and poet Nikolai Lvov. Between 1773 and 1776, at the request of Catherine the Great, he painted a series of portraits of her favourite pupils at Smolny Institute (the school she founded for the education of young noblewomen), showing them engaged in such activities as amateur dramatics, playing the harp or dancing the minuet. Thanks to his portraits of foreign visitors to St Petersburg – among them Diderot – Levitsky acquired a reputation outside Russia (his style was even compared with that of Boucher and Watteau). In 1788 illness forced him to retire from the Academy, where he had been the principal teacher of portraiture. During the last thirty years of his life he painted hardly at all.

The son of an icon painter and member of an old Cossack family, until 1788 Vladimir Borovikovsky (1757–1825) lived in Mirgorod, where he painted icons and portraits in the Ukrainian tradition. In 1790, after Catherine the Great expressed her delight at the allegorical decorations which he had been commissioned to paint in honour of her triumphal tour of the Crimea, Borovikovsky moved to St Petersburg, where he studied with Levitsky and with the Austrian portrait painter Johann-Baptist Lampi. That same year he painted a portrait of Catherine the Great, looking more grandmotherly than regal, walking her favourite dog in the park at Tsarskoe Selo. Borovikovsky's portraits of women – often attired in Grecian gowns and backed by a sylvan setting – have been likened to those by Gainsborough and Angelica Kauffmann. In many of them, the sitter is portrayed with the fingers of one hand delicately curled round an apple. As late as the 1790s Borovikovsky's work was tinged with sentimentalism [15]. Then at the beginning of the nineteenth century he adopted a more classical style, producing works like the portrait of Prince Alexander Kurakin [16] that he completed in 1802.

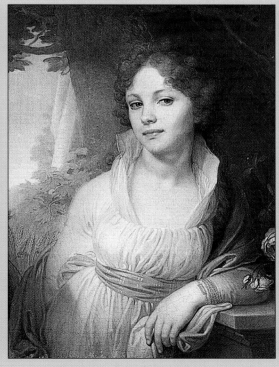

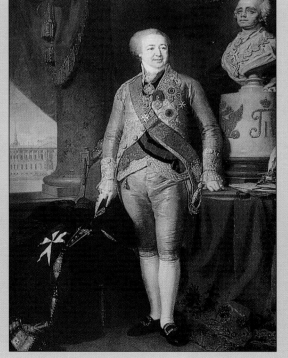

Dmitri Levitsky
14 *Portrait of Maria Diakova.* 1778.
Oil on canvas. 61 x 50 cm.
Tretyakov Gallery, Moscow.

Vladimir Borovikovsky
15 *Portrait of Maria Lopoukhina.* 1797.
Oil on canvas. 72 x 53.5 cm.
Tretyakov Gallery, Moscow.

Vladimir Borovikovsky
16 *Portrait of Prince Alexander Kurakin.* 1801–1802.
Oil on canvas. 259 x 175 cm.
Tretyakov Gallery, Moscow.

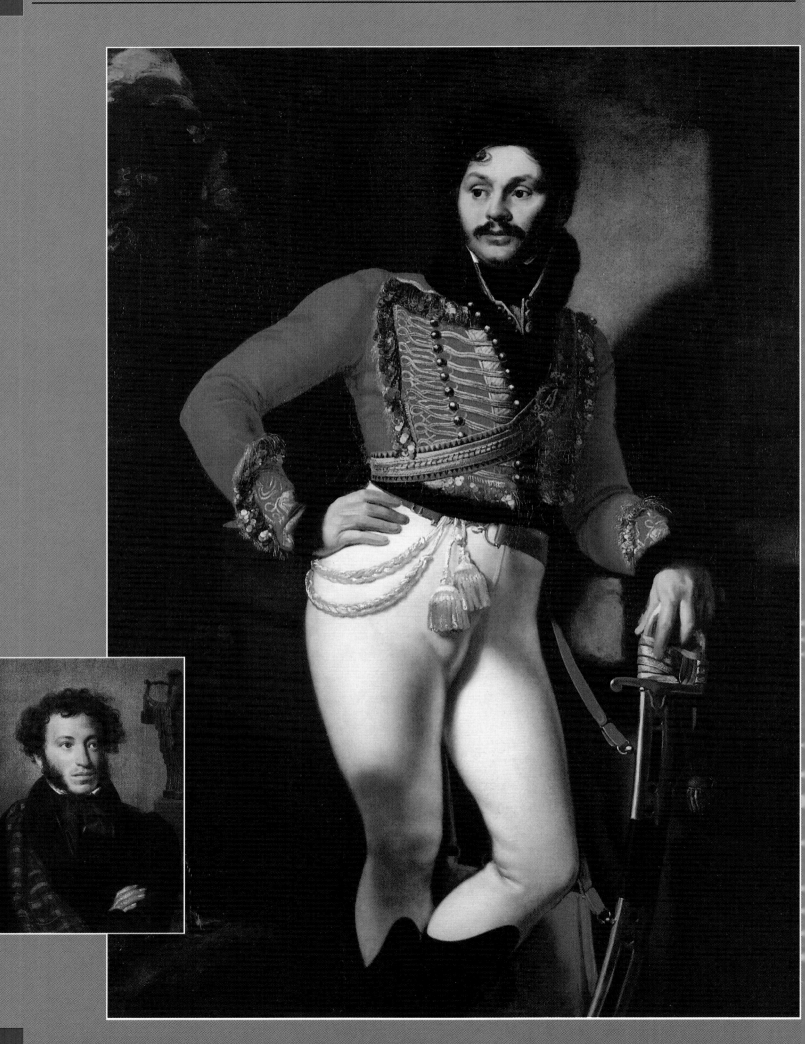

At the start of the nineteenth century, Romanticism was beginning to influence Russian portraiture. Painters began to express themselves more freely, and self-portraits became increasingly common. With its accent on individuality, Romanticism was a perfect match for the self-portrait – which was, after all, a vehicle for psychological probing and spiritual revelation. It also led to important changes of form. In order to focus attention on the face, the sitter's clothes were given less prominence. For the same reason, a neutral background tended to be used.

Romantic portraiture found its fullest expression in the art of Orest Kiprensky (1782–1836), who painted several self-portraits, including a very painterly one with brushes stuck behind his ear. Kiprensky's own life bore the hallmarks of Romanticism. The illegitimate son of an aristocratic army officer, he studied painting at the Academy (where he was enrolled at the age of six) and rapidly became a successful portrait painter. Then in 1805 he was awarded a travelling scholarship, and as soon as the Napoleon Wars ended departed for Rome. There he led a fairly Bohemian existence, and found himself the subject of scandal when an Italian model and a manservant died as a result of a fire at his house. In 1828, after four years back home in Russia, he returned to Italy, married the model's daughter (whom he had entrusted to a convent school) and spent the next eight years roaming Italy with her, until his death from tuberculosis in 1836.

At the Academy, Kiprensky had learned to paint so flawlessly that his brush strokes are practically invisible and his pictures have an ivory-smooth finish. They also display an exceptional ability to convey character and to achieve subtle effects of colour and light. In them it is possible to see something of the spirit of the great Russian poets and novelists of the nineteenth century. Among his best-known works are the portrait of Pushkin [17] that he painted in 1827 and the one of Colonel Yevgraf Davydov [18], an aristocratically nonchalant cavalry officer (and poet), who seems to have stepped straight out of the pages of *War and Peace*. When in Paris in 1822, Kiprensky was invited to exhibit at the Salon. He also had the distinction of being asked to provide the Uffizi Gallery with a self-portrait for their permanent collection.

The career of Vasily Tropinin (1776–1857) was very different from Kiprensky's. Born a serf, he was given to Count Morkov as part of his wife's dowry and spent the first part of his life on the Count's estate in the Ukraine. When Morkov discovered that Tropinin possessed artistic ability, he used him to makes copies of famous works of art and also to paint portraits of his family. In 1799 Morkov sent him to St Petersburg to train as a pastry-cook. Tropinin seized the opportunity to attend classes at the Academy, at first secretly and then with Morkov's approval. But in 1804 Morkov recalled him to the Ukraine to continue working on his estate, both as a servant and as an artist. Eventually, in 1823 – when he was nearly forty-eight – Morkov granted him his freedom.

The following year Tropinin received the title of Academician and moved to Moscow, where he painted portraits of celebrities (including Pushkin and Karamzin) and numerous foreign visitors. In the 1820s he began painting "genre portraits" depicting women at work, with titles such as *Lacemaker* [19], *Spinner and Embroidress*, which are remarkable for their realism and directness. Masterpieces from the later part of his life include his refreshingly unaffected portrait of the writer Varvara Lizogub [20]. One of his most memorable works is the very natural portrait of his own son that he painted in 1818.

Like Tropinin, Alexei Venetsianov (1780–1847) was in his true element when painting ordinary people. The quiet realism of his work represented an important step in the development of Russian painting and had a clearly discernible influence for several decades. Until the age of thirty-nine, Venetsianov worked as a draughtsman and land surveyor in the civil service. After taking up residence in St Petersburg in 1802, he studied with Borovikovsky and ran a newspaper advertisement offering his own services as a portrait painter. In 1811 he received a distinction from the Academy for his self-portrait, which rivals Chardin's for its frankness, and it was for a portrait of Golovachevsky (one of the professors) that he was nominated as an Academician. Nevertheless, in March 1823 he decided to devote his energies primarily to genre painting, and wrote "Venetsianov hereby relinquishes his portrait painting" on the back of a portrait he had just completed.[1]

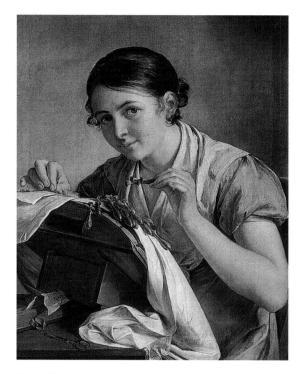

Vasily Tropinin
19 *Lacemaker*. 1823.
Oil on canvas. 74.7 x 59.3 cm.
Tretyakov Gallery, Moscow.

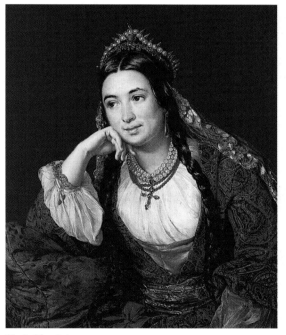

Vasily Tropinin
20 *Portrait of the Writer Varvara Lizogub*. 1847.
Oil on canvas. 82.5 x 68 cm.
Russian Museum, St Petersburg.

Opposite page left (inset)
Orest Kiprensky 17 *Portrait of Alexander Pushkin*. 1827. Oil on canvas. 63 x 54 cm. Tretyakov Gallery, Moscow.

Opposite page, right:
Orest Kiprensky 18 *Portrait of Colonel Yevgraf Davydov*. 1809. Oil on canvas. 162 x 116 cm. Russian Museum, St Petersburg.

However, with Venetsianov the distinction between portraiture and genre painting is often blurred, as can be seen from his *Girl with a Birch-bark Jar* and his *Reaper* [21], both painted after 1823. Also, he clearly did not interpret his "relinquishment" of portraiture very seriously, since he subsequently painted affectionate portraits of his wife and daughter and of young serfs and peasants – including a series in which he portrayed various peasant girls with face and hair framed by a shawl. In 1834 he painted a portrait of Gogol, whose progressive ideas he greatly admired.

Venetsianov's declared aim was "to depict nothing in any way different from how it appears in nature . . . without recourse to the style of any other artist, that is, not to paint à la Rembrandt, à la Rubens and so forth, but simply, so to speak, à la Nature[2]". In 1819 he resigned from the civil service and went to live at Safonkovo, the country estate to the east of Moscow that he had bought a few years earlier. At Safonkovo, he started teaching some of his neighbours and their serfs to paint. In the end, more than seventy pupils had absorbed his approach to art, including several who became popular teachers and transmitted his ideas to the next generation.

Alexei Venetsianov
21 *Reaper*. Before 1827. Oil on canvas. 30 x 24 cm. Russian Museum, St Petersburg.

Karl Briullov
22 *Portrait of Cyril and Maria Naryshkin*. 1827. Watercolour on paper. 44.1 x 35.4 cm. Russian Museum, St Petersburg.

Among Venetsianov's contemporaries, the most popular Russian portrait painter was undoubtedly Karl Briullov (1799–1852), whose fashionable clients in Rome and St Petersburg were very different from the shepherds and dairymaids that sat for Venetsianov in Safonkovo. Briullov was taught to paint by his father, a Huguenot woodcarver, before going to the preparatory school of the Academy at the age of ten. Then in 1822 he was awarded a bursary which enabled him to travel to Italy, where he stayed until 1835. Briullov's portraits from the 1820s are unmistakably Romantic in spirit, and some of his outdoor portraits from that period, such as his watercolour of *Cyril and Maria Naryshkin* [22], have an Italian setting. In 1827 he painted one of his most delightful and best known works, a picture of a girl gathering grapes (intended as part of a series of genre portraits), to which he gave the title *Italian Midday* [23].

Karl Briullov
23 *Italian Midday*. 1827. Oil on canvas. 64 x 55 cm
Russian Museum, St Petersburg.

Karl Briullov
24 *Portrait of the Artist with Baroness Yekaterina Meller-Zakomelskaya and her Daughter in a Boat.* 1833–1835.
Oil on canvas. 151.5 x 190.3 cm. Russian Museum, St Petersburg.

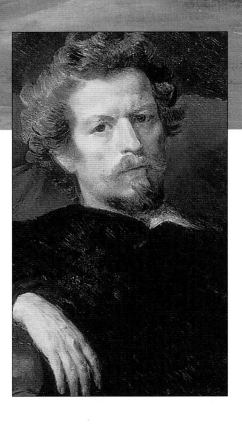

Towards the end of the 1820s and during the1830s he produced increasingly large and elaborate compositions, such as *The portrait of the Artist with Baroness Yekaterina Meller-Zakomelskaya and her Daughter in a Boat* [24].

As Briullov's art developed, his style evolved beyond Romanticism. His portraits began to exhibit more psychological preoccupations, often giving the impression of being unposed and placing a greater emphasis on the sitter's personality. The ultimate development of his style can be seen in the remarkable self-portrait that he painted in 1848 [25].

Karl Briullov
25 *Self-Portrait.* 1848.
Oil on board. 64.1 x 54 cm
Tretyakov Gallery, Moscow.

Historical painting

Early Russian history painting was closely linked to religious painting, and only freed itself from the canons of icon painting at the start of the eighteenth century. One of the first Russian paintings in which a realistic reconstruction of a historical event was used to convey a patriotic message was Ivan Nikitin's depiction of the victory of Prince Dmitri of Moscow over the Tatars at Kulikovo in 1380 – the individuality of the combatants, the fury of the battle, and the musculature of the men and horses all being vividly portrayed.

However, history painting in Russia did not come into its own until the founding of the Academy, where it was regarded as superior to other art forms (both religious and mythological themes were treated as a subspecies of history painting). One of the most celebrated pictorial works from this period was not a painting but a mosaic of Peter the Great's victory over Charles XII of Sweden at Poltava in 1709, produced by the workshop of M.V. Lomonosov between 1762 and 1764.

One constraint on the development of realistic history painting was the lack of reliable historical and archaeological sources, which deterred many artists from attempting accurate representations of places, people and events. Another inhibiting factor was the Academy's worship of classicism. Events from Russian history were depicted less frequently than subjects from antiquity or mythology – such as Bruni's *The Death of Camilla, Sister of Horatius* (1824) and Losenko's *Hector Taking Leave of Andromache* [26], which melodramatically exploits the pathos of the couple's inner anguish and outer stoicism.

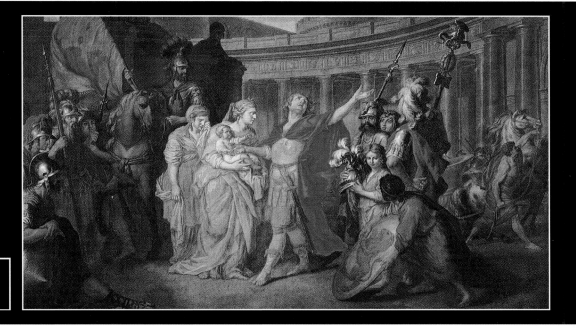

Anton Losenko
26 *Hector Taking Leave of Andromache.* 1773.
Oil on canvas. 155.8 x 211.5 cm.
Tretyakov Gallery, Moscow.

Even when events from Russian history were chosen, Russians were often represented in classical mode – in Greek or Roman costume, or forced into heroic poses imitating those of antiquity. Sometimes the result verged on the absurd, as in Andrei Ivanov's painting (c. 1810) of an act of bravery during the siege of Kiev in 968, where the scanty attire and statuesque posture of the heroic youth have an obvious debt to ancient Greek sculpture.

The ultimate manifestation of this infatuation with classical themes was Karl Briullov's masterpiece *The Last Day of Pompeii* [27]. Painted between 1830 and 1833, while he was living in Italy, it caused a stir throughout Europe. Briullov[3] gleefully boasted that Sir Walter Scott spent a whole morning gazing at it, allegedly declaring it to be "not a painting but an epic", and Gogol[4] described it as "a feast for the eyes". It was also admired by George Bulwer (-Lytton), who visited Italy in 1833 and whose almost identically entitled book was published in 1834. The painting earned Briullov all sorts of honours, including the prestigious Grand Prix at the Paris Salon, and was instrumental in establishing his reputation as the greatest Russian painter of his day.

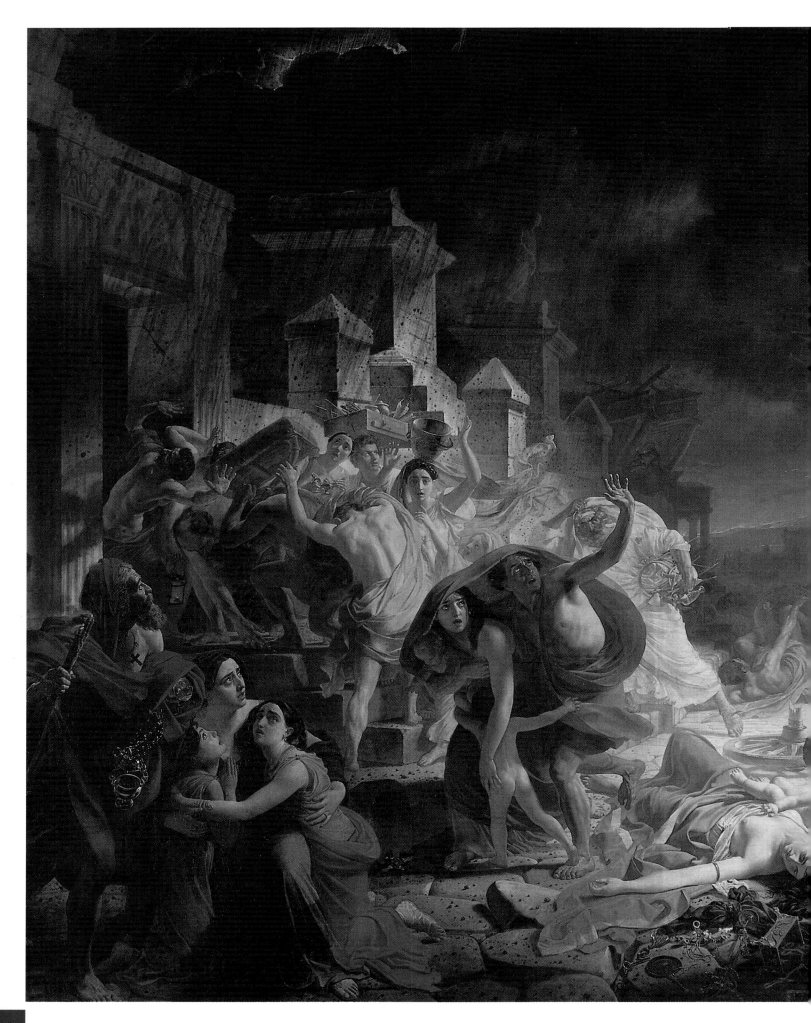

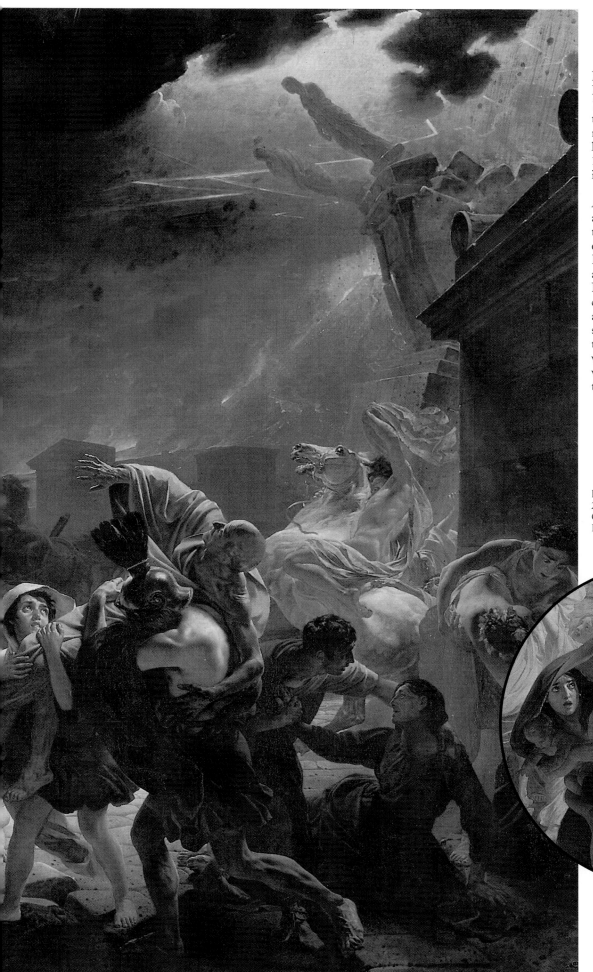

Briullov's most serious rival was Fyodor Bruni (1799–1875), whose masterpiece, *The Bronze Serpent*, was no less ambitious than *The Last Day of Pompeii* and more than matched it in size. Bruni laboured at it for fifteen years (from 1826 to 1841), but much to his chagrin it failed to elicit the same acclaim.

A small flood of caricatures, lampoons and paintings with nationalistic themes was unleashed in reaction to events such as Napoleon's invasion of Russia in 1812 and the Decembrists' attempt to oust the as yet uncrowned Nicholas I in 1825. Later, in 1853, the crushing of their coup was recalled in a painting by Vasily Timm (1820–95), showing Nicholas receiving the news that the rebel troops had been overwhelmed by the Imperial guards, whose presence is a visible reminder of tsarist power.

Karl Briullov
27 *The Last Day of Pompeii.* 1830–1833
Oil on canvas. 456.5 x 651 cm.
Russian Museum, St Petersburg.

Religious Painting

In 1843 Briullov and a number of other artists, including Bruni, were commissioned to decorate the interior of St Isaac's Cathedral in St Petersburg. The most important murals were entrusted to Briullov, whose painting of the Virgin, surrounded by saints and angels, covers the inside of the huge central dome. The damp, cold and stone dust in the newly built cathedral undermined his health, and in 1847 he was compelled to reluctantly abandon the murals, which he had hoped would be the crowning glory of his artistic career.

Alexander Ivanov
28 *Apollo, Hyacinth and Zephyr.* 1831–1834.
Oil on canvas. 100 x 139.9 cm.
Tretyakov Gallery, Moscow.

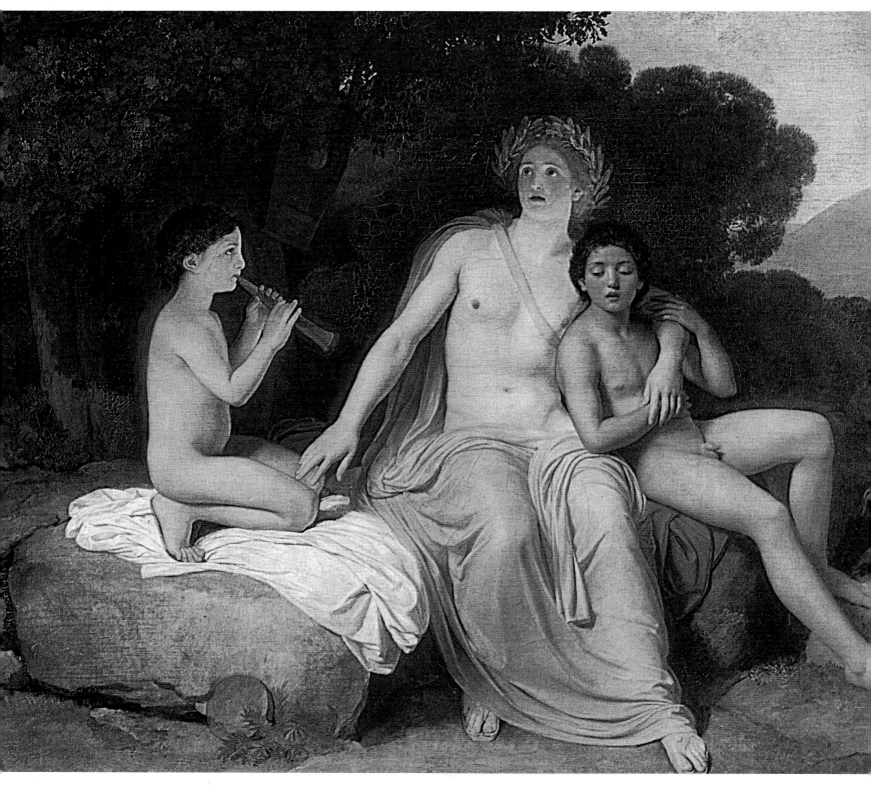

Two other painters who produced major historical and religious works were Anton Losenko (1737–73) and Alexander Ivanov (1806–58), whose father – Andrei Ivanov (see above) – was professor of historical painting at the Academy. Losenko was born in a small town in the Ukraine and orphaned when young. After a course of singing lessons, he was sent to St Petersburg because of his remarkable voice. There, at the age of sixteen, he was entrusted to the care of Argunov (by that time one of the leading portraitists), then studied at the Academy, where he eventually became professor of history painting. Losenko's artistic education was completed in Paris and Rome, and several of his religious works – such as *The Miraculous Catch* and *Abraham's Sacrifice* – show the influence of Italian Renaissance painting. Curiously, his *Cain* (1768) and *Abel* (1769) were intended as exercises in life painting and were only given their Biblical names several decades after his death.

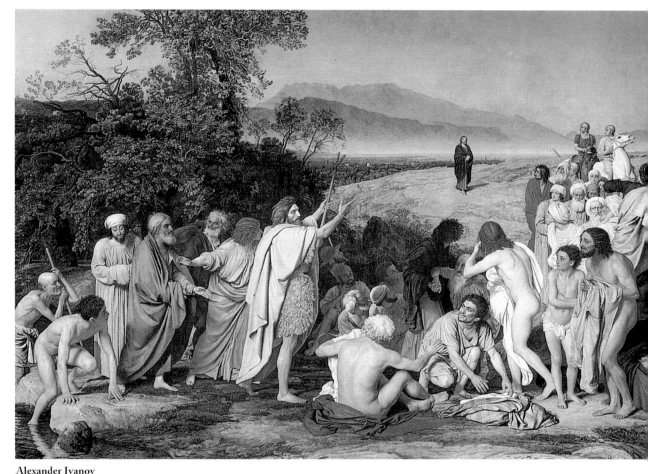

Alexander Ivanov
29 *The Appearance of Christ to the People.* 1837–1857. Oil on canvas. 540 x 750 cm. Tretyakov Gallery, Moscow.

A contemporary of Briullov, Alexander Ivanov was indisputably the most influential religious painter of his day. After making his mark with pictures such as *Apollo, Hyacinth and Zephyr* [28] and *The Appearance of Christ to Mary Magdalene* (1836), he embarked on *The Appearance of Christ to the People* [29], a huge canvas that was to occupy much of his energy for the next twenty years, from 1837 to the year before he died. Nevertheless, despite all those years of effort, Ivanov was never happy with the painting and never regarded it as finished. Indeed, it has an undeniably laboured quality, and many of his preparatory studies – landscapes, nature studies, nudes and portraits, including a head of John the Baptist that is masterpiece in its own right – have a vitality that is absent from the painting itself.

During the last decade of his life Ivanov produced more than 250 *Biblical Sketches*, many of them remarkable for their limpid colours and spiritual intensity. His great ambition was to convert these watercolour studies into murals for a temple that would encompass every aspect of human spirituality. This project, which drew on mythology as well as Christian ideas, loomed so large in his imagination that he made endless excuses to avoid working on the interior of St Isaac's Cathedral, in order to concentrate on the ideal temple taking shape in his mind.

Landscape

It was only in the last quarter of the eighteenth century and during the first part of the nineteenth century that landscape painting in Russia emerged as a separate genre. Artists such as Fyodor Alexeyev (1753–1824), Fyodor Matveyev (1758–1826), Maxim Vorobiev (1787–1855) and Sylvester Shchedrin (1791–1830) produced masterpieces of landscape painting, but their work was heavily influenced by the Latin tradition – by painters such as Claude Lorrain, Poussin and Canaletto – and it is in the work of Venetsianov and his followers (for example, in his *Summer: Harvest Time* and *Spring: Ploughing* [30] that landscape with a truly Russian character makes its first appearance.

Alexei Venetsianov
30 *Spring. Ploughing.*
First half of the 1820s.

Two of Venetsianov's most promising pupils were Nikifor Krylov (1802–31) and Grigory Soroka (1823–64). Despite the brief span of their working lives, both of these were to have a considerable influence on the painters who came after them. The countryside in Krylov's best-known picture, *Winter Landscape* (1827), is unmistakably Russian, as are the people that enliven it. In order to paint the scene realistically, he had a simple wooden studio erected, looking out over the snow-covered plain to the woodlands visible in the distance. Krylov's artistic career had barely begun when, at the age of twenty-nine, he succumbed to cholera. Only a small number of his works have survived.

Soroka died in even more tragic circumstances. He was one of the serfs belonging to a landowner named Miliukov whose estate, Ostrovki, was close to Venetsianov's. Conscious of Soroka's talent, Venetsianov tried to persuade Miliukov to set the young painter free, but without success. (True to his humanitarian ideals, Venetsianov pleaded for the freedom of other talented serf artists and in some cases purchased their liberty himself.) Later, in 1864, Soroka was arrested for his part in local agitation for land reforms and sentenced to be flogged. Before the punishment could be carried out, he committed suicide. One of the most representative of his paintings is *Fishermen: View of Lake Moldino* (late 1840s), which is remarkable for the way it captures the silence and stillness of the lake.

For a period of thirty or forty years most of the leading Russian landscape painters were taught by Maxim Vorobiev, who became a teacher at the Academy in 1815 and continued to teach there – except for long trips abroad, including an extended stay in Italy – almost up to the time of his death. Vorobiev and Sylvester Shchedrin were chiefly responsible for introducing the spirit of Romanticism into Russian landscape painting, while remaining faithful to the principles of classical art. Especially during the last decade of his life, Shchedrin favoured dramatic settings. Vorobiev went through a phase when he was attracted by landscapes shrouded in mist or lashed by storms, and both he and Shchedrin delighted in Romantic sunsets and moonlit scenes.

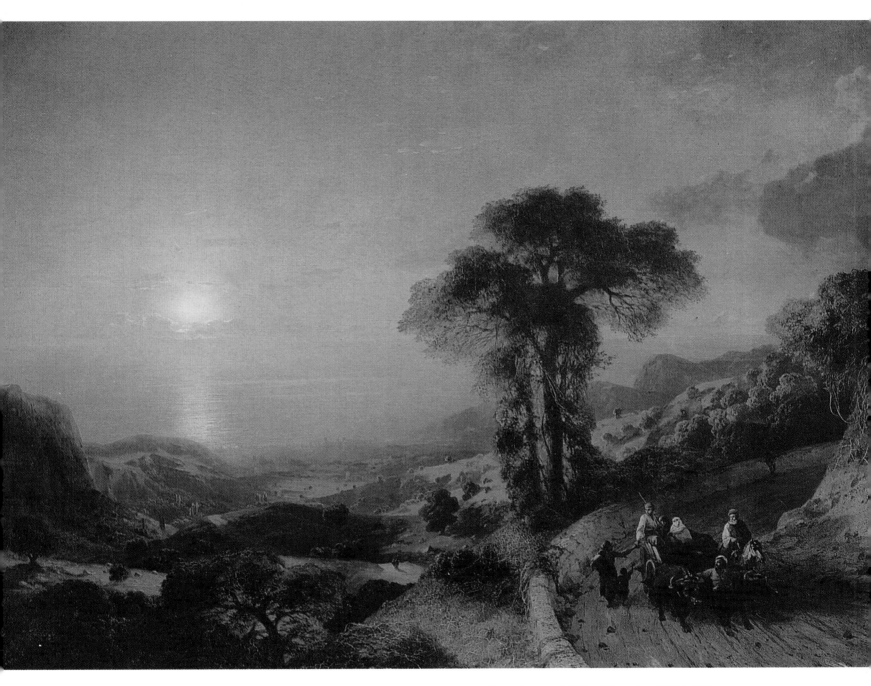

Ivan Aivazovsky
31 *View of the Sea and Mountains at Sunset.* 1864.
Oil on canvas. 122 x 170 cm.
Russian Museum, St Petersburg.

Among Vorobiev's most talented pupils were Mikhail Lebedev (1811–37) – whose landscapes are less overtly Romantic than Vorobiev's or Shchedrin's – and Ivan Aivazovsky (1817–1900), one of the most popular scenic painters of his time and certainly the most prolific. Influenced to some extent by Turner, he created magnificent seascapes, such as *Moonlit Night in the Crimea, View of the Sea and Mountains at Sunset* [31] and *The Creation of the World* [32]. One of Aivazovsky's most famous works, *The Ninth Wave* (1850), owes its title to the superstition among Russian sailors that in any sequence of waves the ninth is the most violent.[5] Like many of his paintings, it bears the imprint of Romanticism: the sea and sky convey the power and grandeur of Nature, while in the foreground the survivors of a shipwreck embody human hopes and fears. Although the sea is the dominant theme in the majority of the 6,000 pictures that Aivazovsky produced, he also painted views of the coast and countryside, both in Russia (especially in the Ukraine and Crimea) and during travels abroad.

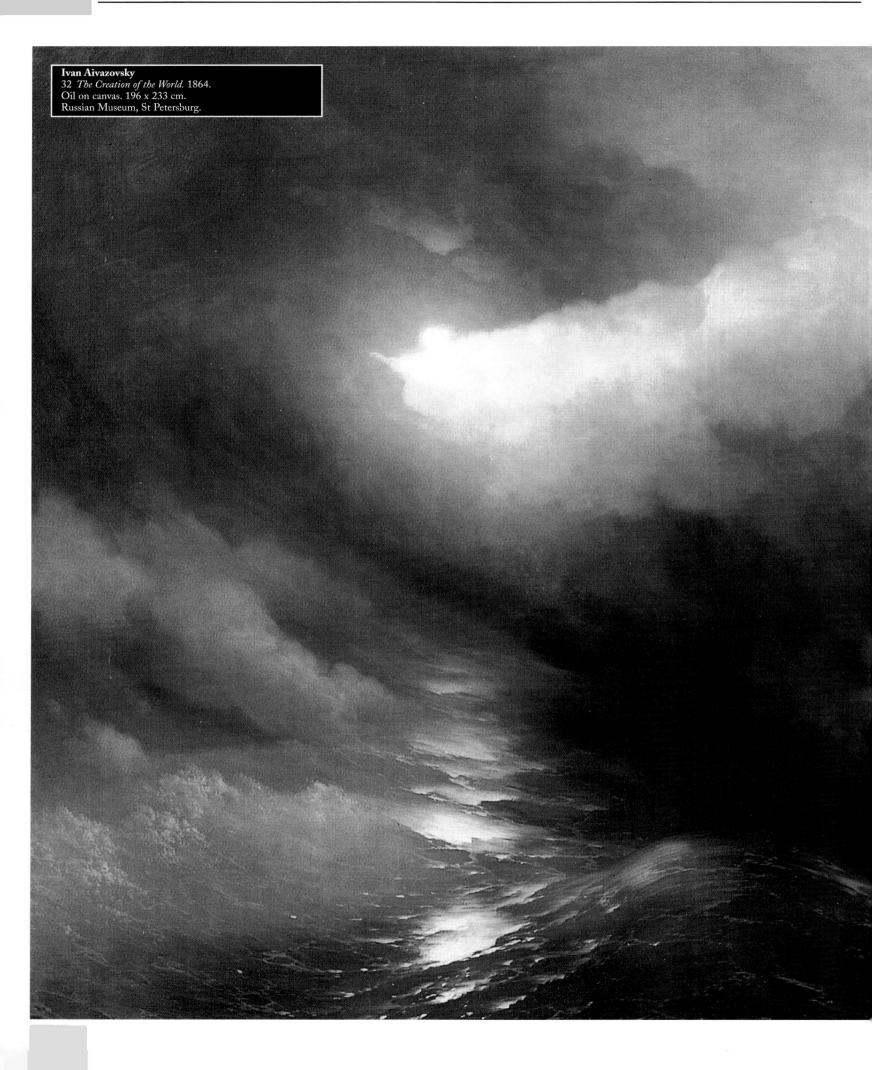

Ivan Aivazovsky
32 *The Creation of the World.* 1864.
Oil on canvas. 196 x 233 cm.
Russian Museum, St Petersburg.

The enthusiasm for all things French that had been so prevalent in Russia during the eighteenth century diminished following the Napoleonic Wars – which is one reason that Russian painters, in common with European artists and writers generally, began to transfer their allegiance to Italy. This trend was reinforced by the Academy's veneration of antiquity and the Italian Renaissance, and also by the first stirrings of the Romantic movement. Fyodor Matveyev painted little else besides Italian architecture and landscape. Both Sylvester Shchedrin (who spent the last twelve years of his life in Italy) and Mikhail Lebedev delighted in idyllic fishing scenes and tableaux of Italian peasant life. Aivazovsky painted views of Venice and Naples (many of them bathed in moonlight), and Fyodor Alexeyev [33] actually became known as "the Russian Canaletto".

Fyodor Alexeyev
33 *View of the Admirality*. 1810.
Oil on canvas. 138 x 178 cm. Russian Museum, St Petersburg.

During the first half of the nineteenth century a steady stream of Russian painters travelled to Italy or took up residence there – among them the Chernetsov brothers (who also travelled to Egypt, Turkey and Palestine) and such influential painters as Briullov, Kiprensky and Alexander Ivanov, whose *Appian Way at Sunset* and *Water and Stones near Pallazzuolo* [34] have an almost Pre-Raphaelite quality. In 1846, Nestor Kukolnik – a fashionable poet and aesthete, whose portrait was painted by Briullov – declared that Russian painting had virtually become a "continuation of the Italian school".[6]

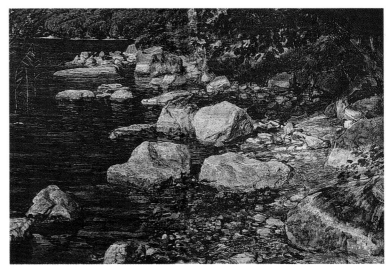

Alexander Ivanov
34 *Water and Stones near Pallazzuolo*. Early 1850s.
Tretyakov Gallery, Moscow.

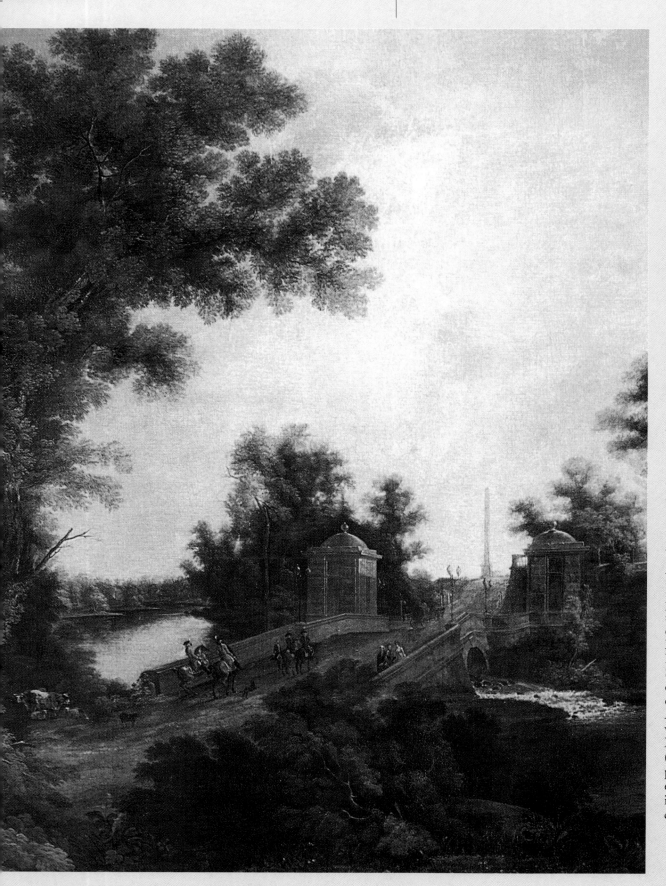

The architecture of their own country also caught the imagination of Russian painters. Both Fyodor Alexeyev and Vorobiev (who had been one of Alexeyev's pupils) produced numerous paintings of the buildings, streets and squares of St Petersburg and Moscow. So did Semion Shchedrin (1745–1804), the uncle of Sylvester. Professor of landscape painting at the Academy from 1776 until his death, he painted charming, sensitive views of the parks and gardens of the Imperial residences near St Petersburg – such as *Stone Bridge at Gatchina* [35], one of a series of decorative panels that he produced between 1799 and 1801.

Alexeyev's images of the city created by Peter the Great are much more than topographical records. They are executed with a harmony and appreciation of beauty that became a hallmark of Russian landscape painting throughout the nineteenth century. The skilful handling of complicated effects of chiaroscuro, both in terms of brushwork and perspective, coupled with the wealth of observation of city life and the detail of the buildings, give his work an enduring artistic and historical value.

Andrei Martynov (1768–1826) and Stepan Galaktionov (1778–1854) were nicknamed "the poets of St Petersburg". Martynov, who was a pupil of Semion Shchedrin, painted atmospheric views of the avenues of elegant houses; the gardens of Monplaisir; the quays along the Neva lined by palaces; and the Smolny Convent, seen from a distance, dissolving into the evening sky. Like Vorobiev and Aivazovsky, he managed to travel widely, and painted in Siberia, Mongolia and China. Galaktionov (another of Semion Shchedrin's pupils) was a lithographer and engraver as well as a painter, which is reflected in the careful, detailed character of his work.

Semion Shchedrin
35 *Stone Bridge at Gatchina.* 1799-1801.
Oil on canvas. 256 x 204 cm.
Decorative panel for the Mikhailovsky Palace, St Petersburg.

Interiors

Grigory Soroka
36 *The Study in a Country House at Ostrovki.* 1844.
Oil on canvas. 54 x 65 cm.
Russian Museum, St Petersburg.

With the establishment of the Academy, instead of being treated as a branch of "perspective painting", the depiction of interiors came to be regarded as an artistic discipline in its own right. An outstanding example of the new genre was the watercolour "portrait" of the salon of the palace in St Petersburg belonging to Catherine the Great's military supremo, Prince Alexander Bezborodko, by his close friend the architect and artist Nikolai Lvov. Painted in 1790, in a gamut of greens and lilacs, it has an intimacy in keeping with their friendship, coupled with a theatricality in some measure due to the extravagant drapery. By making ingenious use of mirrors and the views from the windows, Lvov managed to include glimpses of both the city and the mountains. This touch of artistic sophistry would doubtlessly have been appreciated by the prince, who was a connoisseur and generous patron of the arts.

Compositions of this kind became increasingly common during the first half of the nineteenth century, stimulated no doubt by the interest in interior design that seized Europe during the post-Napoleonic period. In 1828 Vorobiev was appointed professor of perspective at the Academy. At the same time Venetsianov, as part of his own curriculum, made pupils paint carefully observed interior scenes. Many of these have survived, among them views of the Hermitage and the state rooms of the Winter Palace. Other notable paintings of interiors by Venetsianov's pupils include Soroka's *The Study in a Country House at Ostrovki* [36], Alexei Tyranov's delightful picture of the Chernetsov brothers in their studio (1828), Alexander Denisov's *Sailors at a Cobbler's* (1832), Yevgraf Krendovsky's *Preparations Before the Hunt* (1836) and Lavr Plakhov's *Coachmen's Room at the Academy* (1834).

Alexei Venetsianov
37 *The Threshing Floor,* detail.

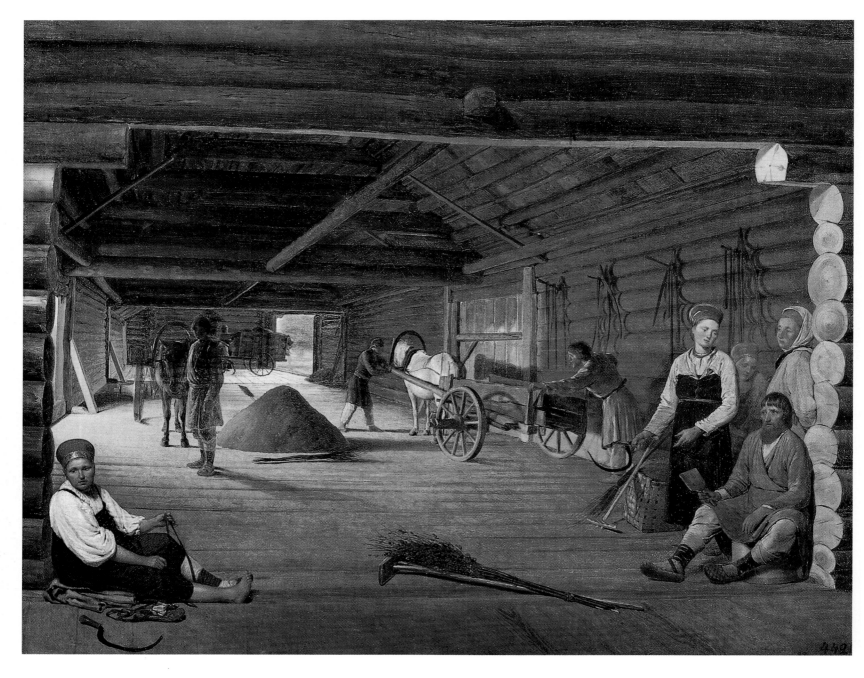

Alexei Venetsianov
37 *The Threshing Floor.* 1821-1823.
Oil on canvas. 66.5 x 80.5 cm.
Russian Museum, St Petersburg.

Venetsianov's own treatment of interiors underwent a sudden transformation, thanks to *The Choir of the Church of the Capuchin Monastery on the Piazza Barberini* by the French artist François Granet. Venetsianov saw it in the Hermitage in 1820 and was instantly struck by a desire to apply Granet's treatment of space and light to a vernacular interior. The result was *The Threshing Floor* [37], which he painted some months later. In order to get the light and details right, he had one of the end walls of the threshing barn removed. It is interesting to compare this interior with *The Kitchen* by Yuri Krylov (1805–41), painted five or six years later. It is not known whether Krylov was one of Venetsianov's pupils, but the mood, the attention to detail, and the preoccupation with perspective and light must surely have been influenced by the earlier work.

Above and right, detail from:
Mikhail Vrubel
110 *Dogrose*. 1884.
Watercolour on paper. 24.5 x 19.5 cm.
Museum of Russian Art, Kiev.

Still Life

In Russia, still life did not emerge as a separate artistic category until the second half of the nineteenth century. Indeed, until that time there were relatively few Russian painters who devoted their energies primarily to still life. Its most brilliant proponent was Ivan Khrutsky (1810–85), whose decorative pictures of fruit and vegetables were influenced by the Dutch masterpieces displayed in the Hermitage. Dutch and Italian still lifes served as models for most of Khrutsky's contemporaries – though one or two of them departed from the norm by substituting indigenous vegetables, such as onions, carrots, mushrooms and parsley, in place of the hothouse fruits typically included in the Dutch and Italian compositions.

Some of Venetsianov's pupils, such as Kapiton Zelentsov (1790–1845) and Alexei Tyranov (1808–59), painted lively, minutely observed compositions of everyday objects. Still-life elements also frequently figure in portraits and pictures of interiors by them – for example, on the desk in the foreground of Soroka's *The Study in a Country House at Ostrovki* [36].

Count Fyodor Tolstoy (1783–1873) – a friend and admirer of Venetsianov and relative of the famous novelist – was an exceptionally versatile artist who became known as a sculptor and medallist and also for his silhouettes. In addition, he produced natural-history studies of birds and flowers, and interior scenes with such titles as *At the Window on a Moonlit Night*. One of the art forms at which he excelled was the creation of charmingly convincing *trompe l'oeil* miniatures, in pen-and-ink and gouache, featuring flowers and berries plus butterflies or birds.

Genre painting

In the 1770s the Academy offered a class of "domestic exercises", but scenes from ordinary everyday life – which came to be known as genre painting – were scarcely considered as worthy topics for art and did not enjoy the same prestige as portraits or historical tableaux. Initially, as with landscape and interiors, Venetsianov's interest in peasant life was partly responsible for genre painting being viewed as a separate artistic discipline.

Although, as with other artists, the distinction between Venetsianov's genre pictures and his other types of painting is sometimes blurred, what sets them apart is the quiet focusing on the men, women and children who appear in these tableaux – on their activities, surroundings, identity and lifestyle. Many of his genre paintings – such as *Cleaning the Sugar Beet, Peasant Children in a Field* and *The Morning of a Landowner's Wife* – capture a "frozen" moment of time. The same is true of the lively medley of people, animals, carts and carriages in *Square in a Provincial Town* by Yevgraf Krendovsky (1810–53), a wide-angled panorama notable for its ingenious manipulation of perspective.

Above right:
Mikhail Shibanov
39 *Solemnizing the Wedding Contract.* 1777.
Oil on canvas. 199 x 244 cm.
Tretyakov Gallery, Moscow.

Above left:
Mikhail Shibanov
38 *Peasant Meal.* 1774.
Oil on canvas. 103 x 120 cm.
Tretyakov Gallery, Moscow.

One of the first Russian artists to specialize in this type of painting was Mikhail Shibanov. A serf of Prince Grigory Potemkin (the favourite of Catherine the Great), he had first-hand knowledge of peasant life. The dates of his birth and death are not known, though he died after 1789. The family that figures in his most famous painting – *Peasant Meal* [38], painted in 1774 – are shown gathered round a farmhouse table. It is doubtful whether the Academy had ever previously been asked to consider a work of art that featured ordinary people in a humble domestic setting engaged in a commonplace daily routine. By portraying the dignified solidarity of this peasant family, Shibanov showed that it was possible to produce a masterpiece without painting in the grand manner. The same qualities are apparent in *Solemnizing the Wedding Contract* [39], which he painted three years later. There is no distance between Shibanov and the people who feature in these pictures. For the first time in the history of Russian art, peasants are treated not as exotic characters or curiosities but as real people, endowed with an aesthetic and moral worth.

Pavel Fedotov
40 *The Major's Marriage Proposal.* 1848. Oil on canvas. 58.3 x 75.4 cm. Tretyakov Gallery, Moscow.

Another artist who left a vivid record of peasant life was I.A. Ermenev. As with Shibanov, we do not know his precise dates, but he was probably born in 1746 and died some time after 1789. The son of an equerry at the court of Catherine the Great, he was orphaned at an early age. After graduating at the Academy, he went to study in Paris. There he witnessed the events of the French Revolution, which deepened his preoccupation with the condition of the lower classes. Ermenev's paintings have poignant titles – *Poor Woman and Her Daughter, Blind Singers, Peasants at Table, Poor Man and Woman, Old Man Seated with a Bowl*. Dressed in tatters or patched clothes, often with rheum-filled eyes and with rags on their swollen feet, the serfs and beggars that people his pictures are a far cry from the fashionably attired courtiers who sat for Rokotov, Borovikovsky or Levitsky. Ermenev died alone, unrecognized, and his work was virtually overlooked until after his death.

By the middle of the nineteenth century, Russian writers and painters were also beginning to focus attention on other sectors of society that had, until then, scarcely figured in art. Landowners, civil servants, the military and the clergy all became possible subjects for artistic comment. As a reaction against the repressive and bureaucratic regime of Nicholas I, the behaviour of the ruling class was frequently depicted in a satirical light.

One of the most astute social commentators was Pavel Fedotov (1815–52). To Fedotov's contemporaries, the social status of the dramatis personae in his best-known picture – *The Major's Marriage Proposal* [40], painted in 1848 – would have been immediately recognizable. Marriageable young ladies, like the one whose hand the languid major is seeking, could be seen promenading on St Petersburg's Nevsky Prospekt and in the city's parks. All the figures, down to the servants in the background, are portrayed with an unerring eye for detail. Fedotov's pictures pillory social evils (in this case the way women were treated as marketable chattels), mostly with humour though occasionally with bitterness. In 1844, at the age of twenty-nine, Fedotov abandoned a military career in favour of painting. Eight years later he died in a mental institution, the balance of his mind eroded by poverty and frustration.

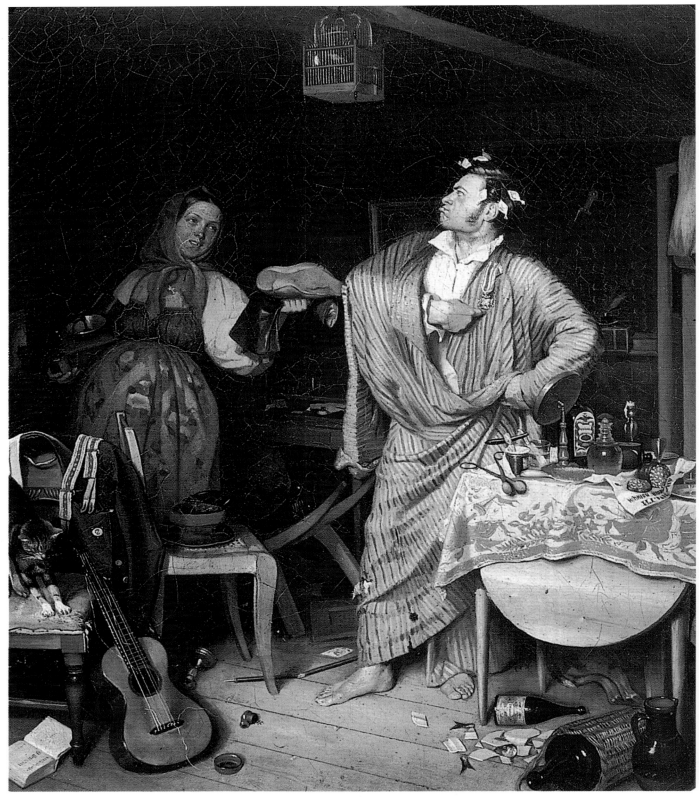

Pavel Fedotov
41 *The Newly Decorated Civil Servant.* 1846. Oil on canvas. 48.2 x 42.5 cm. Tretyakov Gallery, Moscow.

Fedotov's *The Newly Decorated Civil Servant* [41] infuriated the self-important officials caricatured by him to such an extent that he was banned from selling reproductions until the medal had been removed from the civil servant's dressing-gown and the title changed to *The Morning After a Party*.[7] His sense of the absurd is keenly evident in works like *The Discriminating Bride* (1847), *A Poor Aristocrat's Breakfast* (1849) and *Encore! Encore!* (1851–2), which features an army officer desperately trying to relieve the tedium of a rural posting by teaching his dog to jump over a stick. Fedotov's last paintings have a more sombre atmosphere – such as *The Gamblers* (1852) and *The Young Widow* (1851–2), an extremely moving picture inspired by his own sister's bereavement.

The Itinerants

In 1863 – the year that the first Salon des Refusés was held in Paris – fourteen high-profile art students (thirteen painters and a sculptor) resigned from the Imperial Academy of Arts in St Petersburg in protest against its conservative attitudes and restricting regulations. Their next move was to set up an artists' cooperative, but it soon became apparent that a more broadly based and better organized association was needed, and this eventually led to the formation of the Society for Itinerant Art Exhibitions. The Society was incorporated in November 1870, and the first of its forty-three exhibitions was held in November 1871 (the last one took place in 1923). The four artists who spearheaded the setting up of the Society were Ivan Kramskoi,

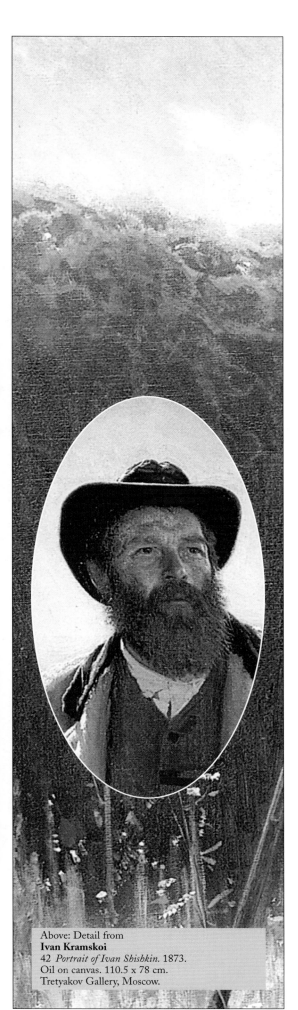

Above: Detail from
Ivan Kramskoi
42 *Portrait of Ivan Shishkin.* 1873.
Oil on canvas. 110.5 x 78 cm.
Tretyakov Gallery, Moscow.

Vasily Perov, Grigory Miasoyedov and Nikolai Gay. One of their prime concerns, reflected in the name of the Society, was that art should reach out to a wider audience. To further that aim – perhaps inspired by the *narodniki* (the Populists then travelling around Russia preaching social and political reform) – they undertook to organize "circulating" exhibitions, which would move from one town to another.

Like the Impressionists in France (who also held their first exhibition in 1871), the *peredvizhniki* – variously translated as Itinerants, Travellers and Wanderers – embraced a broad spectrum of artists, with differing styles and a great variety of artistic preoccupations. But, initially at least, the Society was a more tightly knit organization, and ideologically its aims were more coherent. Living at the time when the writings of Herzen, Chernyshevsky, Turgenev, Dostoyevsky and Tolstoy were awakening social consciences, most of the Itinerants were actively concerned with the conditions in which the ordinary people of

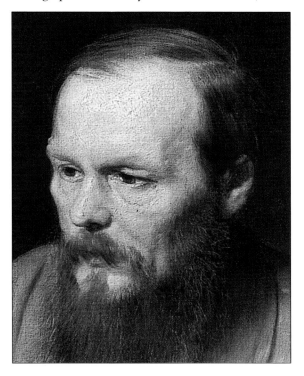

Detail from
Vasily Perov
45 *Portrait of Fyodor Dostoyevsky.* 1872.
Oil on canvas. 99 x 80.5 cm.
Tretyakov Gallery, Moscow.

Russia lived, and strove to stimulate awareness of the appalling injustices and inequalities that existed in contemporary society. The artistic movement that focused on these concerns came to be known as Critical Realism.

Portraiture

The most prominent role in setting up the artists' cooperative was played by Ivan Kramskoi (1837–87), who had also been a leading member of the "Revolt of the Fourteen". Although initially drawn to historical and genre painting, he was to find his fullest expression as a portrait painter. Among the gallery of celebrities who appear in his paintings are fellow-Itinerant Ivan Shishkin [42] – pictured against a backdrop of trees surveying the landscape before setting up his easel – and the singer Elizaveta Lavrovskaya (1879) on the stage of a concert hall, receiving an ovation. His portrait of the forty-four-year-old Leo Tolstoy [43], who sat for him while writing *Anna Karenina*, focuses on the thoughtful intensity of the novelist's gaze. Kramskoi's portrait of Nikolai Nekrasov [44], painted during the poet's harrowing final illness, shows the poet courageously attempting to finish his *Last Songs*. Even more heart-rending is his painting entitled *Inconsolable Grief* (1884), depicting a grieving woman standing beside a wreath of flowers, painted when his own wife was mourning the death of their son.

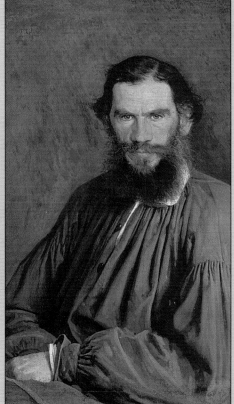

Ivan Kramskoi
42 *Portrait of Ivan Shishkin.* 1873.
Oil on canvas. 110.5 x 78 cm.
Tretyakov Gallery, Moscow.

Ivan Kramskoi
43 *Portrait of Leo Tolstoy.* 1872.
Oil on canvas. 98 x 79.5 cm.
Tretyakov Gallery, Moscow.

Ivan Kramskoi
44 *Nikolai Nekrasov in the Period of his "Last Songs".* 1877. Oil on canvas. 105 x 89 cm.
Tretyakov Gallery, Moscow.

Vasily Perov (1834–82), a warm-hearted man whose views commanded respect among his fellow Itinerants, almost invariably shows his models sitting in a quiet and dignified pose. With great subtlety, he conveys the haunted sensitivity of Dostoyevsky [45], the mental energy of the dramatist Alexander Ostrovsky [46], and the shrewdness of the merchant Ivan Kamynin [47] – whose family refused to allow this portrait to be exhibited at the World Fair in Paris in 1878 because it did not present a sufficiently genial image of him. Many of Perov's liveliest genre paintings, such as *Hunters at Rest* [100], *A Meal in a Monastery* and *The Angler*, rely on observation of character for their vivacity, satire or humour.

Vasily Perov
45 *Portrait of Fyodor Dostoyevsky*. 1872.
Oil on canvas. 99 x 80.5 cm.
Tretyakov Gallery, Moscow.

Vasily Perov
46 *Portrait of the Writer Alexander Ostrovsky*. 1871.
Oil on canvas. 103.5 x 80.7 cm.
Tretyakov Gallery, Moscow.

Vasily Perov
47 *Portrait of the Merchant Ivan Kamynin*. 1872.
Oil on canvas. 104 x 84.3 cm.
Tretyakov Gallery, Moscow.

Both Manet and Velázquez had an influence on Ilya Repin (1844–1930), yet the style of his portraiture remains very much his own. Among his most enchanting portraits are the ones of his daughters Vera [48] and Nadezhda [49] and the idyllic group portrait *On a Turf Bench* (1876), all painted *en plein air*.

Ilya Repin
48 *Autumn Bouquet: Portrait Of Vera Repina, the Artist's Daughter.* 1892.
Oil on canvas. 111 x 65 cm.
Tretyakov Gallery, Moscow.

Ilya Repin
50 *Portrait of Leo Tolstoy.* 1887.
Oil on canvas. 124 x 88 cm.
Tretyakov Gallery, Moscow.

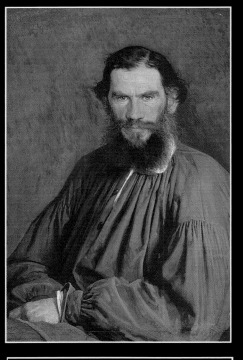

Ivan Kramskoi
43 *Portrait of Leo Tolstoy.* 1872.
Oil on canvas. 98 x 79.5 cm.
Tretyakov Gallery, Moscow.

Ilya Repin
49 *In the Sunlight: Portrait of Nadezhda Repina, the Artist's Daughter.* 1900.
Oil on canvas. 94.3 x 67 cm.
Tretyakov Gallery, Moscow.

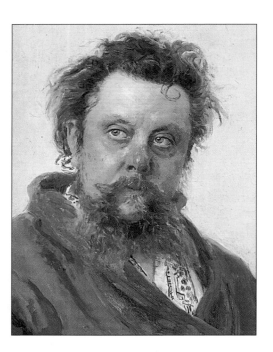

Repin was a close friend of Leo Tolstoy. He made numerous paintings and sketches of the novelist, and it is interesting to compare the portrait reproduced here [50] with the one painted by Kramskoi [43] in 1872. An interval of fifteen years separates the two paintings, during which Tolstoy had become increasingly ascetic. No less revealing is Repin's portrait of Mussorgsky [51] painted in hospital (hence the dressing-gown) shortly before the composer's early death, hastened by alcoholism. One of Repin's most memorable portraits is *The Archdeacon* (1877), which splendidly conveys the patriarchal robustness of this "lion among the clergy"[1] who, he felt, embodied "the echo of a pagan priest".[2]

Ilya Repin
51 *Portrait of Modest Mussorgsky.* 1881. Oil on canvas. 69 x 57 cm. Tretyakov Gallery, Moscow.

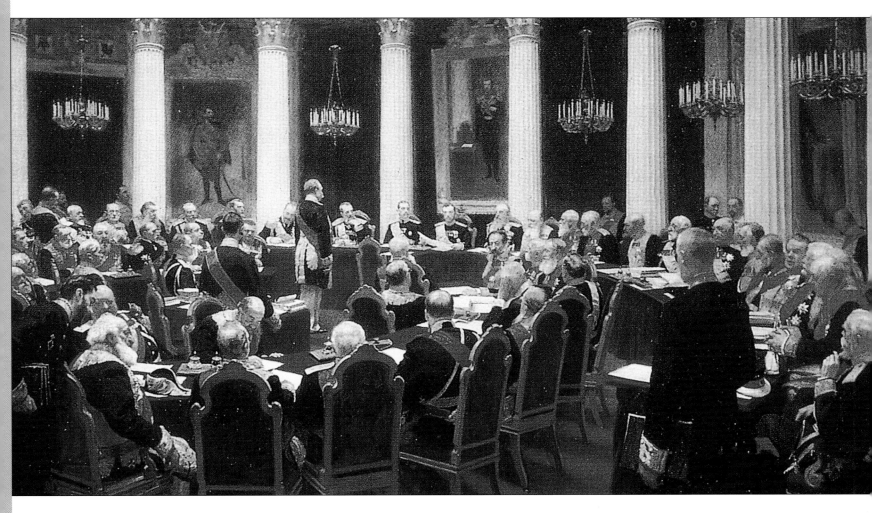

The most demanding official commission undertaken by Repin was a painting of the formal session of the State Council held on 7 May 1901 [52]. In order to complete this gigantic group portrait, he prepared dozens of studies, so he could accurately capture the character of each of the 100 councillors, and enlisted the help of two of his pupils, Boris Kustodiev and Ivan Kulikov. The painting was commissioned to celebrate the Council's centenary – but, whether intentionally or unintentionally, Repin succeeded in conveying its aura of implacable conservatism, and one critic remarked that he had painted a vision of "Carthage on the eve of destruction".[3]

Many of the other Itinerants were gifted portrait painters, among them Yuri Leman, Alexei Kharlamov, Nikolai Yaroshenko (1846–98) – dubbed "the conscience of the *peredvizhniki*",[4] who succeeded Kramskoi as leader of the Itinerants – and Nikolai Gay, who painted a marvellously expressive self-portrait during the two years preceding his death. The portraiture of two of the most brilliant of the Itinerants, Serov and Surikov, will be discussed in the third part of this book.

Ilya Repin
52 *Formal Session of the State Council Held to Mark its Centenary on 7 May 1901*. 1903.
Oil on canvas. 400 x 877 cm. Russian Museum, St Petersburg.

Historical painting

Among the Itinerants, the undisputed master of history painting was Vasily Surikov (1848–1916). Born in a remote Siberian town, Krasnoyarsk, of Cossack ancestry, he felt strong personal links with the people and history of Russia. Like many other Russian artists in the 1870s and 1880s, he was particularly fascinated by the Petrine era – because both the reign of Peter the Great and that of Alexander II (from 1855 to 1881) were periods of national development and liberal reforms, yet both rulers behaved autocratically and dealt ruthlessly with their opponents.

Vasily Surikov
53 *The Morning of the Execution of the Streltsy.* 1878–81. Oil on canvas. 218 x 379 cm. Tretyakov Gallery, Moscow

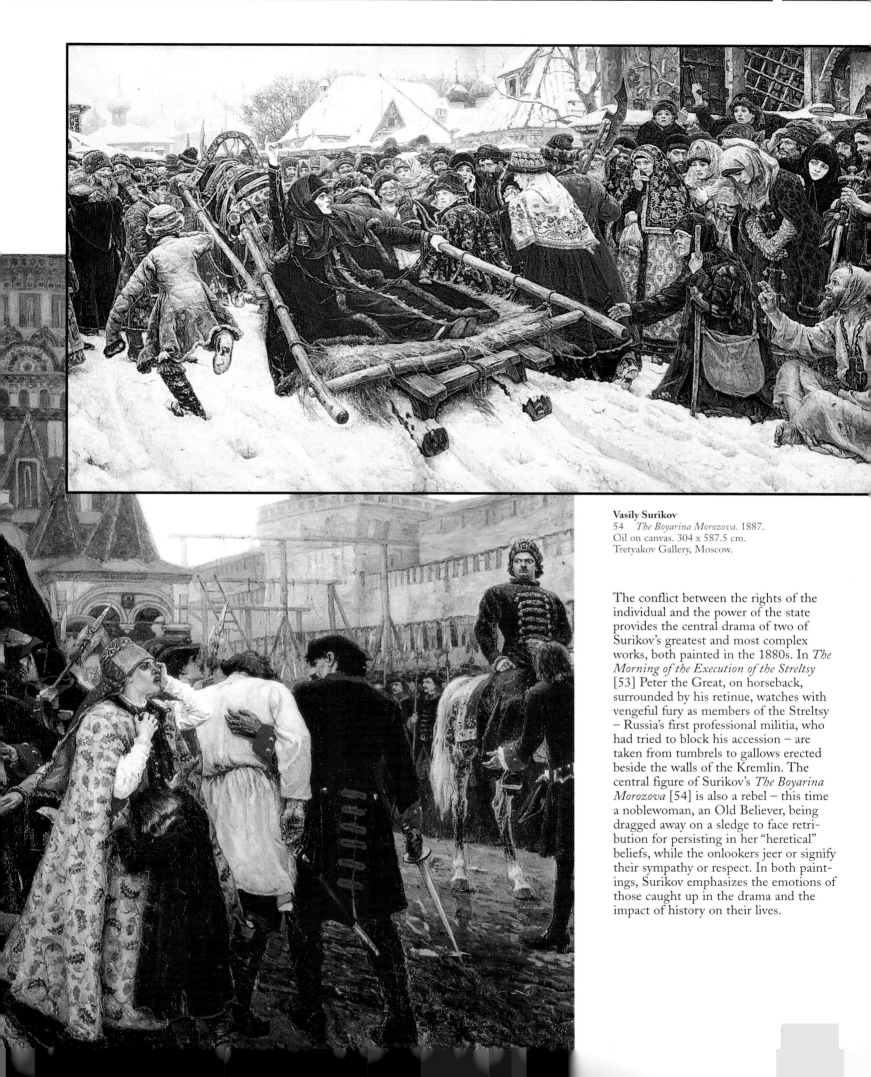

Vasily Surikov
54 *The Boyarina Morozova.* 1887.
Oil on canvas. 304 x 587.5 cm.
Tretyakov Gallery, Moscow.

The conflict between the rights of the individual and the power of the state provides the central drama of two of Surikov's greatest and most complex works, both painted in the 1880s. In *The Morning of the Execution of the Streltsy* [53] Peter the Great, on horseback, surrounded by his retinue, watches with vengeful fury as members of the Streltsy – Russia's first professional militia, who had tried to block his accession – are taken from tumbrels to gallows erected beside the walls of the Kremlin. The central figure of Surikov's *The Boyarina Morozova* [54] is also a rebel – this time a noblewoman, an Old Believer, being dragged away on a sledge to face retribution for persisting in her "heretical" beliefs, while the onlookers jeer or signify their sympathy or respect. In both paintings, Surikov emphasizes the emotions of those caught up in the drama and the impact of history on their lives.

In *Menshikov at Beriozov* [55] Surikov depicts Peter the Great's favourite in exile in Siberia, together with his three children, after Peter's death and the statesman's fall from grace. The four figures, stripped of wealth and status but still a family, are no less eloquent than the crowds in Surikov's more dramatic works.

For Repin, unlike Surikov, history painting was not a prolific area of artistic endeavour. Nevertheless, he made an enormous contribution to it. Several of his paintings probe the psychological truth of historical situations and show an empathy with those whose lives are touched by history.

Vasily Surikov
55 *Menshikov at Beriozov*. 1883.
Oil on canvas. 169 x 204 cm.
Tretyakov Gallery, Moscow.

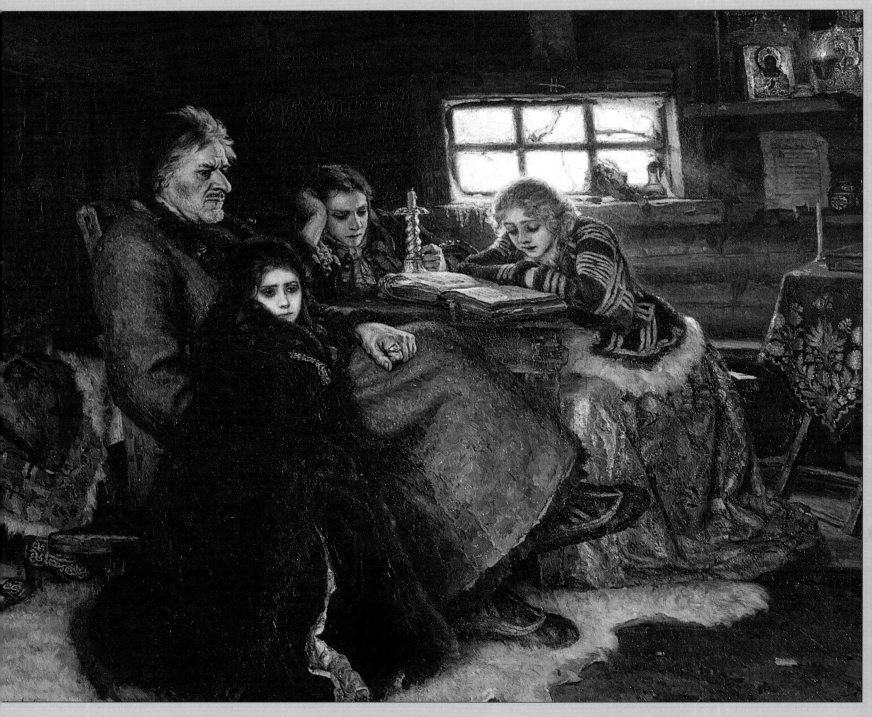

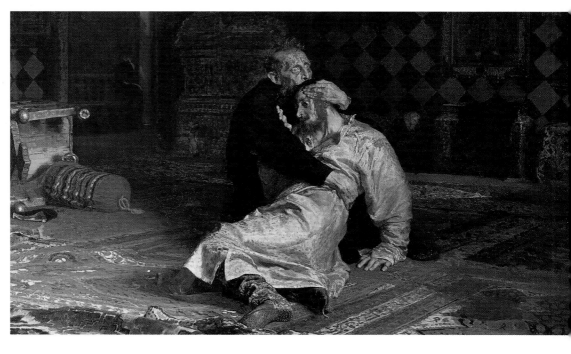

Ilya Repin
56 *Ivan the Terrible and his Son Ivan on 16 November 1581.* 1885.
Oil on canvas. 199.5 x 254 cm. Tretyakov Gallery, Moscow.

His painting showing Ivan the Terrible, grief-crazed, hugging the body of his son, whom he has just killed in a fit of rage, vividly depicts the obscene consequences of tyranny [56]. Repin said that he started work on the picture shortly after the execution of the revolutionaries who assassinated Alexander II, and painted it "in fits and starts" with his emotions "overburdened by the horrors of contemporary life".[5]

Repin's painting of Peter the Great's half-sister Sophia [57], imprisoned in a convent for opposing him, portrays both her undiminished defiance and her anger and horror at the fate of her supporters (the silhouette of a hanged man is visible through the window of her room). In *The Zaporozhye Cossacks Writing a Mocking Letter to the Turkish Sultan* [58], which focuses on the mirth of the letter writers, Repin invites us to admire the Cossacks' independent spirit and to share their enjoyment of their act of effrontery.

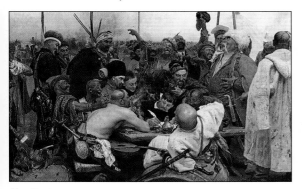

Ilya Repin
58 *The Zaporozhye Cossacks Writing a Mocking Letter to the Turkish Sultan.* 1880-91. Oil on canvas. 203 x 358 cm.
Russian Museum, St Petersburg.

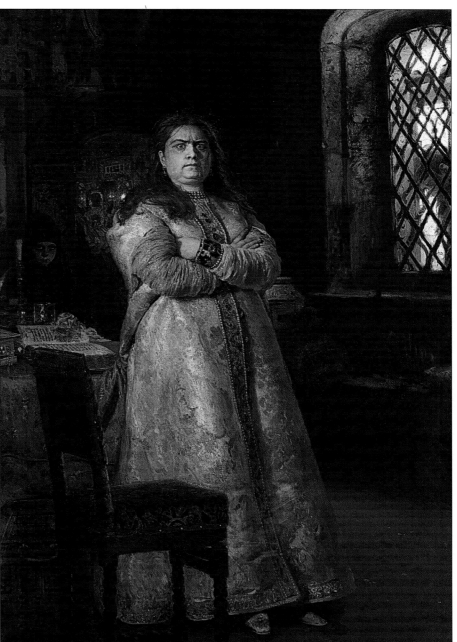

Ilya Repin
57 *Tsarevna Sophia in 1698, a Year after her Confinement to the New Maiden Convent, at the Time of the Execution of the Streltsy and the Torture of All her Servants.* 1879.
Oil on canvas. 201.8 x 145.3 cm. Tretyakov Gallery, Moscow.

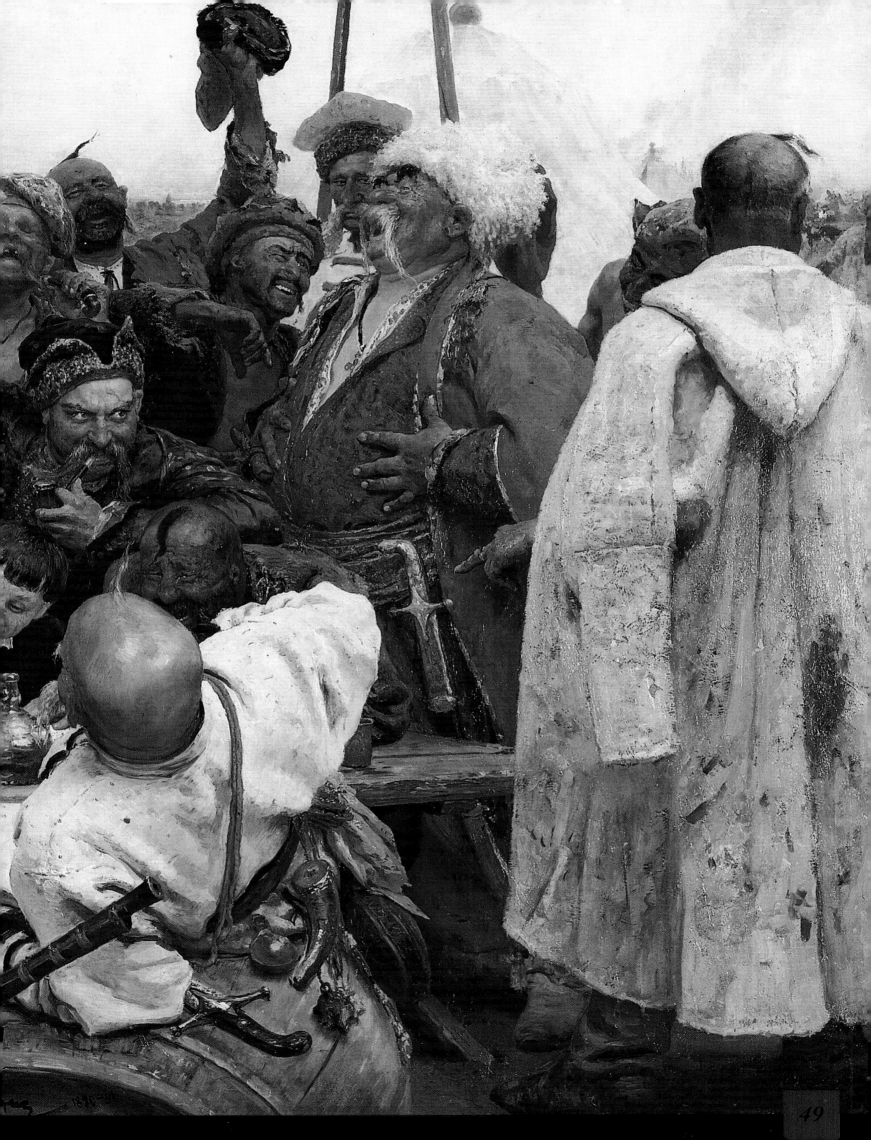

Vasily Perov
59 *The Condemnation of Pugachev.* 1879.
Oil on canvas. 226 x 330 cm.
Russian Museum, St Petersburg.

Nikolai Gay
60 *Peter I Interrogating his Son Alexei at Peterhof.* 1871.
Oil on canvas. 135.7 x 173 cm. Tretyakov Gallery, Moscow.

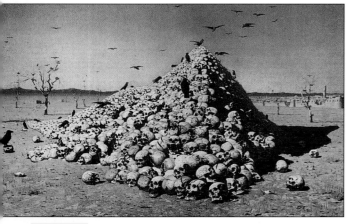

Like Surikov and Repin, most history painters of this period were intent on expressing libertarian ideas. In *Princess Tarakanova* (1864), showing the beautiful princess forgotten and·about to drown as flood waters invade her prison cell, Konstantin Flavitsky (1830–66) concertinaed historical events to make a more pointed protest against the callous despotism of the tsars. Perov's painting depicting the condemnation of Emelyan Pugachev [59], who led a popular uprising against Catherine the Great, indicated his identification with the spirit of peasant revolution. Nevrev, Polenov and many of their contemporaries painted pictures remonstrating, directly or indirectly, at the plight of the serfs.

The democratic ideals of the Itinerants and their dedication to the pursuit of truth provided a stimulus for Nikolai Gay (1831–94), who in the late 1860s had been experiencing a period of uncertainty that inhibited his artistic development. His picture of Peter the Great interrogating his son Alexei [60], suspected of treason, marked a turning-point in his career. When the painting was shown at the Itinerants' first exhibition, in 1871, it was seen as a celebration of the tsar's idealism in repressing his paternal feelings for the sake of his country.

During the same year Vasily Vereshchagin (1842–1904) painted his grim masterpiece *The Apotheosis of War* [61]. A seasoned soldier, through his art he strove to make the world aware of the horrors of the battlefield and the cruelties of colonialism and tsarist terror. Internationally, Vereshchagin was the most widely known of the major Russian painters of his day. He was also one of the few who did not join the Society for Itinerant Art Exhibitions. After spending much of his life observing war at first hand, he died aboard a battleship that exploded during the Russo-Japanese war.

Vasily Vereshchagin
61 *The Apotheosis of War.* 1871. Oil on canvas. 127 x 197 cm. Tretyakov Gallery, Moscow.

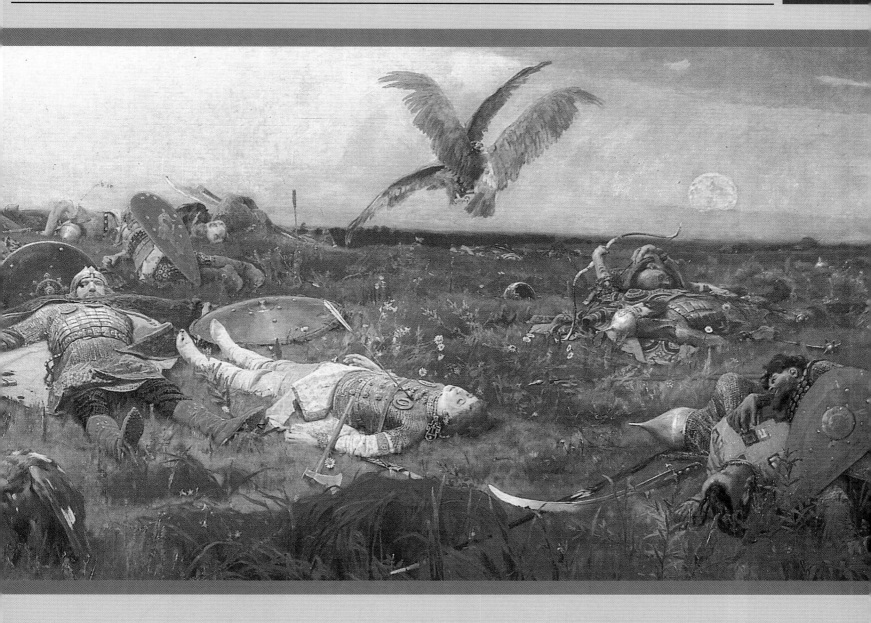

Victor Vasnetsov
62 *After Prince Igor's Battle with the Polovtsy.* 1880.
Oil on canvas. 205 x 390 cm. Tretyakov Gallery, Moscow.

For Aivazovsky and Alexei Bogoliubov (1824–96), naval warfare provided opportunities to explore the effects of light and to display their mastery of the moods of sea and sky. Both painted numerous pictures of naval engagements involving the Russian fleet.

Very different from any of these is the art of Victor Vasnetsov (1848–1926), who described himself as "a historical painter with a fantastic bent".[6] In paintings like the one based on the twelfth-century *bylina* (epic poem) recounting the story of Prince Igor's campaign against the Polovtsy [62], he built on Russia's early history and folklore, creating images that have a mythical aura of their own. Many of his paintings – such as his portrayal of Ivan the Terrible, tormented but still every inch a tsar – have a decorative quality reminiscent of Art Nouveau. The monumental mural on the theme of the Stone Age that he painted for the History Museum in Moscow is a masterpiece of composition, brilliantly re-creating the infancy of mankind.

Religious painting

The religious painting of the Itinerants was marked by an imaginative and psychological intensity that had not been seen since the days of Alexander Ivanov earlier in the nineteenth century.

During 1863, the year when the fourteen artists rebelled against the conservatism of the Academy, Nikolai Gay's powerful painting *The Last Supper* [63] was exhibited in St Petersburg and roused passionate controversy. Dostoyevsky was among those who were disturbed by its realism and theatricality – by the apparition-like silhouette of Judas, the eerie shadows and the air of foreboding as the other apostles watch his departure. Gay's later pictures, which he described as an attempt to create a "Gospel in paint", were no less shocking. In several of them Christ is shown in a very human state of torment, looking more like a political prisoner than the son of God – a notion so shocking that "*Quid est veritas?*" ("What is Truth?") [64] had to be withdrawn when exhibited in 1890 because it was regarded as blasphemous.

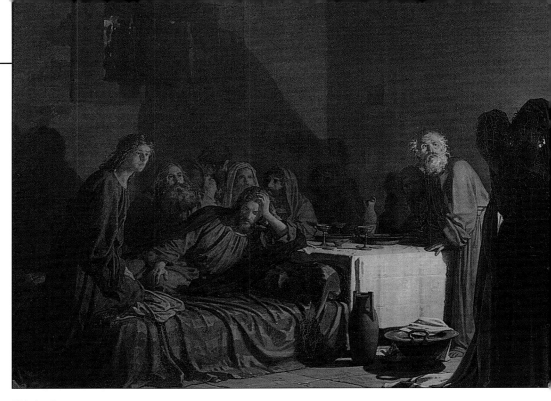

Nikolai Gay
63 *The Last Supper.* 1863. Oil on canvas. 283 x 382 cm. Russian Museum, St Petersburg.

Ivan Kramskoi
65 *Christ in the Wilderness.* 1872. Oil on canvas. 180 x 210 cm. Tretyakov Gallery, Moscow.

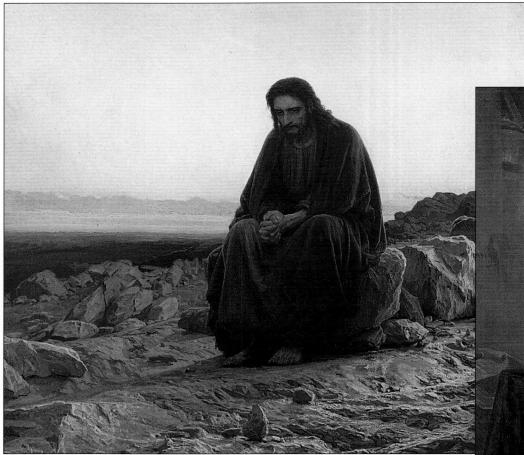

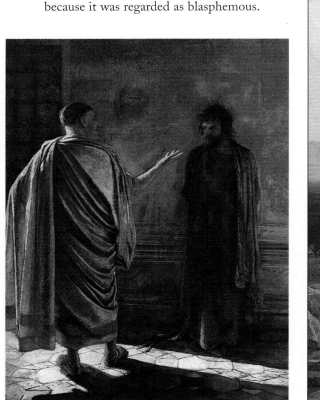

Nikolai Gay
64 *"Quid est veritas?": Jesus and Pilate.* 1890.
Oil on canvas. 233 x 171 cm. Tretyakov Gallery, Moscow.

Kramskoi's *Christ in the Wilderness* [65] also caused a sensation when exhibited, in 1872. It shows Christ in a state of agonized indecision and dejection, hands clasped together out of tension, not in prayer. Kramskoi felt both impelled and daunted by the urge to paint Christ in a way that had never been attempted before, and said that he painted the picture with his own "blood and tears".[7]

Although he worked on *Laughter ("Hail, King of The Jews!")* [66] for at least five years, in the end Kramskoi left it unfinished. "Make a serious attempt to put ideas [of goodness and honesty] into practice," he wrote, "and you will see the laughter that breaks out all around."[8]

Both Repin and Vasily Polenov (1844–1927) produced paintings of Jesus raising the daughter of Jairus. Both admirably convey Jesus's charismatic presence, but Repin's [67] is the more atmospheric of the two. Polenov's enormous *Christ and the Woman Taken in Adultery* [68] is so packed with worldly detail that it seems more like a secular painting than a religious work. During the later part of his life, Polenov produced a series of paintings inspired by Ernest Renan's *Life of Jesus* (1863), a book that had a huge impact on artists and writers both in Russia and elsewhere.

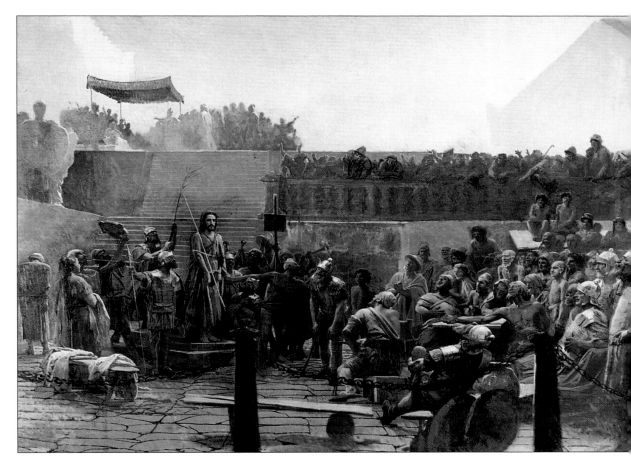

Ivan Kramskoi
66 *Laughter ("Hail, King of the Jews!")*. 1877–1882
Unfinished. Oil on canvas. 375 x 501 cm.
Russian Museum, St Petersburg.

Ilya Repin
67 *The Raising of Jairus's Daughter*. 1871. Oil on canvas. 219 x 382 cm. Russian Museum, St Petersburg.

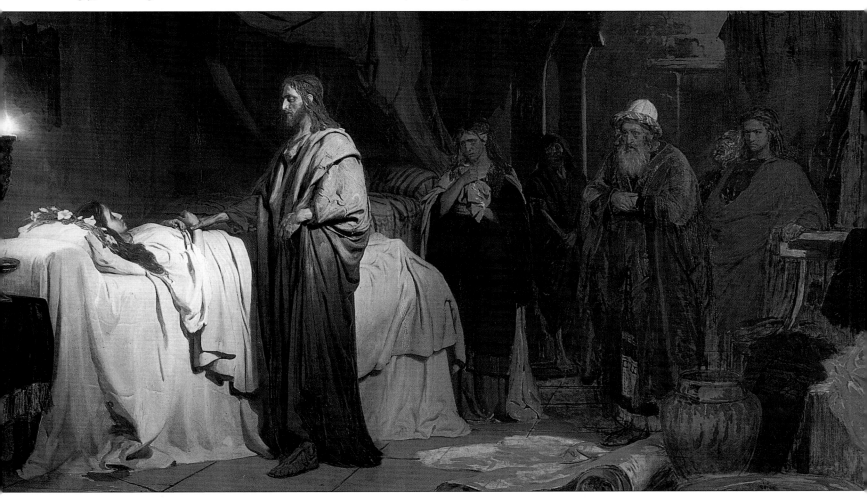

Vasily Polenov
68 *Christ and the Woman Taken in Adultery.* 1887. Oil on canvas. 325 x 622 cm. Russian Museum, St Petersburg.

Landscape

With the Itinerants, the status of landscape painting was greatly enhanced. Even artists like Perov, who were primarily concerned with people rather than landscape, regarded the countryside as something more than a convenient background for portraits and genre paintings. Perov's *The Last Tavern at the City Gates* [69], painted in 1868, is enormously evocative, with its wintry light and the snow-covered road stretching into the distance. Three years later, Fyodor Vasilyev's *The Thaw* [70] and Alexei Savrasov's *The Rooks Have Returned* [71] were among the highlights of the Itinerants' first exhibition. These three paintings in effect mark the watershed between academic Romanticism and a more realistic representation of nature.

Vasily Perov
69 *The Last Tavern at the City Gates.* 1868. Tretyakov Gallery, Moscow.

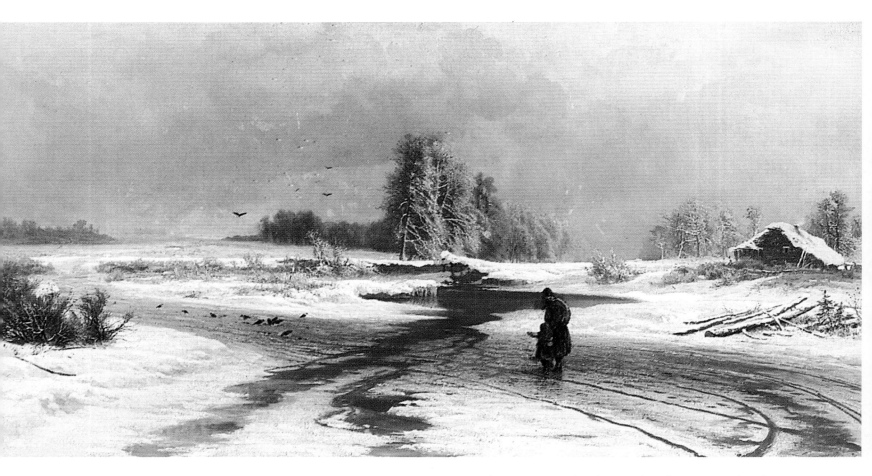

Fiodor Vasilyev
70 *The Thaw.* 1871. 53.5 x 107 cm. Tretyakov Gallery, Moscow.

A mild-mannered and extraordinarily patient teacher, Savrasov exerted a far-reaching influence on Russian landscape painting. From 1857 to 1882 he was in charge of the landscape studio at the Moscow College of Painting, Sculpture and Architecture, where Levitan, Korovin and Nesterov were among his pupils. *The Rooks Have Returned* brilliantly evokes the reawakening of the Russian countryside after the winter.

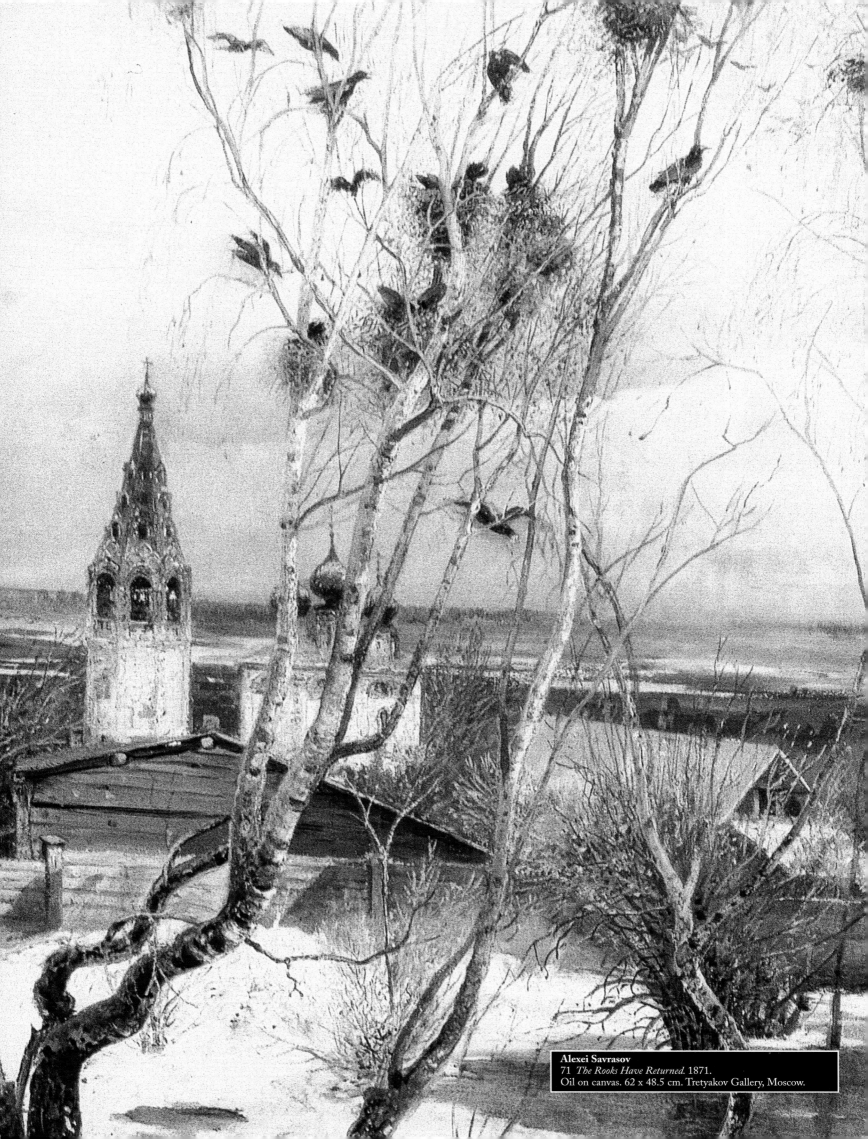

Ivan Shishkin (1832–98) was dubbed the "Tsar of the Forest" by his contemporaries. The technical virtuosity and poetic majesty of his painting speak for themselves. Works such as *Winter* (1890) are unrivalled in the way they convey the texture of snow, while his summer landscapes – such as *Rye* and *Oak Grove* [72] – powerfully express the beauty and colours of the Russian countryside. *Morning in a Pine Forest* [73], unforgettable for its bears, and *Countess Mordvinova's Forest at Peterhof* [74] are among the hundreds of paintings by him that capture the magic of the forest and the character of the trees.

Ivan Shishkin
72 *Oak Grove.* 1887.
Oil on canvas. 125 x 193 cm.
Museum of Russian Art, Kiev.

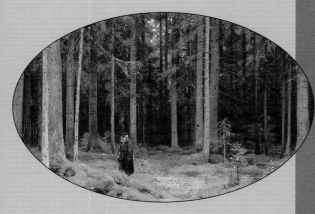

Ivan Shishkin
73 *Morning in a Pine Forest.* 1889.
Oil on canvas. 139 x 213 cm.
Tretyakov Gallery, Moscow.

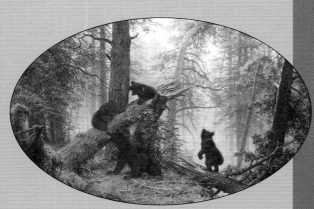

Ivan Shishkin
74 *Countess Mordvinova's Forest at Peterhof.* 1891.
Oil on canvas. 81 x 108 cm. Tretyakov Gallery, Moscow.

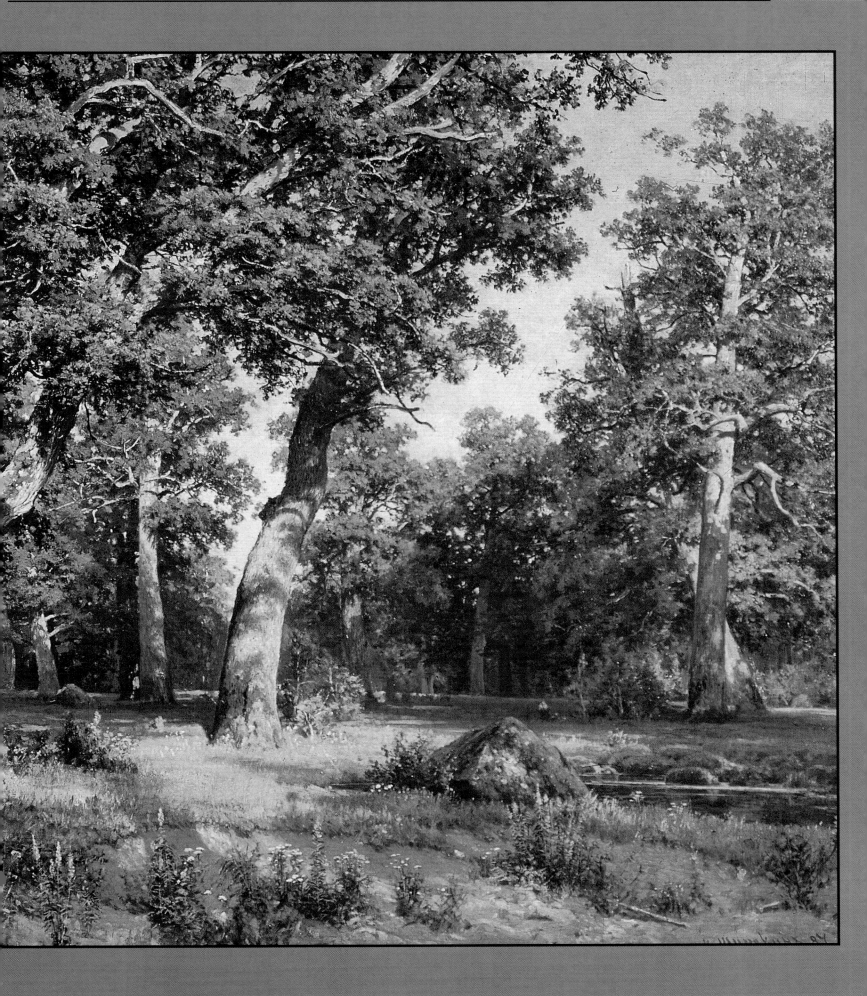

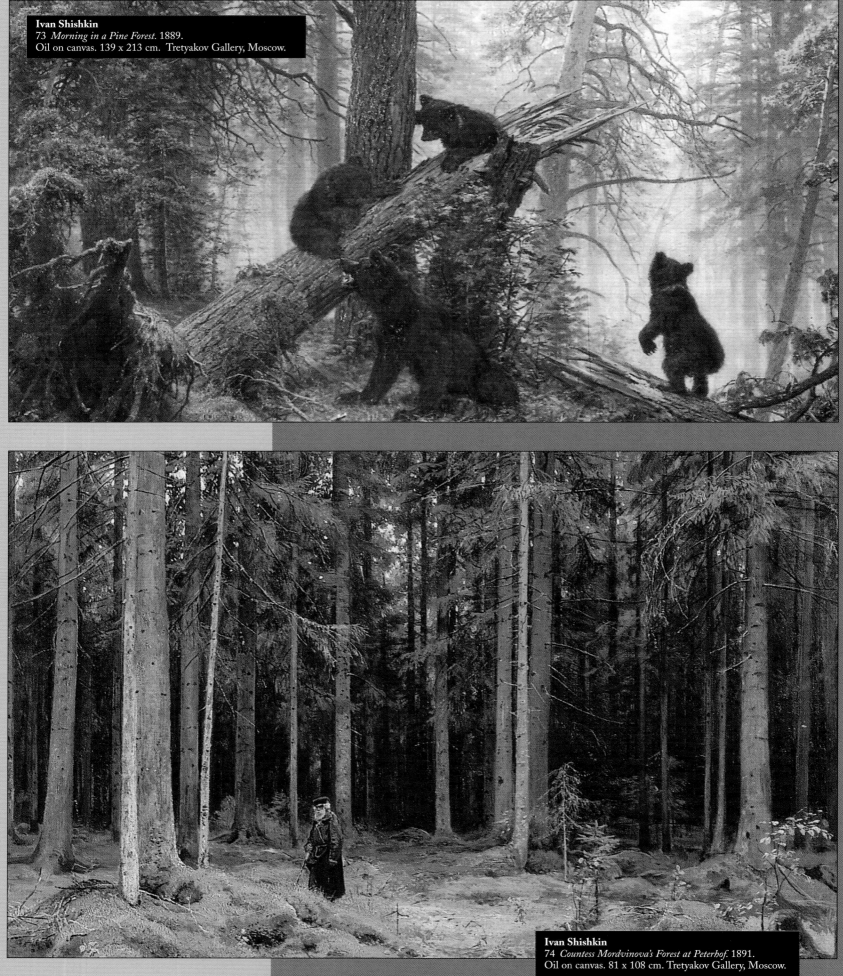

Ivan Shishkin
73 *Morning in a Pine Forest.* 1889.
Oil on canvas. 139 x 213 cm. Tretyakov Gallery, Moscow.

Ivan Shishkin
74 *Countess Mordvinova's Forest at Peterhof.* 1891.
Oil on canvas. 81 x 108 cm. Tretyakov Gallery, Moscow.

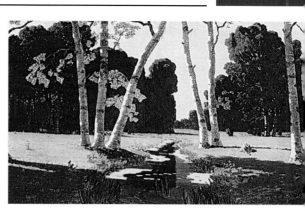

Arkhip Kuindzhi 76 *The Birch Grove*. 1879.
Oil on canvas. 97 x 181 cm. Tretyakov Gallery, Moscow.

During the 1870s the art of Arkhip Kuindzhi (1842–1910) underwent an abrupt transformation. Many of the pictures that he painted in the early and mid-1870s – such as *The Forgotten Village* and *The Pack-Ox Road in Mariupol* – have muted tones, reflecting the harshness of life in rural Russia. Then Kuindzhi began to experiment with a completely different tonal range, which resulted in the marvellously luminous quality of paintings such as *After the Rain* [75] and the brightness of ones like *The Birch Grove* [76], both of which date from 1879.

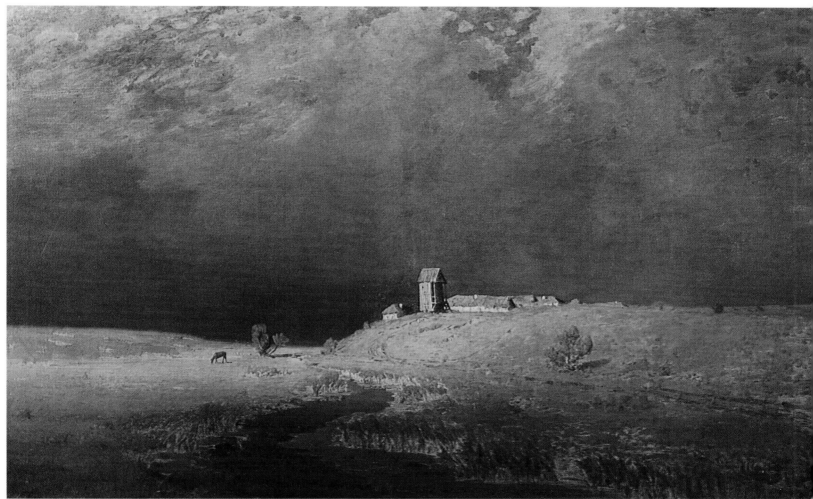

Arkhip Kuindzhi
75 *After the Rain*. 1879. Oil on canvas. 102 x 159 cm.
Tretyakov Gallery, Moscow.

Enthralled by Kuindzhi's new style, Repin declared that "the illusion of light was his God" and no other artist had "equalled the miraculous success of his paintings". However, there were artists who tried to emulate Kuindzhi's "lunar colours", and ones who made similar use of dramatic light effects – for example, Nikolai Dubovskoi (1859–1918), who painted *The Calm Before the Storm* [77] in 1890.

Detail from:
Nikolai Dubovskoi
77 *The Calm Before the Storm*. 1890.
Oil on canvas. 76.5 x 128 cm. Russian Museum, St Petersburg.

Nikolai Dubovskoi
77 The Calm Before the Storm. 1890.
Oil on canvas. 76.5 x 128 cm. Russian Museum, St Petersburg.

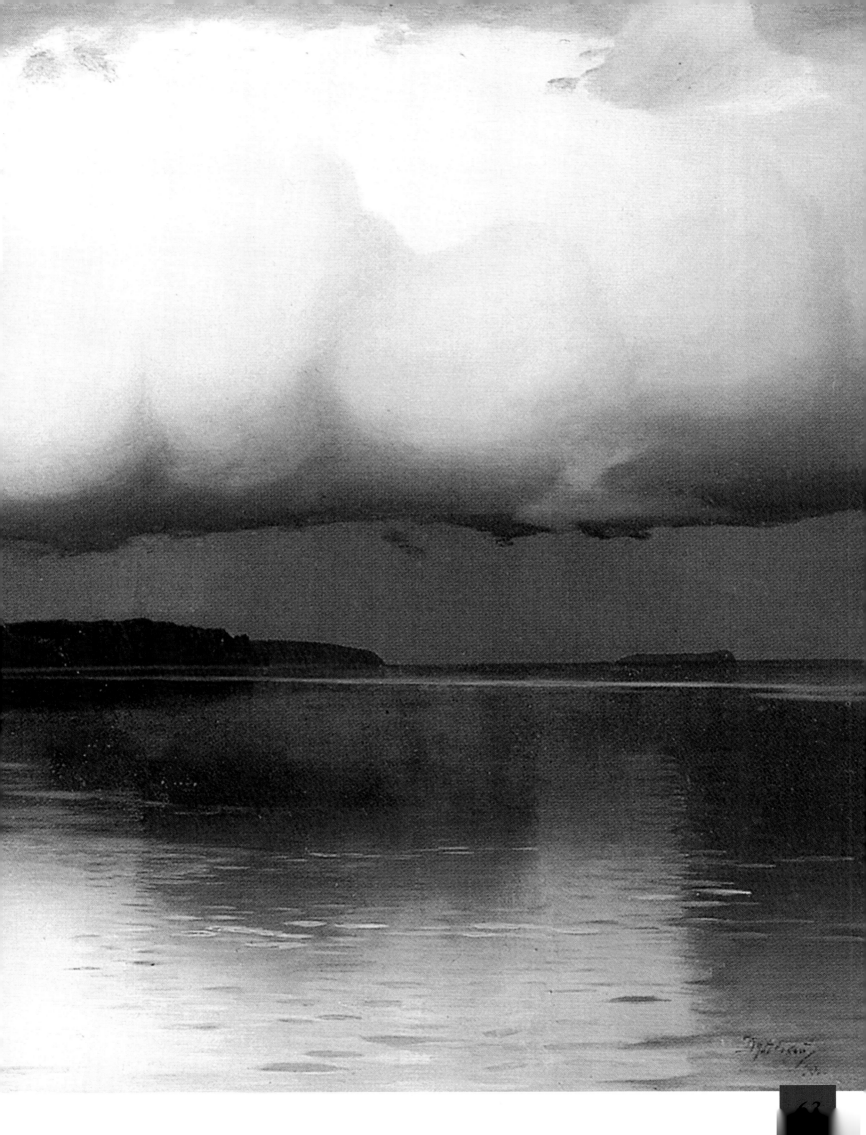

Vasily Polenov
78 *Moscow Courtyard.* 1878.
Oil on canvas. 64.5 x 80.1 cm. Tretyakov Gallery, Moscow.

Vasily Polenov (1844–1927) was also a master of pleasing light effects, as is amply demonstrated by his painting of a tranquil Moscow backyard, more farmyard than courtyard [78], which helped to establish a vogue for landscape paintings with prominent genre elements, and by the nuances of light and shade in *Overgrown Pond* [79]. An enthusiastic advocate of *plein-air* painting, he succeeded Savrasov as head of the landscape studio at the Moscow College of Painting, Sculpture and Architecture.

One of the greatest and best-known landscape painters among the Itinerants, Isaac Levitan (1860–1900), had the advantage of studying under both Savrasov and Polenov. Although his art is perhaps less epic than Shishkin's, his style and subject matter are more varied – perhaps surprisingly, since he died at a comparatively early age.

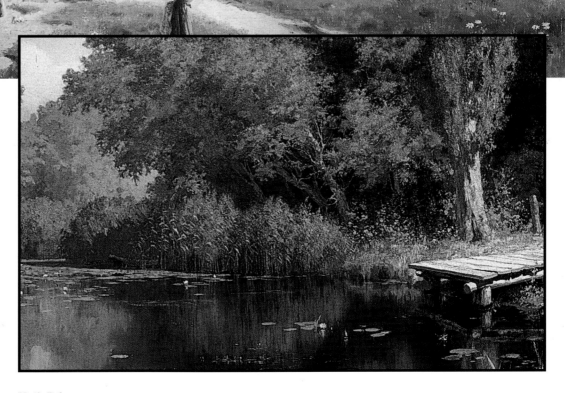

Vasily Polenov
79 *Overgrown Pond.* 1879. Oil on canvas. 77 x 121.8 cm. Tretyakov Gallery, Moscow.

Levitan, like Shishkin, was a supreme master of the use of colour, composition, and light and shade. All the seasons of the year, the different times of day, and the infinite variety of nature figure in Levitan's canvases. But, unlike Shishkin, who had a preference for summer landscapes, Levitan preferred the fresh colours of spring [80] and the muted cadences of autumn [81]. When he painted summer scenes, such as *Secluded Monastery* [82], he preferred to work in the evening, when the light was softer, or even at dusk.

Isaac Levitan
81 *Golden Autumn*. 1895.
Oil on canvas. 82 x 126 cm. Tretyakov Gallery, Moscow.

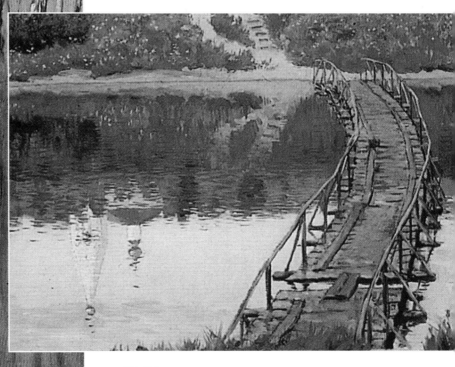

Isaac Levitan
80 *Spring Flood*. 1897.
Oil on canvas. 64.2 x 57.7 cm. Tretyakov Gallery, Moscow.

Detail from:
Isaac Levitan
82 *Secluded Monastery*. 1890.
Oil on canvas. 87.5 x 108 cm. Tretyakov Gallery, Moscow.

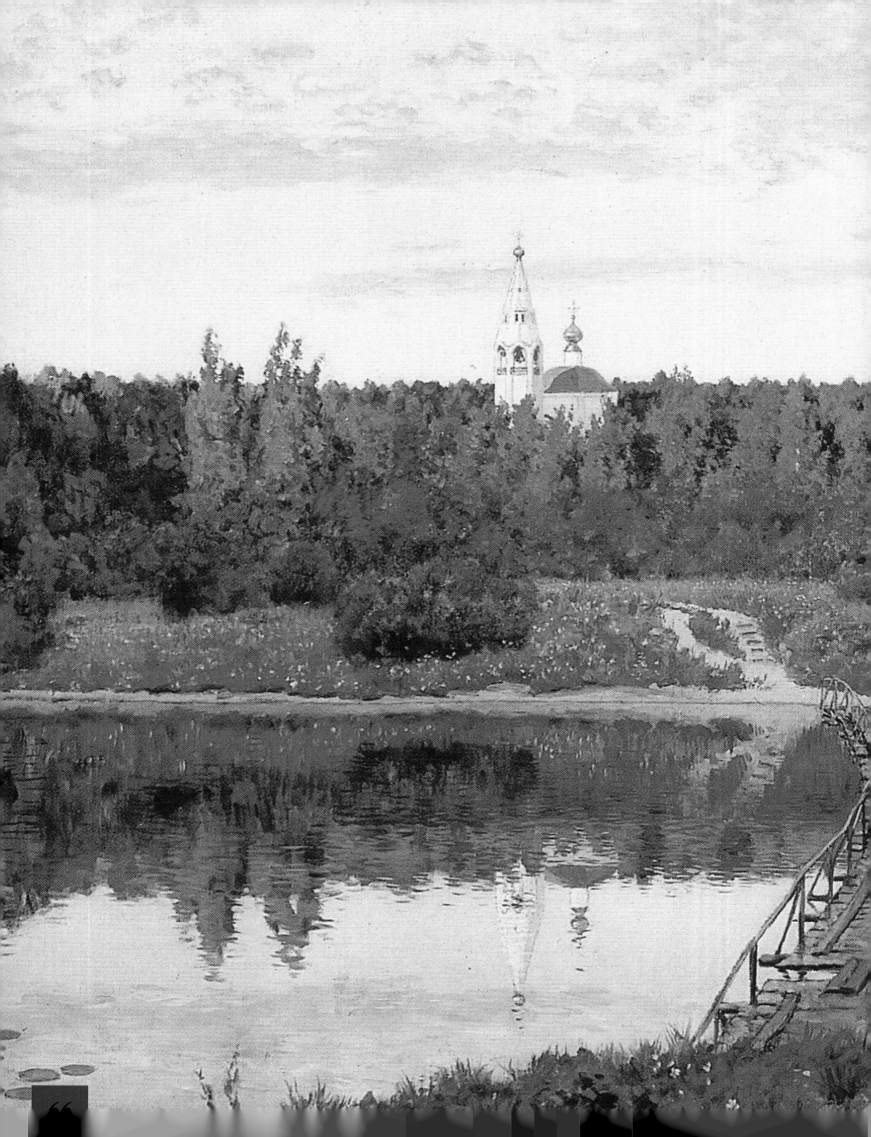

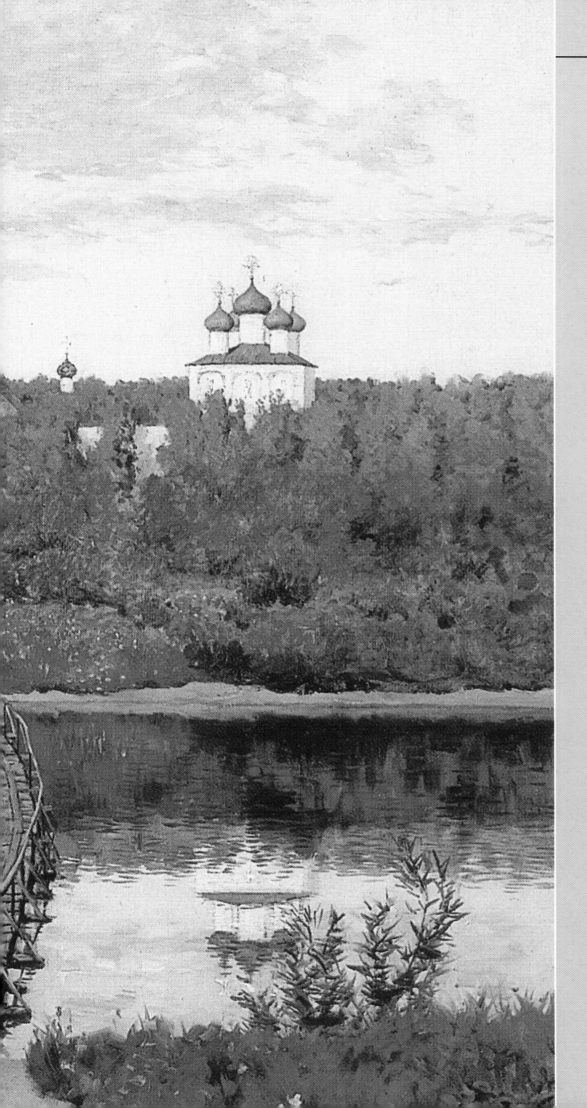

Isaac Levitan
82 *Secluded Monastery.* 1890.
Oil on canvas. 87.5 x 108 cm.
Tretyakov Gallery, Moscow.

Isaac Levitan
83 *Vladimirka (The Road to Vladimir)*. 1892.
Oil on canvas. 79 x 123 cm. Tretyakov Gallery, Moscow.

Isaac Levitan
84 *Summer Evening: Fence*. 1900.
Oil on board. 49 x 73 cm. Tretyakov Gallery, Moscow.

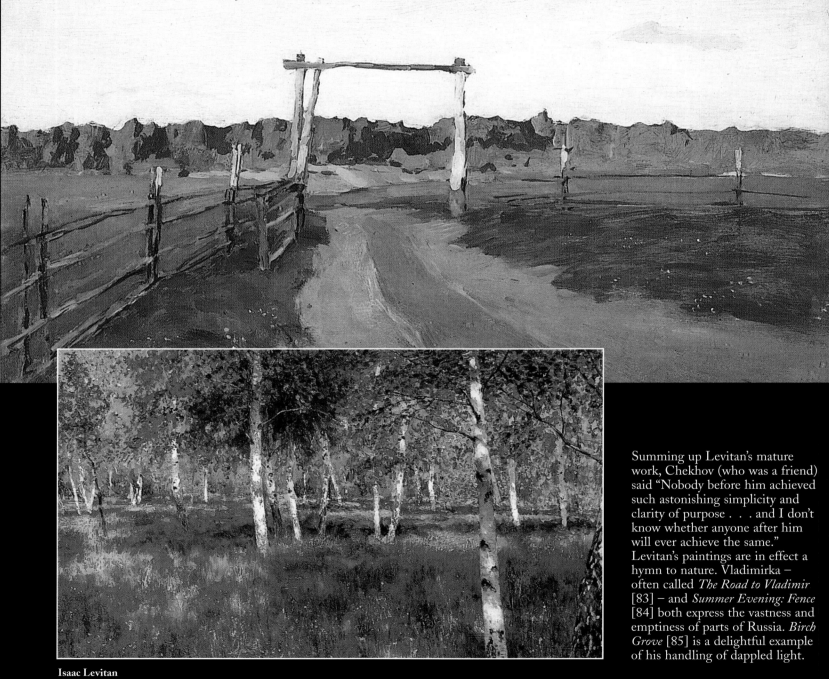

Summing up Levitan's mature work, Chekhov (who was a friend) said "Nobody before him achieved such astonishing simplicity and clarity of purpose . . . and I don't know whether anyone after him will ever achieve the same." Levitan's paintings are in effect a hymn to nature. Vladimirka – often called *The Road to Vladimir* [83] – and *Summer Evening: Fence* [84] both express the vastness and emptiness of parts of Russia. *Birch Grove* [85] is a delightful example of his handling of dappled light.

Isaac Levitan
85 *Birch Grove*. 1885–1889. Oil on paper pasted on canvas. 28.5 x 50 cm. Tretyakov Gallery, Moscow.

Genre painting

During the first half of the nineteenth century painters such as Venetsianov and Shibanov sympathetically portrayed aspects of everyday life in Russia, while others, such as Fedotov and Ermenev, laid the foundations of Critical Realism, which directly or by implication commented on social and moral issues. The Itinerants and other painters active during the second half of the century built on these foundations, providing a vivid record of the reality of people's lives.

One painter who would have appreciated Fedotov's *The Artist Who Married Without a Dowry Relying on his Talent* was Vasily Pukirev (1832–90), whose dramatic painting *The Unequal Marriage* [86] had an autobiographical basis. The parents of the girl he loved had made her marry an elderly general, since they did not regard painting as an eligible career. Pukirev himself figures in the congregation, standing unhappily, with arms crossed, behind the reluctant bride. This painting, which was to enjoy enormous popularity, made its debut in September 1863 at the same exhibition as Nikolai Gay's *The Last Supper*. Together they heralded a much freer and more innovative approach to academic art.

Detail from:
Vasily Pukirev
86 *The Unequal Marriage*. 1862.
173 x 136.5 cm. Tretyakov Gallery, Moscow.

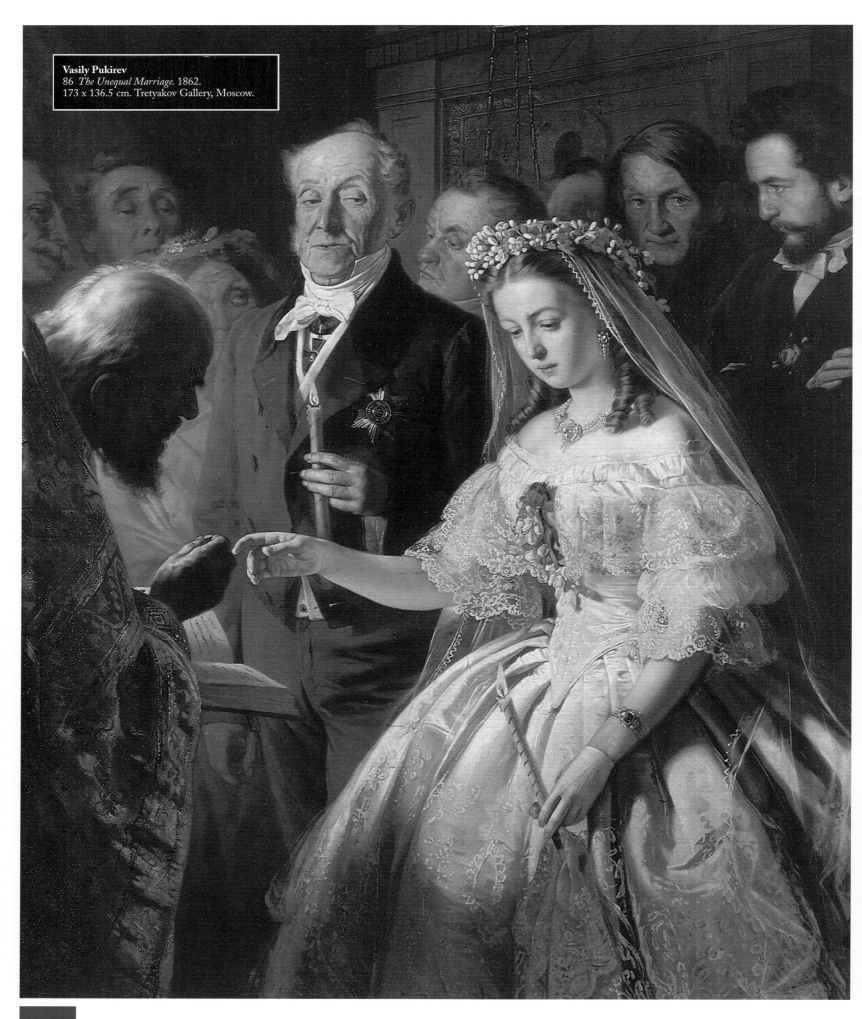

Vasily Pukirev
86 *The Unequal Marriage.* 1862.
173 x 136.5 cm. Tretyakov Gallery, Moscow.

Like Fedotov and Pukirev, Nikolai Nevrev (1830–1904) had a sharp eye for humbug. In *Bargaining: A Daily Scene in the Serfdom Era (From the Recent Past)* [87] the object of derision is a landowner selling a pretty serf to cover his debts. The anachronism and obscenity of serfdom is underlined by the "civilized" surroundings in which the deal is being struck. Leonid Solomatkin (1837–83) was a less overt moralist, but in many of his paintings comedy has a mordant edge – as can be seen from *Morning at a Tavern* [88] and the grotesque jollity of *The Wedding* (1872).

The Mockers [89] by Illarion Pryanishnikov (1840–94), in which merchants and their affluent customers laugh at a dancing beggar, was based on a scene from a play by Alexander Ostrovsky.

Nikolai Nevrev
87 *Bargaining: A Daily Scene in the Serfdom Era (From the Recent Past)*. 1866.

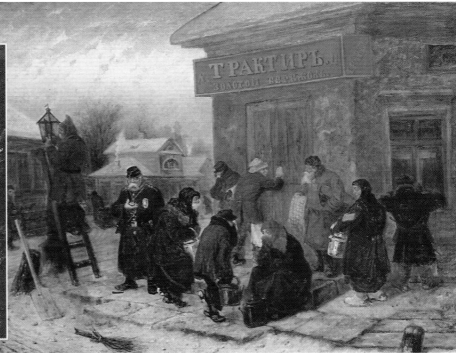

Illarion Pryanishnikov
89 *The Mockers: At Moscow's Gostiny Dvor Shopping Arcade*. 1865. Tretyakov Gallery, Moscow.

Leonid Solomatkin
88 *Morning at a Tavern*. 1873.

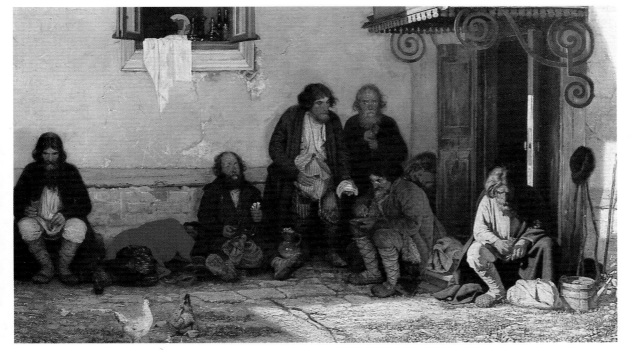

In *The Zemstvo is Dining* [90] by Grigory Miasoyedov (1834–1911) the contrast between rich and poor is more oblique in pictorial terms, though no less obvious. The peasants are obliged to eat their frugal lunch outside, while decanters and washing-up glimpsed through the window reveal that the more affluent members of the *zemstvo* (rural district council) have been banqueting in the council chamber.

Grigory Miasoyedov
90 *The Zemstvo is Dining*. 1872. Oil on canvas. 74 x 125 cm. Tretyakov Gallery, Moscow.

Vasily Maximov
91 *Arrival of the Sorcerer at a Peasant Wedding.* 1875.
Oil on canvas. 116 x 188 cm.
Tretyakov Gallery, Moscow.

The prime concern of many artists of this period, both Itinerants and non-Itinerants, was to convey the reality of people's lives. Vasily Maximov (1844–1911) grew up in a village and spent much of his adult life in rural Russia, different aspects of which are portrayed in paintings such as *Arrival of the Sorcerer at a Peasant Wedding* [91], *The Sick Husband* and *All in the Past* [92]. In the paintings of Konstantin Savitsky (1844–1905), often people *en masse* – rather than individuals – are the heroes, as in *Repairing the Railway* [93] and *Off to War* [94].

Vasily Maximov
92 *All in the Past.* 1889.
Oil on canvas. 72 x 93.5 cm. Tretyakov Gallery, Moscow.

Detail from:
Konstantin Savitsky
93 *Repairing the Railway.* 1874. Oil on canvas. 100 x 175 cm. Tretyakov Gallery, Moscow.

Kontstantin Savitsky
94 *Off to War.* 1888. Oil on canvas. 207.5 x 303.5 cm. Russian Museum, St Petersburg.

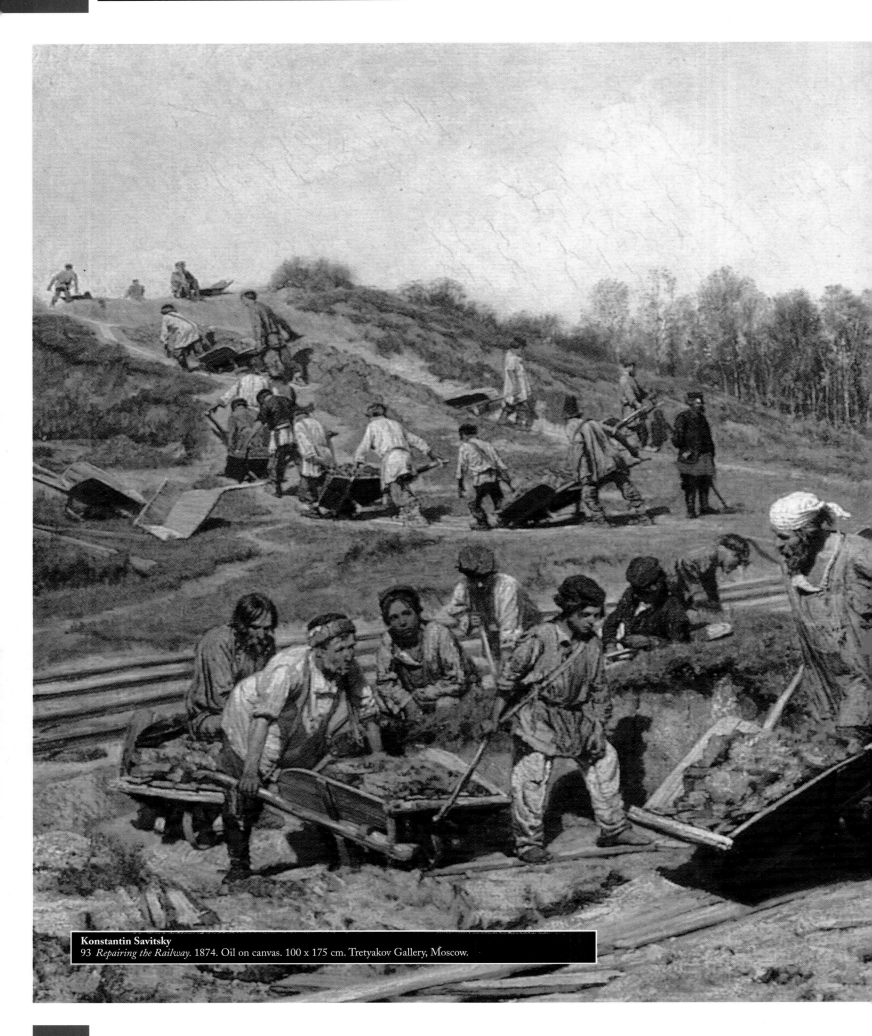

Konstantin Savitsky
93 *Repairing the Railway*. 1874. Oil on canvas. 100 x 175 cm. Tretyakov Gallery, Moscow.

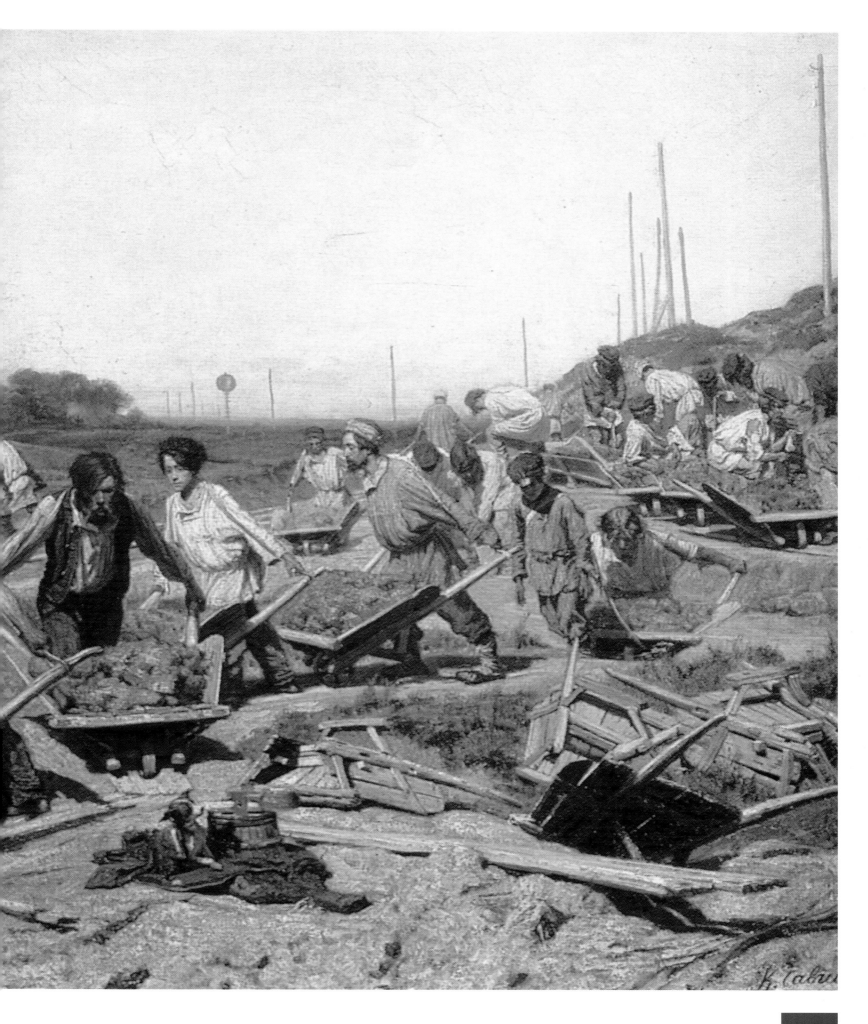

Vladimir Makovsky
95 *Bank Crash*. 1881.
Oil on canvas. 68.2 x 104.2 cm.
Tretyakov Gallery, Moscow.

Vladimir Makovsky (1846–1920) was equally
adept at portraying crowds of people, as in *Bank
Crash* [95] and *A Doss-House* (1889), even
though these and most of his other canvases are
half the size of Savitsky's *Off to War*. Both urban
and village life figure in his paintings. The best
ones, such as *In the Doctor's Waiting Room* [96]
and *On the Boulevard* [97], or *The Rendez-vous*
(1883) and *Declaration of Love* (1889–91), quiet-
ly capture fleeting moments from people's lives.
The unevenness of Makovsky's work led Benois[9]
to describe his art as "cold" and "heartless",
while Dostoyevsky[10] enthusiastically praised his
"love of humanity".

Vladimir Makovsky
96 *In the Doctor's Waiting Room*. 1870.
Oil on canvas. 69.4 x 85.3 cm. Tretyakov Gallery, Moscow.

Vladimir Makovsky
97 *On the Boulevard*. 1886–1887.
Oil on canvas. 53 x 68 cm.
Tretyakov Gallery, Moscow.

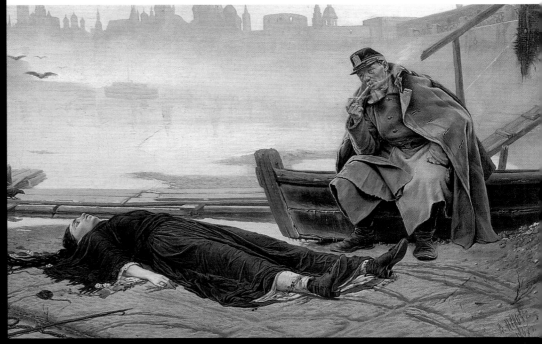

Vasily Perov
98 *The Last Farewell*. 1865. Tretyakov Gallery, Moscow.

Vasily Perov
99 *The Drowned Girl*. 1867. Tretyakov Gallery, Moscow.

Vasily Perov
100 *Hunters at Rest*. 1871.
Oil on canvas. 119 x 183 cm. Tretyakov Gallery, Moscow.

Vasily Perov
101 Easter Procession in the Country. 1861.
Oil on canvas. 71.5 x 89 cm. Tretyakov Gallery, Moscow.

Perov's genre works range from comedy to tragedy. In *The Last Farewell* [98] the bowed and huddled figures accompanying the coffin on the sledge poignantly convey the harshness of life. In *The Drowned Girl* [99] the stillness of the two figures, alone in the riverside dawn, is no less expressive. In contrast to these sombre sentiments are the hilarity of pictures such as *Hunters at Rest* [100] and the whimsicality (barely masking anticlerical satire) of *Easter Procession in the Country* [101], in which the joy of Easter is marred by the weather and the drunkenness of the priests.

Pryanishnikov faithfully captured the atmosphere of a rather more normal religious procession [102], but Repin's *Religious Procession in Kursk Province* [103] – on which he worked from 1880 to 1883 – represents a totally different level of artistic achievement. The woman holding a miraculous icon, the mounted police and stewards, the merchants, shopkeepers, peasants, clergy, beggars, cripples, children . . . everyone is carefully characterized, creating a multifaceted image of provincial Russia, or even of Russia as a whole. Thanks to the masterly use of perspective, the whole procession seems to be moving steadily forward and to be imbued with life.

Illarion Pryanishnikov
102 *A Religious Procession*. 1893.
Oil on canvas. 101.5 x 165 cm. Russian Museum, St Petersburg.

Ilya Repin
103 *Religious Procession in Kursk Province*. 1880–1883.
Oil on canvas. 175 x 280 cm. Tretyakov Gallery, Moscow.

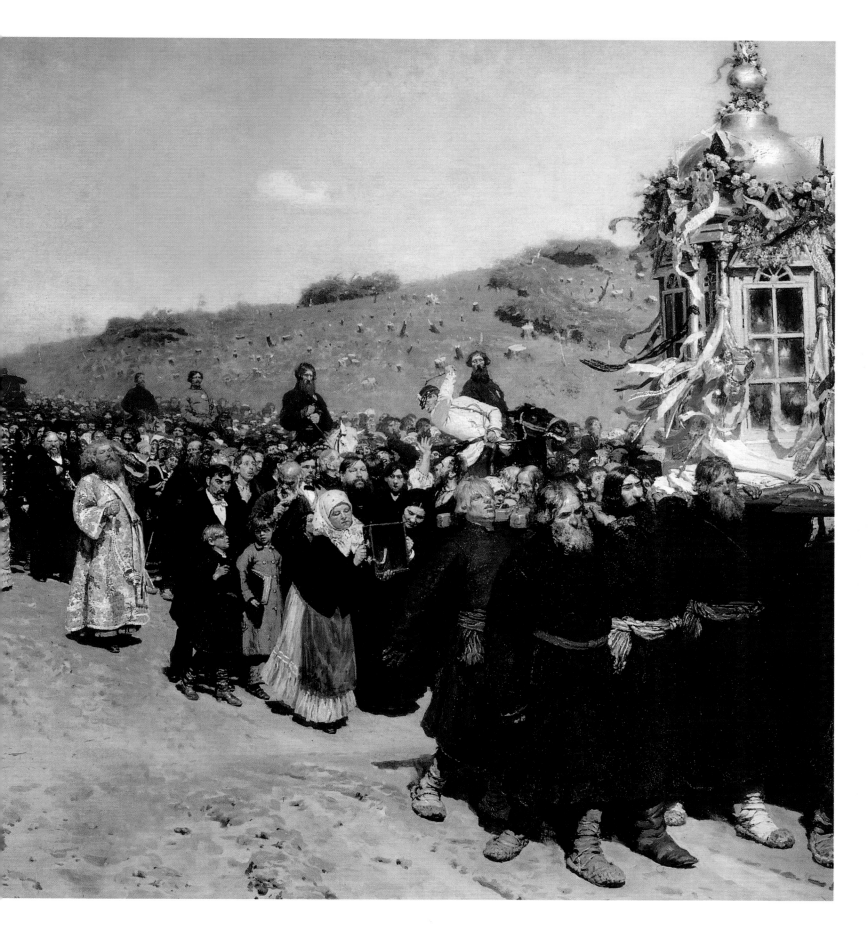

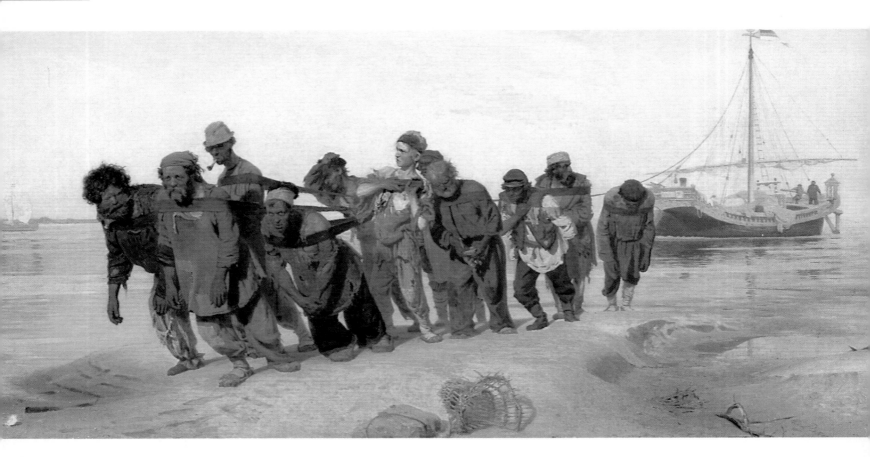

Ilya Repin 104 *Barge Haulers on the Volga.* 1870–1873. Oil on canvas. 131.5 x 281 cm. Russian Museum, St Petersburg.

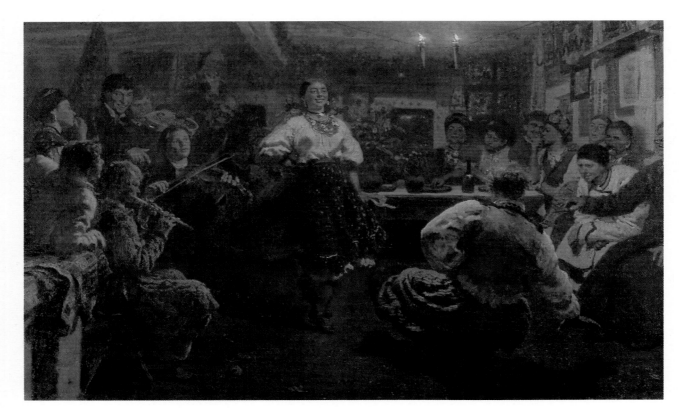

The use of perspective and composition are no less important in *Barge Haulers on the Volga* [104] – often called *The Volga Boatmen* – which Repin painted between 1870 and 1873, while still in his late twenties. Its power and immediacy made it one of the most widely known paintings in Russia and inspired a flood of realist pictures with contemporary themes. Repin wrote that the choice and use of colour "should express the mood of a painting, its spirit . . . like a chord in music."[11] The bright colour scheme and harsh shadows, the facial expressions of the haulers, their strength and exertion express both the human dignity of their labour and its inhuman demands.

Ilya Repin 105 *Vechornitsy (Ukrainian Peasant Gathering).* 1881. Oil on canvas. 116 x 186 cm. Tretyakov Gallery, Moscow.

The variety of Repin's genre painting and his gift for characterization can be seen from *Vechornitsy (Ukrainian Peasant Gathering)* [105], *Reading for an Examination* [106] and *Seeing Off a Recruit* [107]. In *They Did Not Expect Him* [108] – started in1884 and completed in 1888 – Repin makes marvellous use of his talent for drama.

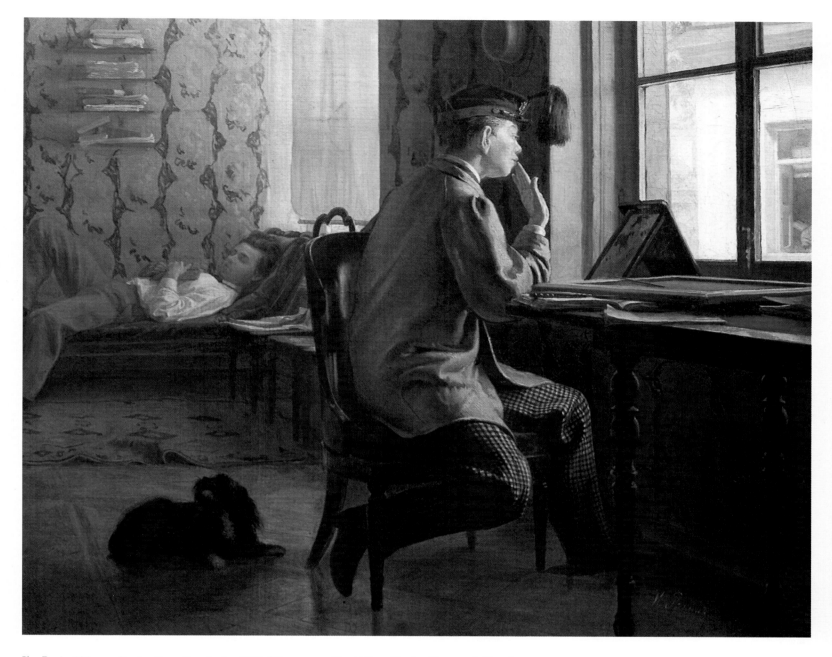

Ilya Repin 106 *Reading for an Examination.* 1864. Oil on canvas. 38 x 46.5 cm. Russian Museum, St Petersburg.

As a result of the revolutionary movement that culminated in the assassination of Alexander II, hundreds of political suspects were imprisoned or deported to Siberia. In 1883 the new tsar, Alexander III, declared an amnesty for political offenders. The drama of *They Did Not Expect Him* lies partly in the reactions of the family to the "returnee", partly in his own anxiety about how they and others will react to his return, and partly in the intrusion of nightmarish reality into a seemingly untroubled domestic scene.

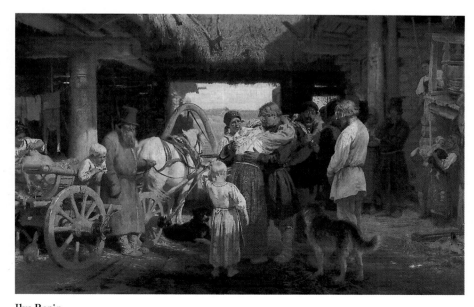

Ilya Repin
107 *Seeing Off a Recruit.* 1879. Oil on canvas. 143 x 225 cm. Russian Museum, St Petersburg.

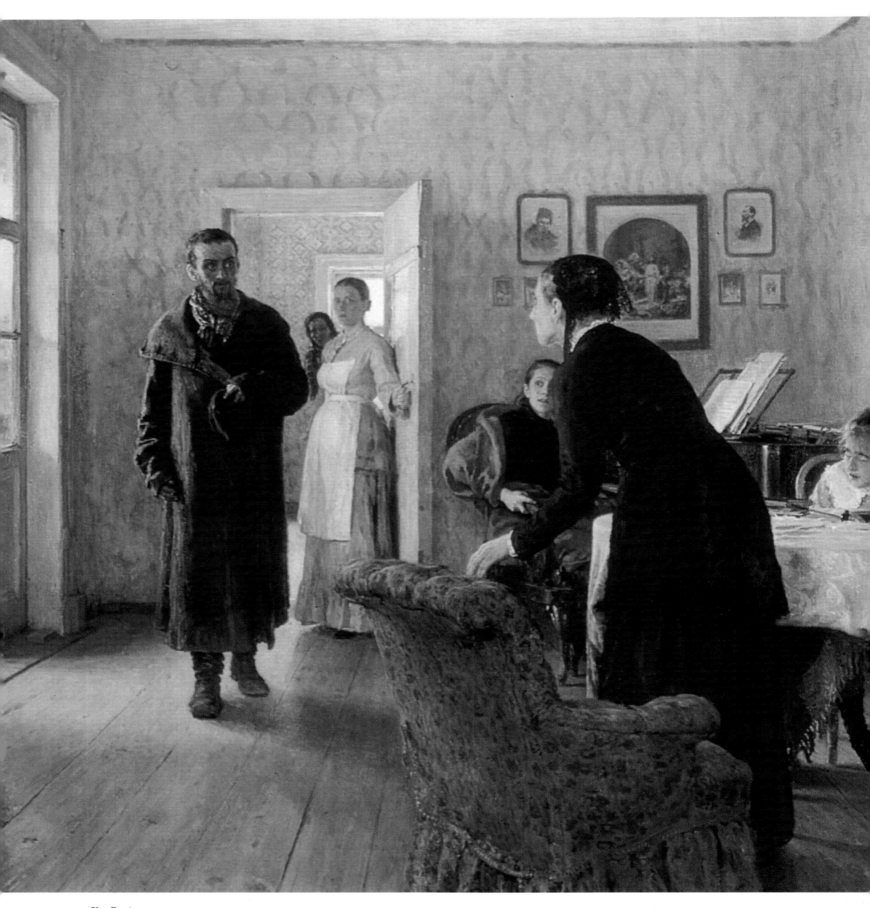

Ilya Repin
108 *They Did Not Expect Him.* 1884-1888.
Oil on canvas. 160.5 x 167.5 cm. Tretyakov Gallery, Moscow.

Still Life

Although there are some pleasing still lifes from the second
half of the nineteenth century, it was not until the earlier part of
the twentieth century that still-life painting in Russia came into its own.

Repin's *Apples and Leaves* [109] echoes the Dutch and Italian masterpieces
of earlier centuries, which he would have had ample opportunity to study
both while abroad and at the Hermitage.

Detail from:
Ilya Repin
109 *Apples and Leaves.* 1879.
Oil on canvas. 64 x 75.5 cm. Russian Museum, St Petersburg.

Ilya Repin
109 *Apples and Leaves.* 1879.
Oil on canvas. 64 x 75.5 cm.
Russian Museum, St Petersburg.

More distinctively, and slightly ahead of its time, the patterned background and vase of Mikhail Vrubel's *Dogrose* [110] belong to the decorative world of Art Nouveau, in contrast to the simple blocks of colour used in his *Still Life with Plaster Mask and Sconce* [111]. Like many other of his paintings, including the portrait of Savva Mamontov reproduced in the third part of this book [113], he left this still-life "unfinished" – whether as a conscious decision or through lack of time, or because of the mental turmoil that plagued him periodically throughout his life, is not known.

Above:
Mikhail Vrubel
111 *Still Life with Plaster Mask and Sconce.* 1885.
Unfinished. Watercolour on paper. 18.5 x 11.7 cm.
Museum of Russian Art, Kiev.

Left:
Mikhail Vrubel
110 *Dogrose.* 1884. Watercolour on paper. 24.5 x 19.5 cm.
Private collection, Kiev.

A new world of Art

By the 1890s the Society for Itinerant Exhibitions had become so well established that three of its members (Repin, Polenov and Bogoliubov) were invited to draw up a new constitution for the Academy. Then Repin, Shishkin, Kuindzhi and Makovsky were appointed professors. But at the very moment when the Itinerants had succeeded in storming the heights of academe, the Society began to fall apart. Although it continued to hold exhibitions until the 1920s, there was internal bickering about who should be allowed to join or participate in exhibitions, and up-and-coming artists began to regard the Society as backward-looking and no longer a dynamic force. Moreover, new ideas about art were in the air. Realism and populism were out of vogue, replaced by a preoccupation with "art for art's sake". This manifested itself in numerous forms, ranging from Impressionism and Russian Art Nouveau to the abstract art of the 1920s and 1930s. As happened elsewhere (for example, in France and Germany), the various movements gave rise to a plethora of groups, associations, exhibitions and magazines. Among the most influential of these affiliations was the one known as the World of Art.

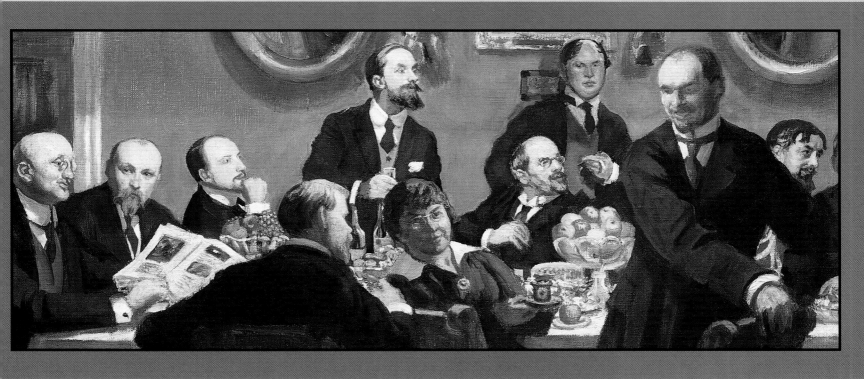

Detail from:
Boris Kustodiev
112 *Group Portrait of the World of Art Artists.* 1916–1920. Sketch. Oil on canvas. 52 x 89 cm. Russian Museum, St Petersburg.

The World of Art (*Mir iskusstva*) was founded by a group of young artists, writers and musicians in St Petersburg that included Alexander Benois, Konstantin Somov, Léon Bakst, Yevgeny Lanceray, the writer Dmitri Filosov and the future impresario Sergei Diaghilev, who was intent on "exalting Russian art in the eyes of the West"[1].

Boris Kustodiev
112 *Group Portrait of the World of Art Artists.* 1916–1920. Sketch.
Oil on canvas. 52 x 89 cm. Russian Museum, St Petersburg.

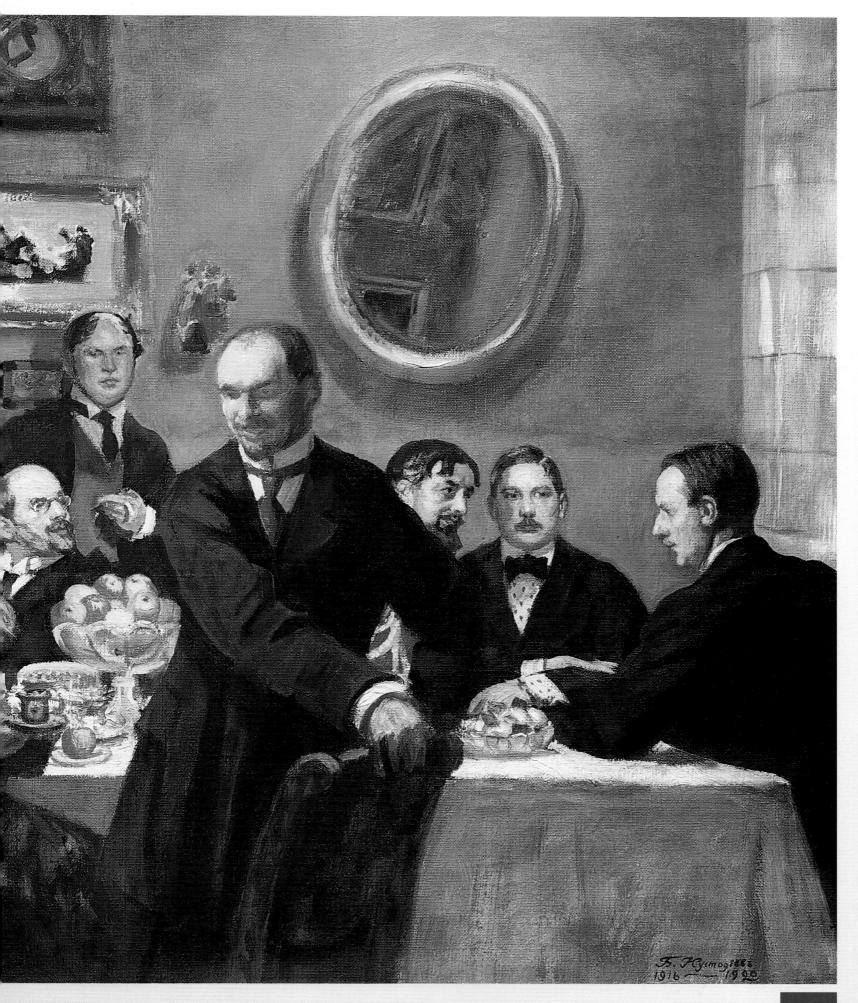

Diaghilev soon proved to be a promoter and motivator with an unusual ability to recognize artistic potential. In 1898, at the age of twenty-six, he staged an exhibition of Russian and Finnish artists, persuading a number of well-known Moscow painters to participate – among them Korovin, Levitan, Nesterov, Riabushkin, Serov and Vrubel. The following year he launched a monthly magazine, also called Mir iskusstva, notable for the calibre of its principal contributors, which included Benois, Bakst and Igor Grabar. The magazine was only published for six years (until 1904), but – partly because of its enthusiasm for the *style moderne* (as Art Nouveau was called in Russia) – it had an immense influence not just on painting but on a variety of art forms.

When the World of Art society was reborn in 1910 (after the period of turmoil that followed the Russo-Japanese War and the Revolution of 1905), it attracted a new wave of supporters, including Konchalovsky, Kuznetsov, Roerich, Sapunov, Serebriakova, Saryan and Kustodiev, who sketched one of their meetings [112] as a preparatory study for a large-scale composition that was going to be "both decorative and realistic, monumental and true to life".[2] But, despite these lofty intentions, it failed to materialize. Artists as diverse as Dobuzhinsky, Maliavin, Tatlin and Chagall took part in the exhibitions that the society organized, the last of which was held in 1924.

But the World of Art movement had further ramifications. Diaghilev commissioned a great many members of the group to produce stage and costume designs for his opera and ballet productions, which gave them an opportunity to work on a grand scale and to explore analogies between the rhythms of painting, dance and music. And because Diaghilev's productions toured Europe, it helped them to become known internationally.

The artists associated with the World of Art were also fortunate in having an imaginative patron, the millionaire merchant Savva Mamontov – memorably portrayed by Vrubel [113] and Serov – who was endlessly hospitable, encouraging them to stay at Abramtsevo, his country estate near Moscow, where he provided a creative environment for them to work in. As well as establishing craft workshops there, he invited well-known artists to participate in building and decorating a new village church, urged them to decorate pottery and other artefacts produced in the Abramtsevo workshops, and got them to design and paint scenery for his private opera company. Another generous patron was Princess Maria Tenisheva, who set up craft studios on her estate at Talashkino, near Smolensk, and also helped to finance Diaghilev's magazine. Unfortunately a rift with the Princess, added to Diaghilev's high-handedness, plus internal dissensions, contributed to the magazine's demise.

Mikhail Vrubel
113 *Portrait of Savva Mamontov.* 1897.
Unfinished. Oil on canvas. 187 x 142.5 cm. Tretyakov Gallery, Moscow.

When *Mir iskusstva* ceased publication, many artists who had belonged to the World of Art society transferred their allegiance to the Union of Russian Artists, which had been founded the previous year (1903) by disgruntled members from within the World of Art group. That it was based in Moscow was in itself significant. Founded in 1832, the Moscow College of Painting, Sculpture and Architecture had for a long time offered a more flexible and progressive alternative to St Petersburg's Imperial Academy of the Arts. Several of the most influential Itinerants had studied or taught there, and Moscow painters such as Korovin, Arkhipov, Maliavin, Nesterov, Riabushkin, Yuon and Grabar, all of whom were to a greater or lesser extent influenced by Impressionism, emerged as a distinct group.

The World of Art and the Union of Russian Artists were in effect the forerunners of the most innovative period of Russian art, which spawned a bewildering array of artistic groups and movements, often with bizarre names, among them the Link, the Triangle, the Wreath and the Union of Youth. One of the most seminal was the Blue Rose group, which launched a highly influential monthly magazine, *The Golden Fleece*. Reviewing their first exhibition, held in March 1907, the Symbolist poet Sergei Makovsky[3] declared that the group were "in love with the music of colour and line" and described them as the "heralds of the new primitivism". Prominent exhibitors included Larionov and Goncharova (his lifelong companion and collaborator), Kuznetsov, the Miliuti brothers, Sapunov, Saryan and Sudeikin. Among the painters who influenced the group were Vrubel and Victor Borisov-Musatov (1870–1905), whose Symbolist paintings [114 and 115] made a huge impression when Diaghilev organized a retrospective exhibition of his work in 1907. *The Golden Fleece* exhibitions held in 1908 and 1909 were notable for the participation of major French artists, among them Impressionists and Post-Impressionists, Fauves and Nabis.

Victor Borisov-Musatov
114 *Ornamental Lake.* 1902. Tempera on canvas. 177 x 216 cm. Tretyakov Gallery, Moscow.

Victor Borisov-Musatov
115 *Walk at Sunset.* 1903.
Oil on canvas. 53.5 x 104 cm.
Russian Museum, St Petersburg.

Although Mikhail Larionov (1881–1964) and Natalia Goncharova (1881–1962) had joined the Blue Rose group and been active participators in the *Golden Fleece* exhibitions, their ideas were constantly evolving. Moreover, Larionov was an organizer of immense energy, and in 1909 the two of them, together with David Burliuk, set up the Knave of Diamonds group (sometimes translated as the Jack of Diamonds), which held its first exhibition in 1910. But before long Larionov and Goncharova felt the need to move on, and organized further exhibitions (as well as artistic debates and other events), including the Donkey's Tail (1912), Target (1913) and "No. 4 – Futurists, Rayonists, Primitives" (1914). Most of the Russian avant-garde painters participated in the exhibitions of one or other of these groups – among them Burliuk, Chagall, Exter, Falk, Jawlensky, Kandinsky, Konchalovsky, Kuprin, Lentulov, Lissitzky, Malevich, Mashkov and Tatlin.

An offshoot of the Knave of Diamonds was the group known as the Moscow Painters (1924–6), which was in turn succeeded by the Society of Moscow Artists (1927–32). The latter, in particular, was dominated by "Cézannists" and had a noticeable preference for landscape and still life. Falk, Grabar, Krymov, Kuprin and Mashkov were members of both organizations, as was Aristarkh Lentulov (1882–1943), an idiosyncratic innovator who was also an energetic organizer and propagandist. A more eclectic association was the Union of Youth (1910–14), based in St Petersburg, which embraced Cézannists, Cubists, Futurists and Nonobjectivists. Its literary section, called Hylaea (founded in 1913), formed an important link between writers and artists.

Mikhail Larionov
116 *Cock and Hen*. 1912.
Oil on canvas. 69 x 65 cm.
Tretyakov Gallery, Moscow.

Abstraction

The second decade of the twentieth century marked the start of an accelerating move towards abstraction. In 1913 Larionov published a manifesto explaining the principles of his latest artistic credo – called Rayonism, because its basis was "the crossing of reflected rays from various objects".[4] Rayonist works ranged from semi-abstract pictures such as Larionov's *Cock and Hen* [116] and Goncharova's *The Green and Yellow Forest* (1912) to his totally abstract *Blue Rayonism* (also painted in 1912).

Around the same time, Vasily Kandinsky (1866–1944) graduated from the style of works such as *Boat Trip* (see below) to the more fully abstract style of his *Improvisations and Compositions*, which he painted between 1910 and 1912. *Black Spot I* [117] and *Non objective* [118] are examples of his fully abstract style. Like many of the other pioneers of avant-garde painting, Kandinsky evolved a system of theoretical principles, which played an important role in the development of his work. After the Revolution, he became head of the painting department of Inkhuk (the Institute of Artistic Culture) in Moscow, but resigned when his "Symbolist philosophy" failed to be adopted as the basis of the Institute's teaching program. He then returned to Germany, where he had lived between 1896 and 1914, and was able to put his theoretical ideas into practice when he accepted a teaching post at the Bauhaus in 1922.

Vasily Kandinsky
117 *Black Spot I*. 1912.
Oil on canvas. 100 x 130 cm. Russian Museum, St Petersburg.

Vasily Kandinsky
118 *Non objective*. 1916. Oil on canvas. 50 x 66 cm. Art Museum, Krasnoyarsk.

Right:
Kasimir Malevich
119 *Haymaking.* 1909-1910 (or after 1927?)
Russian Museum, St Petersburg.

Kasimir Malevich (1878–1935) took
a different route to abstraction. For a
time he worked closely with Larionov
and Goncharova, producing delight-
ful Primitivist gouaches with peasant
themes. Next came his "tubular"
Cubo-Futurist phase, notable for
masterpieces such as *Haymaking*
[119] and *Taking in the Harvest*
(1911), which progressively led him
towards a less figurative and more
"mechanistic" style. Eventually, prob-
ably in 1913, he arrived at a system of
abstract painting, which he called
Suprematism, based on geometric
forms. Among the thirty-five abstract
works that Malevich made public in
1915 was *Black Square*, one of the
most famous of his Suprematist
works. "The keys of Suprematism", he
wrote, "lead me to the discovery of
something as yet uncomprehended . .
. there is in man's consciousness a
yearning for space and a 'desire to
break away from the earthly globe'."[5]
Malevich worked on his *White on
White* series – arguably the ultimate
in Suprematism – from 1917 to 1918.
Principle of Painting a Wall: Vitebsk
[120] dates from 1919.

Kasimir Malevich
120 *Principle of Painting a Wall: Vitebsk.* 1919.
Watercolour, gouache and India ink on paper.
34 x 24.8 cm.

Vladimir Tatlin
121 *Sailor.* 1911. Tempera on canvas. 71.5 x 71.5 cm. Russian Museum, St Petersburg.

Kandinsky's "Symbolist philosophy" and Malevich's Suprematism found a rival in Constructivism, the brainchild of Vladimir Tatlin (1885–1953). Indeed, the rivalry between Malevich and Tatlin was such that on several occasions they came to blows. According to Camilla Gray, Tatlin "disliked his stepmother only a little more intensely than his father".[6] Not surprisingly perhaps, to escape the torment of their relationship, at the age of eighteen he enrolled as a sailor. While in the merchant navy, he learned to paint and produced such memorable pictures as *Fishmonger* (1911) and *Sailor* [121] as well as some slightly Picassoesque nudes such as *Nude* [122]. For a time Tatlin was influenced by Larionov and Goncharova, and worked with them closely. But in 1913 their collaboration came to an end. Deeply impressed by Picasso's "constructions", that winter he began to create "painting reliefs" and "relief constructions", incorporating materials such as wood, metal, glass and plaster, until the distinction between painting and sculpture was effectively submerged. After the Revolution, he played a leading role in the organization of Soviet art, became increasingly interested in technical design, and for the last nineteen years of his life spent much time designing a glider, based on his observation of the organic structure of flying insects and insect flight.

In Russia, the 1920s and 1930s were decades of infinite experiment. The array of artists who made major contributions to the development of abstract painting during that period included Nadezhda Udaltsova, Alexandra Exter, El Lissitzky (who produced abstract pictures called "*prouns*"), Olga Rozanova, Mikhail Menkov, Ivan Kliun and Alexander Rodchenko. Constructivism, in particular, had an impact on other art forms – especially sculpture, architecture and interior design.

Vladimir Tatlin
122 *Nude.* 1910–1914. Oil on canvas. 104.5 x 130.5 cm. Russian Museum, St Petersburg.

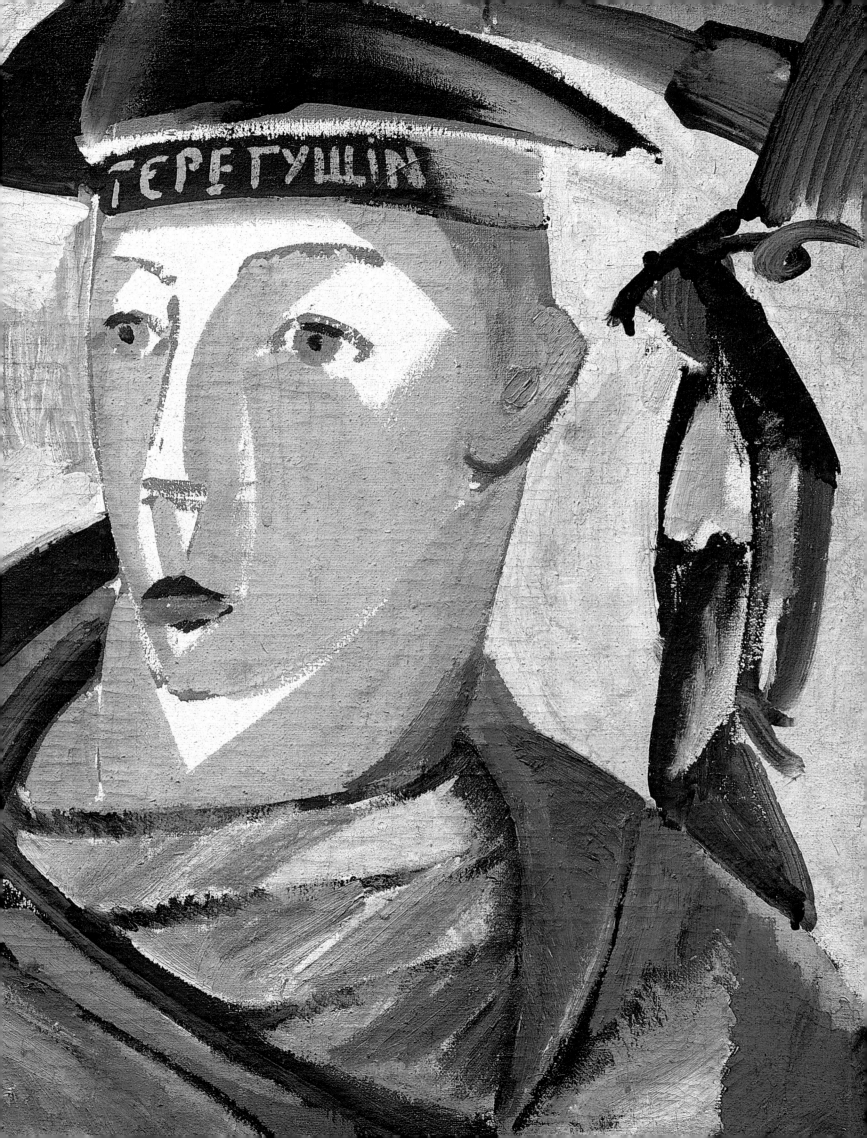

Symbolism

Symbolism – which Kandinsky regarded as the core of his artistic credo – played a prominent part in the development of Russian painting during the first three decades of the twentieth century. Originally a literary movement, it had begun to make its presence felt in the visual arts during the late 1880s. Symbolist artists sought to "resolve the conflict between the material and the spiritual world".[7] As the French poet Jean Moréas put it in his *Symbolist Manifesto*, published in *Le Figaro* in September 1886, their great aim was "to clothe the idea in sensuous form".[8]

Mikhail Vrubel
123 *The Seated Demon*. 1890. Oil on canvas. 114 x 211 cm.
Tretyakov Gallery, Moscow.

In Russia, one of the first Symbolist painters, and one of the most intriguing, was Mikhail Vrubel (1856–1910). Many of his paintings have a surreal, dreamlike quality. Some of the most remarkable – such as *The Bogatyr* (1898), *Pan* (1899) and *The Swan Princess* (1900) – are of mythological figures. And many of them feature either the elaborate patterns characteristic of Art Nouveau or mosaic-like patches of colour akin to those found in the paintings of Gustav Klimt. In 1890 Vrubel was commissioned to illustrate a special edition of the works of Mikhail Lermontov, to mark the fiftieth anniversary of the poet's death.

But even as a child he had been fascinated by Lermontov's poem *The Demon*, a subject that he would return to, both in painting and sculpture, practically until the end of his life. *The Seated Demon* [123] and *The Demon Cast Down* (1902) are two of the most powerful works of Russian Symbolism. A demon, Vrubel frequently had to explain, is not the same as a devil – in Greek mythology, a *daimon* was a spirit that guided the actions of mankind. Tormented by mental illness, Vrubel spent most of the last nine years of his life in hospital, where he continued to work until in 1906 he lost his sight.

Nesterov was "under the spell of a deep religious faith, periodically

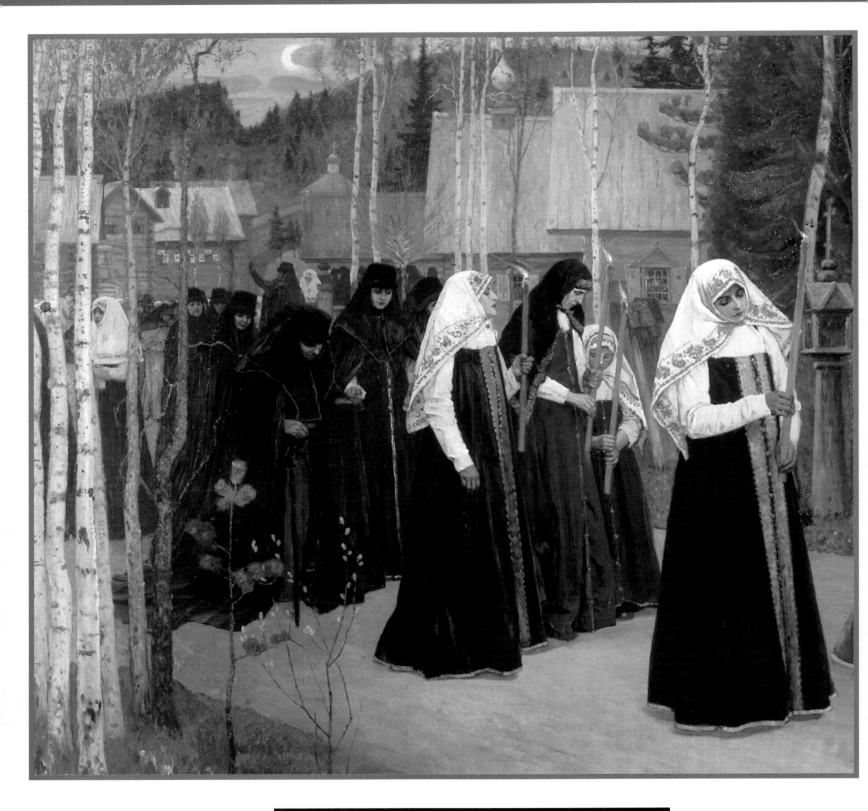

Mikhail Nesterov
124 *Taking the Veil*. 1898. Oil on canvas. 178 x 195 cm.
Russian Museum, St Petersburg.

withdrawing to monasteries and making pilgrimages to remote shrines"

Like many of the Russian Symbolists (among them Borisov-Musatov and Petrov-Vodkin), Mikhail Nesterov (1862–1942) was influenced by Puvis de Chavannes, who painted the murals of the life of Saint Geneviève in the Panthéon in Paris. During the period when he painted *Taking the Veil* [124] and *The Youth of Saint Sergius of Radonezh* [125], Nesterov was "under the spell of a deep religious faith, periodically withdrawing to monasteries and making pilgrimages to remote shrines".[9] After the Revolution his art underwent a dramatic transformation, and he became well-known for portraits with a contemporary flavour and scenes from Soviet life.

Some of the pictures painted by Kuzma Petrov-Vodkin (1878–1939) have a religious nature, such as his *Madonna of Compassion Who Moves Evil Hearts* [126]. Others – such as *Mother* [127] and *Petrograd, 1918* – have a spiritual aura, although their subject or setting is ostensibly secular. In the words of John Milner, "His excitement at the work of Matisse and Cubist artists gave way to his admiration for the traditions of icon painting . . . The result was iconic paintings of precision and boldness with a strong narrative aspect."[10] Petrov-Vodkin's most overtly Symbolist works, such as *Red Horse Swimming* (1912) and *Girls on the Volga* (1915), have a metaphorical quality, but are devoid of religious overtones.

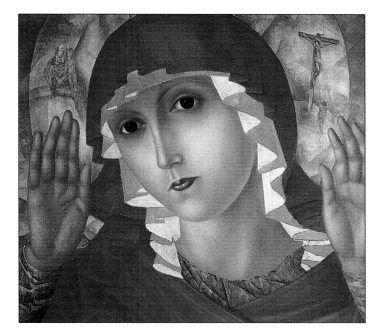

Kuzma Petrov-Vodkin
126 *Madonna of Compassion Who Moves Evil Hearts.* 1914–1915.
Oil on canvas on wood. 100.2 x 110 cm.
Russian Museum, St Petersburg.

Mikhail Nesterov
125 *The Youth of St Sergius of Radonezh.* 1892–1897.
Oil on canvas. 247 x 229 cm. Tretyakov Gallery, Moscow.

Kuzma Petrov – Vodkin
127 *Mother.* 1915.
Oil on canvas. 107 x 98.5 cm. Russian Museum, St Petersburg.

Marc Chagall
128 *I and the Village.* 1911.
Oil on canvas. 191.2 x 150.5 cm. Museum of Modern Art, New York.

Although often more complex in terms of content and symbolic meaning, many of the paintings by Marc Chagall (1887–1985) – such as *I and the Village* [128] and *The Wedding* [129] – also have a mystical or dreamlike aura, heightened by the feeling that the figures within them hover between the material and the spiritual world.

Marc Chagall
129 *The Wedding*. 1918.
Oil on canvas. 100 x 119 cm.
Tretyakov Gallery. Moscow.

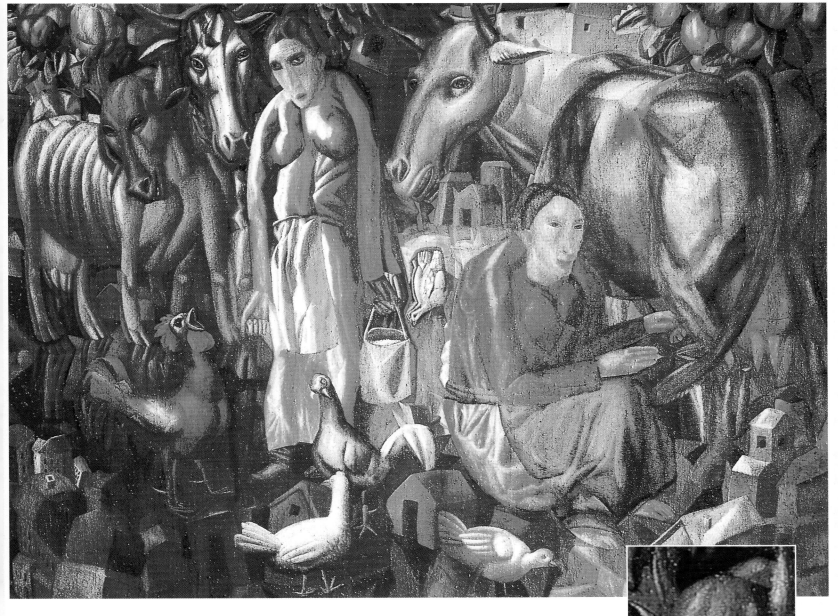

Pavel Filonov
131 *Dairymaids*. 1914. Oil on canvas. 117 x 152.5 cm. Russian Museum, St Petersburg.

The images that feature in the paintings of Pavel Filonov (1883–1941) – who was closely associated with the Russian Futurist movement – are even more surreal, and invariably pregnant with symbolic meaning [130 and 131]. Filonov's imagery has been succinctly summarized by the Russian art historian Dmitri Sarabianov: "His fish always signify Christ, his trees are the trees of life, his boats are Noah's Ark, his men and women are the naked Adam and Eve standing before the world and all history, past and future."[11] Filonov developed a method of painting, not unlike Paul Klee's, that emphasized the value of "organism" as opposed to "mechanism". His artistic credo, known as Analytic Art, "attracted young artists like a magnet",[12] so that by the mid-1920s he was one of the most popular leaders of the avant-garde. Nevertheless, he refused to sell his paintings, "having decided to hand [them] over to the State to be made into a Museum of Analytical Art."[13]

Opposite page:
Pavel Filonov
130 *Living head*. 1926.
Oil on paper mounted on canvas. 105 x 72.5 cm.
Russian Museum, St Petersburg.

Vasily Surikov
132 *Portrait of an Unknown Girl Against a Yellow*
Background. 1911.
Oil on canvas. 51 x 44 cm.
Russian Museum, St Petersburg.

Portraiture

Although the World of Art movement attracted many of the best artists, it did not have a monopoly on talent and had little appeal to the older Itinerants, many of whom were still producing interesting and innovative paintings. Surikov, for example, continued to paint until the year before his death, and during the 1880s and 1890s produced a magnificent series of "costume portraits", often graced with a descriptive title – such as *A Siberian Beauty* or *A Cossack Girl* – in addition to the model's name.

In doing so, he aimed to portray "a special beauty, ancient, Russian".[14] According to Alexander Benois, Surikov was "the first . . . to discover the peculiar beauty of old Russian colouring",[15] and these costume portraits are remarkable for their rich, warm tones. But Surikov also painted portraits that were more "modern" in style and more concerned with the personality of the sitter, such as *Unknown Girl Against a Yellow Background* [132] and *Man with an Injured Arm* [133].

Vasily Surikov
133 *Man with an Injured Arm.* 1913.
Oil on canvas. 68.5 x 53.9 cm.
Russian Museum, St Petersburg.

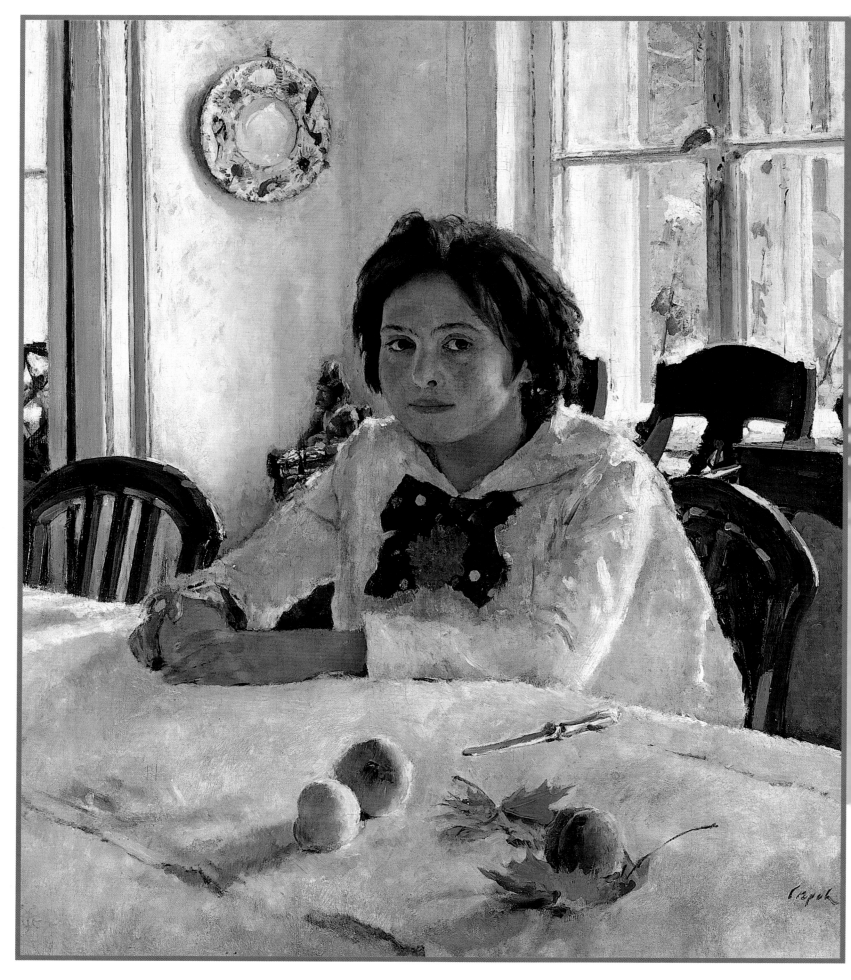

Valentin Serov
134 *Girl with Peaches (Portrait of Vera Mamontova).* 1887. Oil on canvas. 91 x 85 cm. Tretyakov Gallery, Moscow.

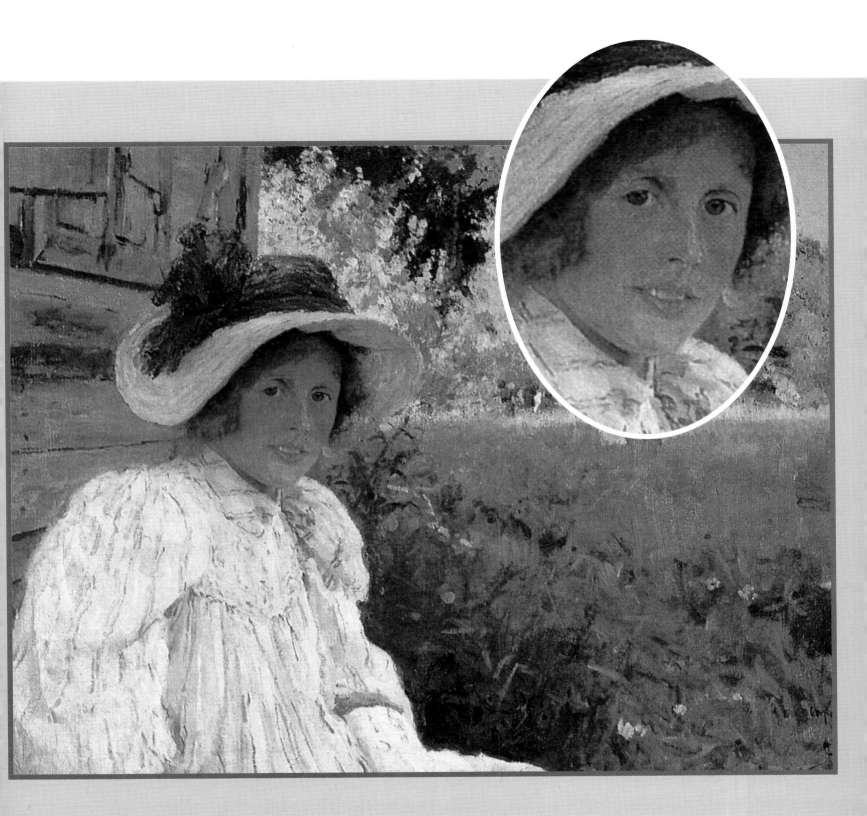

Valentin Serov
135 *In Summer (Portrait of Olga Serova)*. 1895.
Oil on canvas. 73.5 x 93.8 cm. Russian Museum, St Petersburg.

Among the "young *peredvizhniki*" who joined the World of Art group, the most brilliant portraitist was Valentin Serov (1865–1911). Like many of his contemporaries, he delighted in painting out of doors, and some of his most appealing portraits – such as *Girl with Peaches* [134], *Girl in Sunlight* and *In Summer* [135] – owe their naturalness to their setting or to the interplay of sunlight and shadows. Indeed, Serov regarded them as "studies" rather than portraits, giving them descriptive titles that omitted the sitter's name. The subject of *Girl with Peaches* – painted when Serov was only twenty-two – was in fact Mamontov's daughter Vera. The model for *In Summer* was Serov's wife.

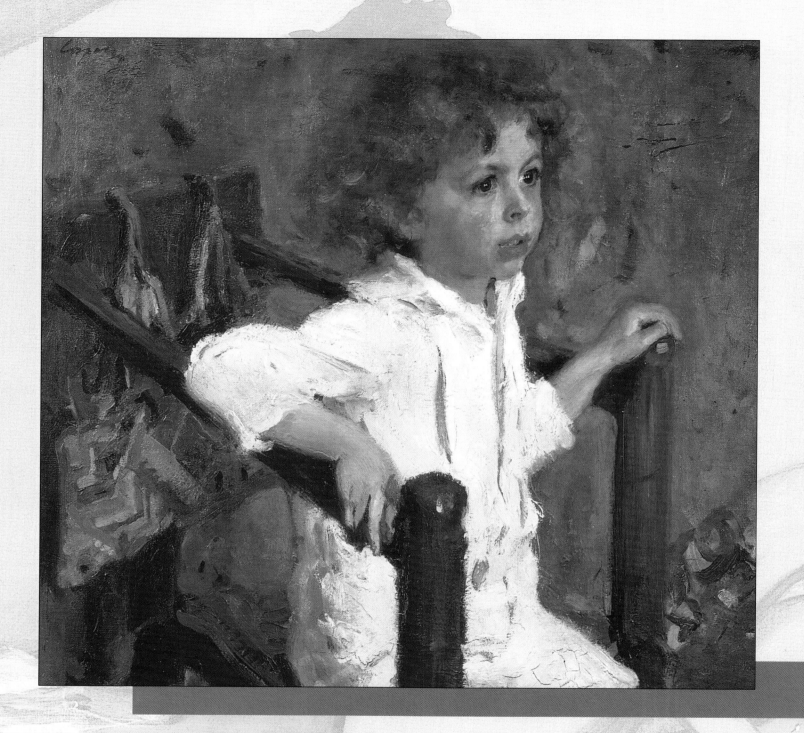

Valentin Serov
136 *Portrait of Mika Morozov.* 1901. Oil on canvas. 62.3 x 70.6 cm. Tretyakov Gallery, Moscow.

When only six years old, Serov began to display signs of artistic talent. Repin acted as his teacher and mentor, giving him lessons in his studio in Paris, at the age of nine, then letting Serov work with him in Moscow, almost like an apprentice. Eventually Repin sent him to study with Pavel Chistiakov – the teacher of many of the World of Art painters, including Nesterov and Vrubel, who was to become a close friend. Because Serov's career spanned such a long period, his style and subject matter vary considerably – ranging from voluptuous society portraits (the later ones notable for their grand style and sumptuous dresses) to sensitive studies of children, like the one he painted of Mika Morozov [136] in 1901. His portraits of Isaac Levitan [137] and the actress Maria Yermolova demonstrate his genius for capturing his sitter's personality. Utterly different from any of these is the famous nude study of the dancer Ida Rubinstein [138], in tempera and charcoal on canvas, which he painted towards the end of his life.

Detail:
Valentin Serov
138 *Portrait of Ida Rubinstein.* 1910.

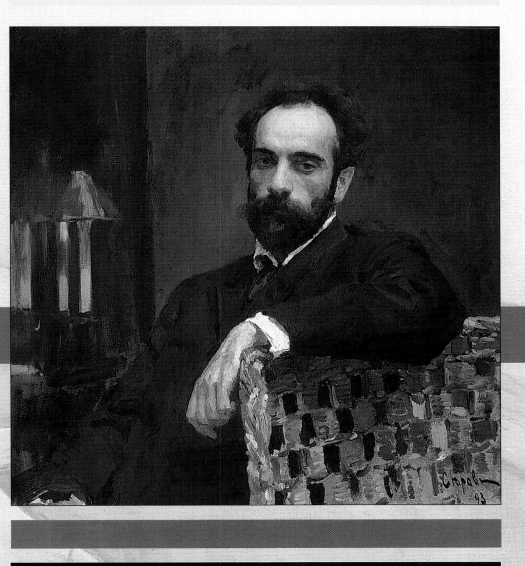

Valentin Serov
137 *Portrait of Isaac Levitan.* 1893. Oil on canvas. 82 x 86 cm. Tretyakov Gallery, Moscow.

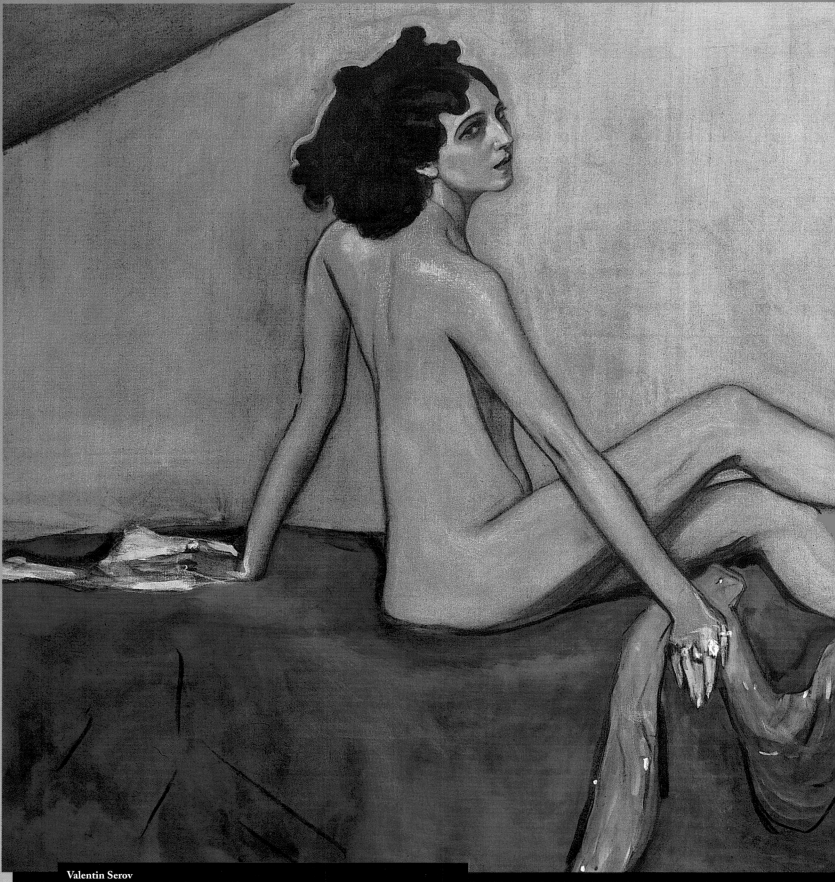

Valentin Serov
138 *Portrait of Ida Rubinstein.* 1910.
Tempera and charcoal on paper. 147 x 233 cm. Russian Museum, St Petersburg.

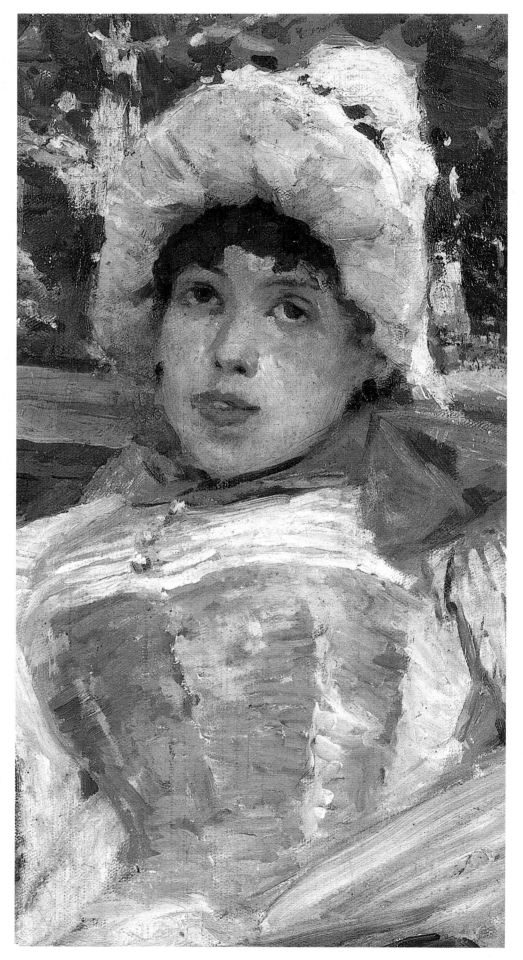

Although Serov's early style has much in common with the French Impressionists, he did not become acquainted with their work until after he had painted pictures such as *Girl with Peaches*. In contrast, Konstantin Korovin (1861–1939) was deeply influenced by the French Impressionists almost from the outset of his career, as can be seen from his *Chorus Girl* [139], which is regarded as one of the first Impressionist works by a Russian painter.

Konstantin Korovin
139 *Chorus Girl.* 1883. Tretyakov Gallery, Moscow.

Alexander Golovin
140 *Portrait of the Stage Director Vsevolod Meyerhold.* 1917. Tempera on panel. 80 x 67 cm. Theatre Museum, St Petersburg.

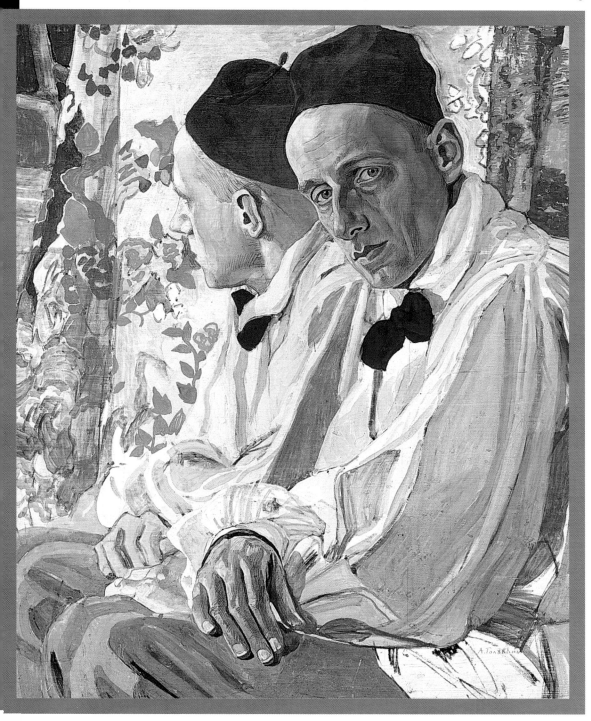

Detail from:
Alexander Golovin
141 *Portrait of Fyodor Chaliapin as Boris Godunov.* 1912. Tempera and gouache on cardboard. 211.5 x 139.5 cm
Russian Museum, St Petersburg.

Together with Korovin, Alexander Golovin (1863–1930) designed the crafts section of the Russian Pavilion at the 1900 Paris World Fair. He then went on to design stage sets and costumes for a number of theatres, including the Imperial Theatres in St Petersburg (where he became the principal decorator), the Bolshoi, the Moscow Arts Theatre and Diaghilev's Ballets Russes. Two of his most powerful paintings arose from his interest in the performing arts, namely his portrait of the theatrical director Vsevolod Meyerhold [140] and the one of the bass singer Fyodor Chaliapin in the role of Boris Godunov [141], which he painted in 1912.

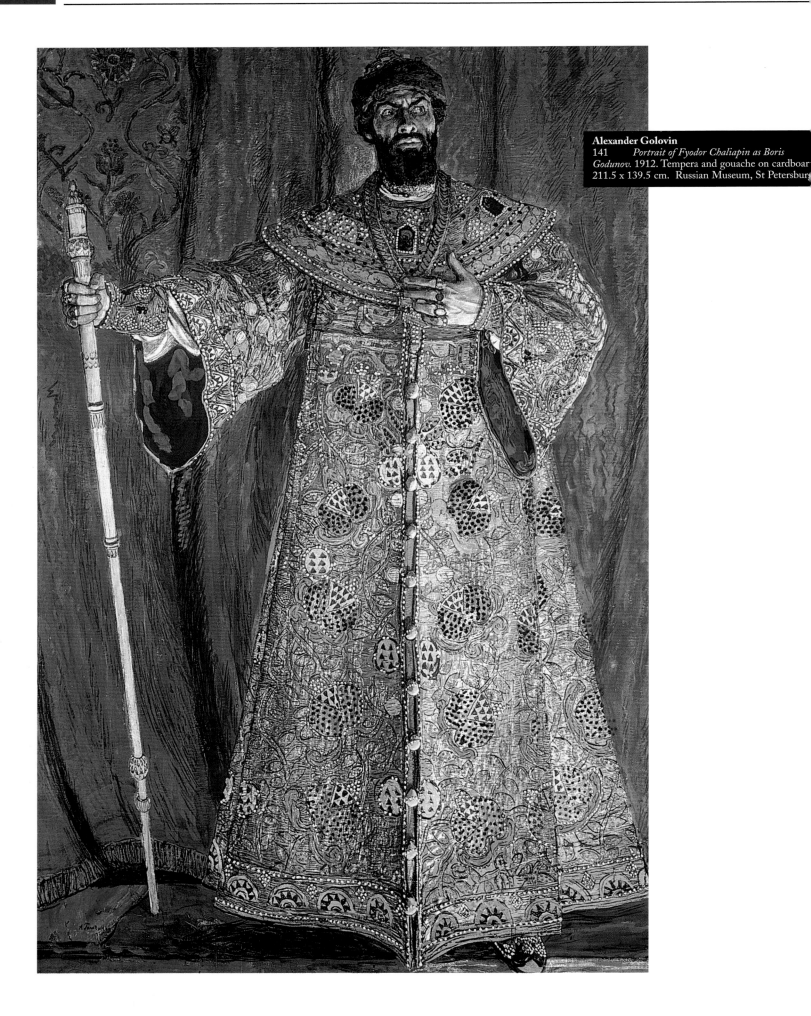

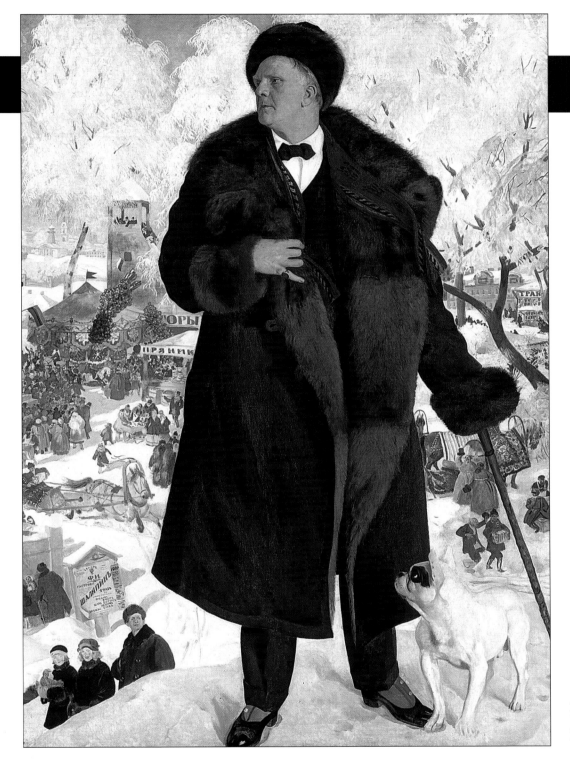

Boris Kustodiev
142 *Portrait of Fyodor Chaliapin.* 1921.
Oil on canvas. 215 x 172 cm.
Theatre Museum, St Petersburg.

Chaliapin was the subject of a number of other portraits, including one (when young) by Serov and one by Boris Kustodiev (1878–1927), who depicted him standing like a fur-coated colossus on a snow-covered hillock, backed by a fairgound scene busy with tiny brightly coloured figures [142]. Many of Kustodiev's portraits and genre paintings are richly decorative – for example, his splendid *Merchant's Wife Drinking Tea* – while the elegance and accuracy of his portrayal of the human figure reflect his early training as a sculptor.

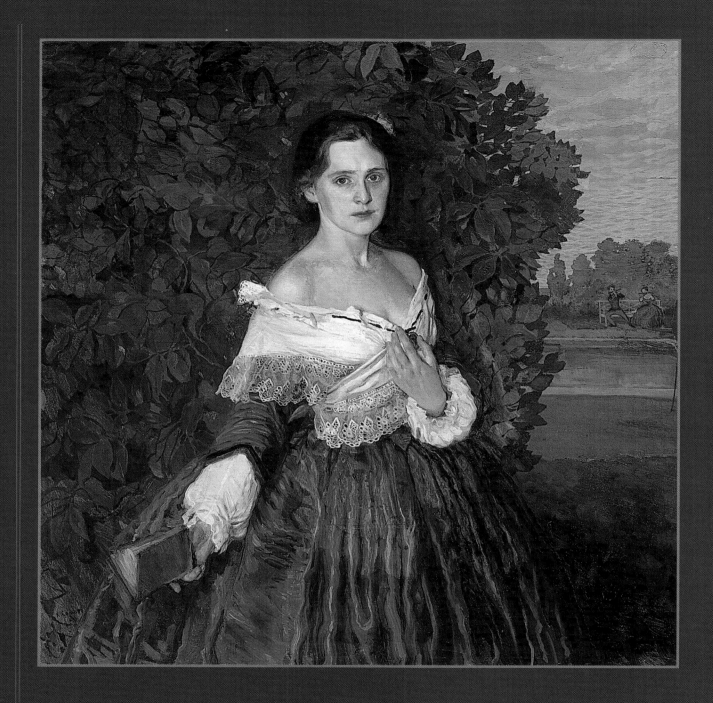

"achieves its effects by an unexpected synthesis of realism and stylization"

Konstantin Somov
143 *Lady in Blue (Portrait of Elizaveta Martynova).* 1897–1900. Oil on canvas. 103 x 103 cm. Tretyakov Gallery, Moscow.

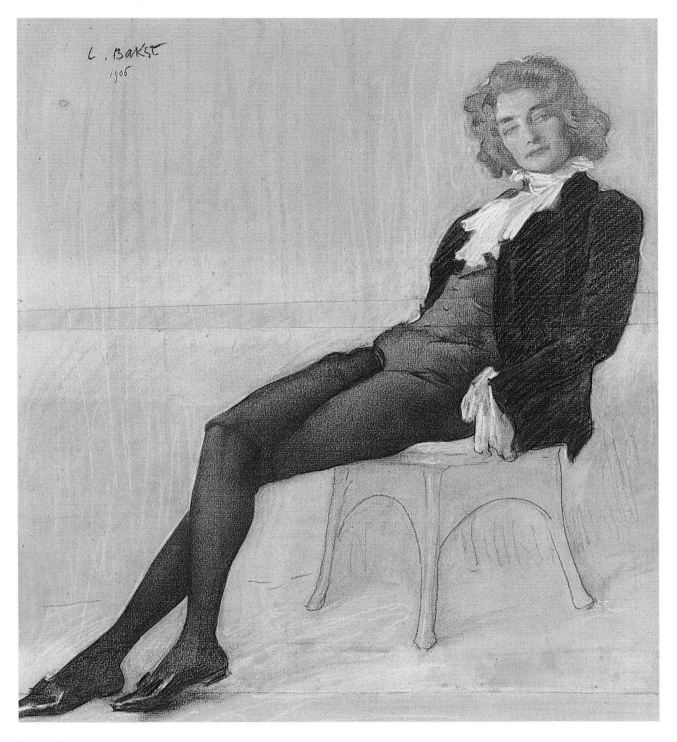

Léon Bakst
144 *Portrait of Zinaida Hippius.* 1906. Pencil and red and white chalk on paper mounted on board. 54 x 44 cm. Tretyakov Gallery, Moscow.

Lady in Blue [143], on which Konstantin Somov (1869–1939) worked from 1897 to 1900, achieves its effects by an unexpected synthesis of realism and stylization. The delicate beauty of the model – the artist Elizaveta Martynova, who died soon after this portrait was painted – appears all the more lifelike because of the artificial pose and scenery, and the old-fashioned dress that Somov asked her to wear. In contrast, the sketch of the poet Zinaida Hippius [144] by Léon Bakst – who produced spectacular costume designs – is uncontrived and naturalistic. Philip Maliavin (1869–1940) painted portraits of several of the World of Art painters, such as Somov and Grabar, that convey their characters and characteristics with great insight and sensitivity.

"expressive" use of colour became more prevalent in

From the first decade of the twentieth century onwards, "expressive" use of colour became more prevalent in Russian portraiture and figure painting – as in Ilya Mashkov's *Artist's Model* [145], Kuzma Petrov-Vodkin's portrait of the poet Anna Akhmatova [146], and Martiros Saryan's portraits of his family [147] and Victoria Alabian [148].

Russian portraiture and figure painting"

Saryan [149], Surikov [150], Vrubel [151], Petrov-Vodkin [152], Robert Falk [153] and
Mikhail Nesterov [154] all painted remarkable self-portraits. Among the pictures that
Nesterov created in the 1930s was his double portrait of the painters Pavel and Alexei
Korin – which, unlike most of his works from the post-Revolutionary period, echoes
his earlier Symbolist style. In terms of style, Vrubel's portraits, like Nesterov's, vary
enormously.

Ilya Mashkov
145 *Artist's Model.* 1920s. Oil on canvas. 140 x 115 cm.

Martiros Saryan
147 *My Family.* 1929. Oil on canvas. 102 x 80 cm. Tretyakov Gallery, Moscow.

Kuzma Petrov-Vodkin
146 *Portrait of Anna Akhmatova.* 1922.
Oil on canvas. 54.5 x 43.5 cm.

Martiros Saryan
148 *Portrait of Victoria Alabian.* 1931.
Oil on canvas. 46 x 61 cm.
Martiros Saryan Museum, Yerevan.

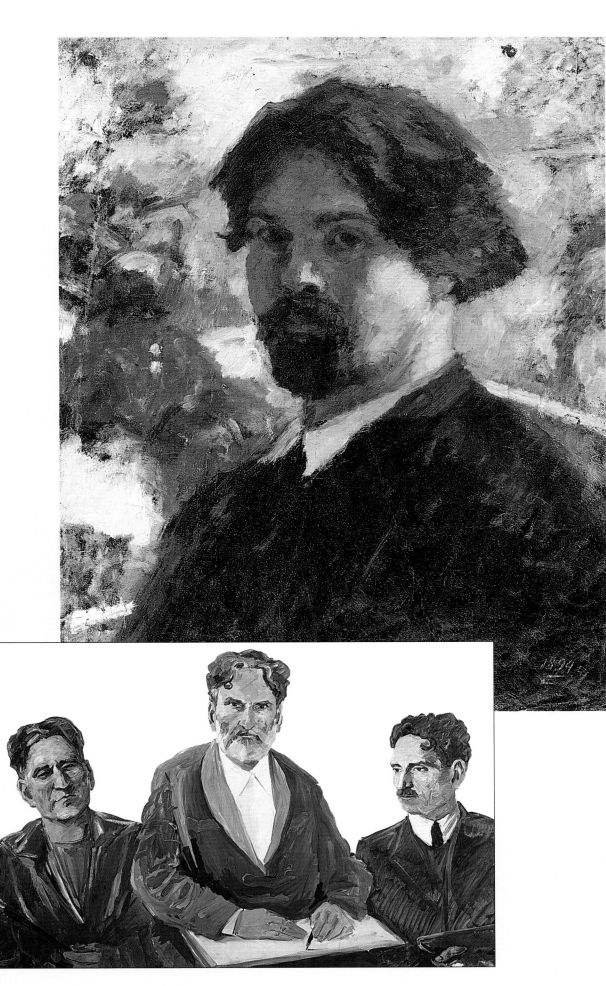

Vasily Surikov
150 *Self-Portrait*. 1894.
Oil on canvas. 51 x 40.5 cm.
Collection of the artist's family, Moscow.

Kuzma Petrov-Vodkin
152 *Self-Portrait*. 1926–1927.
Oil on canvas. 82 x 65 cm.

Martiros Saryan
149 *Self-Portrait: Three Ages*. 1942. Oil on canvas. 97 x 146 cm. Martiros Saryan Museum, Yerevan.

Mikhail Nesterov
154 *Self-Portrait*. 1915.
Oil on canvas. 94 x 110 cm. Russian Museum, St Petersburg

Mikhail Vrubel
151 *Self-Portrait with a Shell*. 1905.
Watercolour, charcoal, gouache, red chalk and pastel on paper. 58.2 x 53 cm.
Russian Museum, St Petersburg.

Robert Falk
153 *Self-Portrait in Yellow*. 1924. Oil on canvas. 100 x 83 cm.

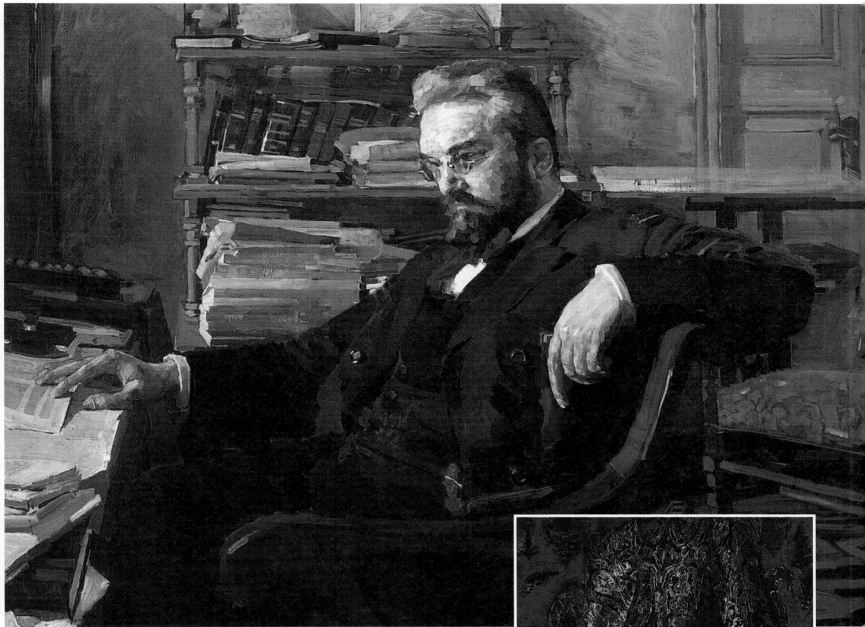

Mikhail Vrubel
155 *Portrait of Konstantin Artsybushev*. 1897. Oil on canvas. 101.5 x 136.7 cm. Tretyakov Gallery, Moscow.

They range from the sober and conventional – for example, the portrait of Konstantin Artsybushev [155] that he painted in 1897 – to highly decorative works such as *Girl Against a Persian Carpet* [156], which is both a sensitive portrait of a child and an inspired exploration of pattern and colour.

Mikhail Vrubel
156 *Girl Against a Persian Carpet*. 1886.
Oil on canvas. 104 x 68 cm.
Museum of Russian Art, Kiev.

Zinaida Serebriakova
157 *At Dinner*. 1914. Oil on canvas. 88.5 x 107 cm. Tretyakov Gallery, Moscow.

Zinaida Serebriakova (1884–1967), who was the daughter of a sculptor, granddaughter and great-granddaughter of architects, the niece of Alexander Benois and the sister of Yevgeny Lanceray, painted portraits that have a lucidity and freshness of vision. Her self-portraits and pictures of children, such as *At Dinner* [157], are particularly delightful. During the 1920s the ballet and dancers featured prominently in her work, while many of her other portraits from the same period include elements of still life that contribute to their feeling of tranquillity.

Still Life

During the first few decades of the twentieth century still-life painting in Russia was one of the most inventive art forms, both in terms of technique and subject matter and imaginative treatment. One reason was that it was a natural vehicle not only for the decorative and aesthetic philosophy of the World of Art movement but also for the Impressionists' and Post-Impressionists' experiments with colour and the avant-garde's experiments with form.

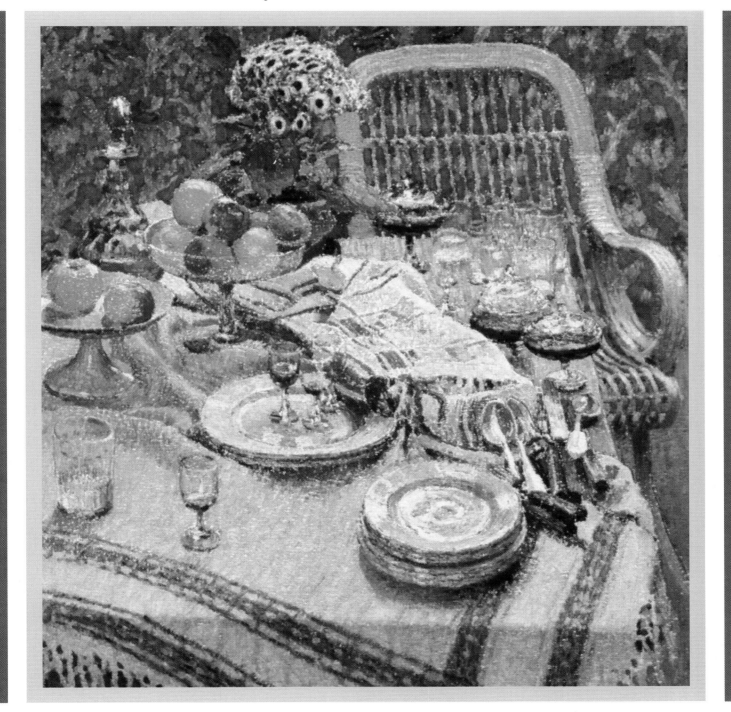

Igor Grabar
158 *The Uncleared Table.* 1907.
Oil on canvas. 100 x 96 cm.
Tretyakov Gallery, Moscow.

Both Korovin and Igor Grabar (1871–1960) produced delightful still lifes in the Impressionist idiom, such as *The Uncleared Table* [158] and *The Blue Tablecloth* [159], while the World of Art painters tended to favour a more sensuous or decorative approach, as in Kustodiev's *Still Life with Pheasants* [160] and Golovin's *Still Life with Flowers and China* [161].

Igor Grabar
159 *The Blue Tablecloth.*
Russian Museum, St Petersburg.

Boris Kustodiev
160 *Still Life with Pheasants.* 1914.
Oil on canvas 41 x 40 cm.
Kustodiev Picture Gallery, Astrakhan.

Alexander Golovin
161 *Still Life with Flowers and China.* c.1912.
Tempera on plywood. 88.5 x 70.5 cm.
Brodsky Memorial Museum, St Petersburg.

Sergei Sudeikin
162 *Still Life with Porcelain Figurines and Roses.* 1909. Oil on canvas mounted on board. 44 x 53.5 cm. Russian Museum, St Petersburg.

Among the artists of the Blue Rose group, Nikolai Sapunov (1880–1912) and Sergei Sudeikin (1882–1946) were noted for their colourful theatre designs. Both were enthusiastic admirers of Russian crafts and decorative traditions – hence the "Primitivist" (folk-inspired) colours of their paintings – and often included nostalgic ephemera, such as antique figurines [162], hand-painted trays [163] and old toys, in their still lifes.

Detail from:
Sergei Sudeikin
163 *Still Life with a Tray.* 1914.
Oil on canvas. 51 x 64.5 cm.
Private collection, St Petersburg.

Like Grabar, Sapunov produced flower paintings remarkable for their handling of colour [164], though in terms of tonal range the two artists could scarcely have been less similar.

Sergei Sudeikin
163 *Still Life with a Tray*. 1914.
Oil on canvas. 51 x 64.5 cm.
Private collection, St Petersburg.

Nikolai Sapunov
164 *Peonies*. 1908.
Tempera on canvas. 107 x 98 cm.
Tretyakov Gallery, Moscow.

At the Knave of Diamonds exhibitions bolder experimental styles were in evidence – discernible influences ranging from Matisse and Cézanne to Primitivism, Expressionism and various types of Cubism (analytical, synthetic etc.). Four of the most active founder members of the group were Alexander Kuprin (1880–1960), Pyotr Konchalovsky (1876–1956), Ilya Mashkov (1881–1944) and Robert Falk (1886–1958). All four produced still lifes that played with colour and form. This creative playfulness resulted in pictures like the ones by Kuprin [165 and 166] and Konchalovsky [167 and 168] reproduced here. Many of Mashkov's still lifes feature fruit or loaves – sometimes stylized and sometimes so realistic that they are almost palpable [169]. For a time, Falk was attracted by Impressionism (especially Cézanne); but by the 1920s, when *Red Furniture* [170] was painted, he had begun to explore what Alan Bird has called "a most private and almost secretive path" of his own.[16]

Alexander Kuprin
165 *Still Life: Cactus and Fruits.* 1918.
Oil on canvas. 96.5 x 113 cm.

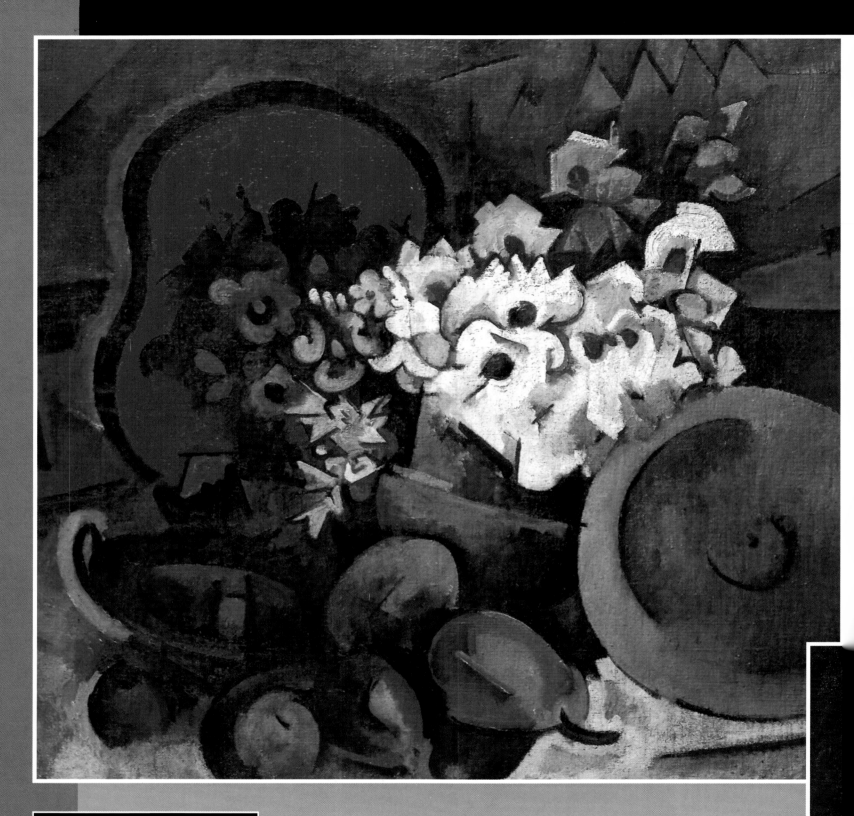

Alexander Kuprin
166 *Large Still Life with Artificial Flowers, a Red Tray and a Wooden Plate.* 1919.
Oil on canvas. 140 x 168 cm
Russian Museum, St Petersburg.

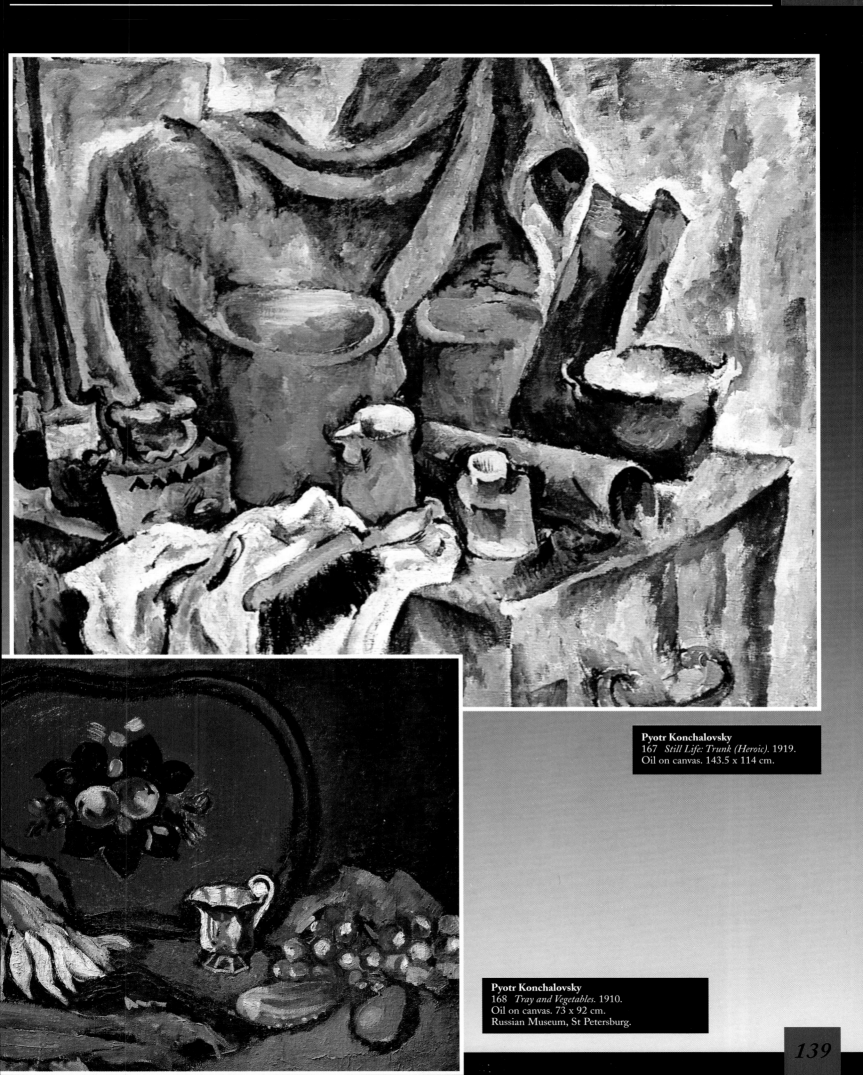

Pyotr Konchalovsky
167 *Still Life: Trunk (Heroic)*. 1919.
Oil on canvas. 143.5 x 114 cm.

Pyotr Konchalovsky
168 *Tray and Vegetables*. 1910.
Oil on canvas. 73 x 92 cm.
Russian Museum, St Petersburg.

Robert Falk
170 *Red Furniture*. 1923. Oil on canvas. 105.6 x 122.8 cm. Tretyakov Gallery, Moscow.

Ilya Mashkov
169 *Muscovite Still Life: Breads*. 1924.
Oil on canvas. 128 x 145 cm.
Tretyakov Gallery, Moscow.

Quite different from any of these were the still lifes of Kuzma Petrov-Vodkin (1878–1939), who became an influential theorist and teacher. At the time of the formation of the Blue Rose group he was working in North Africa (which had an impact on his treatment of light and the human figure), but he was able to participate in the *Golden Fleece* exhibitions. According to Petrov-Vodkin, "the new way of looking at things is markedly an absence of vertical and horizontal lines".[17] Many of his later paintings are notable for their "spherical perspective", but in *Morning Still Life* [171] the intriguing tension of the composition derives from his use of "tilted space".

Kuzma Petrov-Vodkin
171 *Morning Still Life*. 1918. Oil on canvas. 66 x 88 cm.

Mikhail Larionov
172 *Fish in the Setting Sun.* 1904. Oil on canvas. 100 x 95 cm. Russian Museum, St Petersburg.

The style of Larionov's still lifes went through several phases. Works such as *Fish in the Setting Sun* [172] and *Flowers (Two Bouquets)* [173], which date from 1904, have an Impressionist quality, but around that time he began to experiment with more intense colours, resulting in the Fauve-like idiom of *Pears*. Between 1907 and 1913, Larionov and Goncharova poured out a stream of Primitivist pictures, using elements and styles culled from folk art – especially tradesmen's signboards and *lubki* (the Russian wood-cuts, similar to English chapbooks, that had become immensely popular in the seventeenth century).

Opposite page:
Mikhail Larionov
173 *Flowers (Two Bouquets).* 1904. Oil on canvas. 49 x 47 cm.
From the former collection of A.K. Tomilina-Larionova, Paris.

Mikhail Larionov
174 *Bread.* ca 1910. Oil on canvas. 102 x 84 cm. Private collection, Paris.

These were followed by the brilliantly coloured semi-abstract still lifes, such as Larionov's *Rayonist Sausage and Mackerel*, typical of their Rayonist period. Finally, after Larionov suffered shell shock in 1914, they moved to Paris, where they worked as designers for Diaghilev's Ballets Russes.

Like Larionov, the Armenian painter Martiros Saryan (1880–1972) studied under Korovin and Serov at the Moscow College of Painting and Sculpture, where he became friendly with Sudeikin, Kuznetsov and Petrov-Vodkin – all brilliant colourists. His still lifes, like his portraits and land-scapes, have a remarkable zest. Many of them feature fruit [175], vegetables [176] or flowers painted in vibrant, sun-drenched colours. A few include Eastern elements, as in *Buddhist Still Life* [177].

Martiros Saryan
176 *Still Life: Fruit and Vegetables*. 1934. Oil on canvas. 73 x 92 cm. G. Tarverdian collection, Yerevan.

Opposite page:
Martiros Saryan
175 *Still Life: Grapes*. 1911.
Tempera on board. 43.5 x 64 cm. Tretyakov Gallery, Moscow.

Landscape

With its championing of *plein air* techniques, Impressionism inevitably had a considerable impact on Russian landscape painting – and one of the foremost Russian Impressionists was Grabar, whose favourite genre was landscape. In particular, he liked to paint sun and shadows on snow or the contrast between wintry skies and frosted trees, as in *February Azure* [178].

Igor Grabar
178 *February Azure*. 1904. Oil on canvas. 141 x 83 cm. Tretyakov Gallery, Moscow.

Detail from:
Valentin Serov
179 *Colts at a Watering Place,*
Domotkanovo. 1904.

Other snow scenes that are remarkable for their handling of light and colour include Serov's *Colts at a Watering Place* [179] – which makes brilliant use of pastel to capture the frosty sunset – and Surikov's *Zubovsky Boulevard in Winter* [180], where the wintry effect is achieved through the pervasive use of blacks, blues and browns.

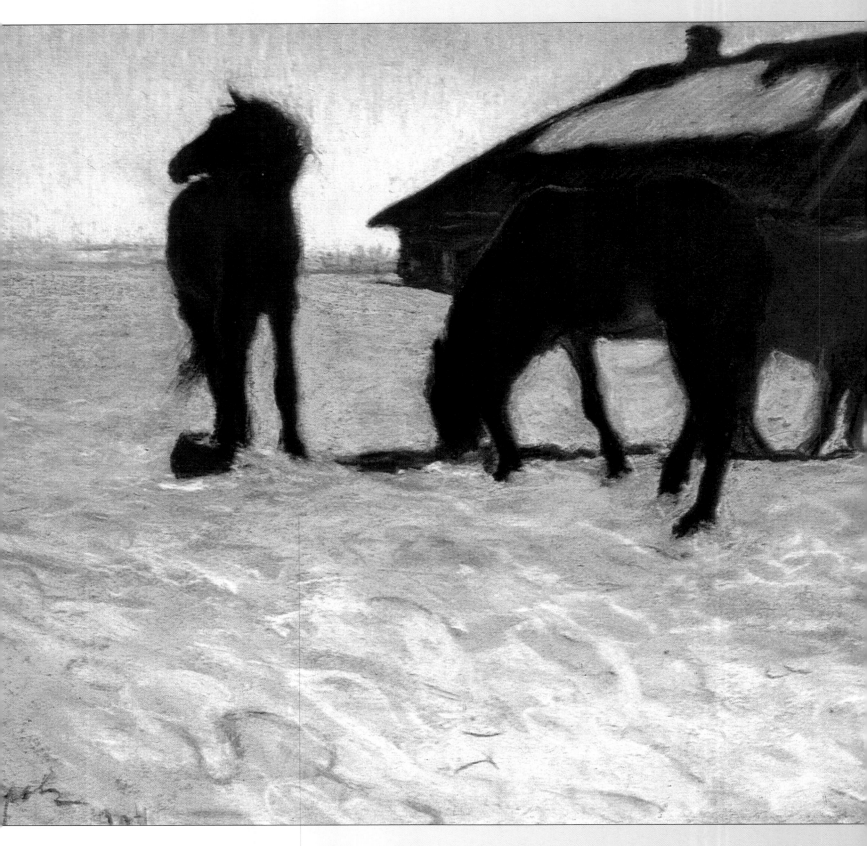

Valentin Serov
179 *Colts at a Watering Place, Domotkanovo.* 1904. Pastel on paper mounted on board. 40 x 63.8 cm. Tretyakov Gallery, Moscow.

Vasily Surikov
180 *Zubovsky Boulevard in Winter*. Oil on canvas. 42 x 30 cm. Tretyakov Gallery, Moscow.

Vasily Baksheyev
181 *Blue Spring*. 1930.
Oil on wood. 44 x 57 cm. Tretyakov Gallery, Moscow.

The style and mood of *Blue Spring* [181] by Vasily Baksheyev
(1862–1958), an almost exact contemporary of Grabar, are
reminiscent of the spring landscapes painted by Savrasov, who was
one of his teachers. Baksheyev devoted his energies almost entirely
to landscape painting from an early stage of his career. The beauty
of slender birches seen against a clear spring sky was a theme that
he returned to again and again.

Konstantin Yuon
182 *Domes and Swallows.* 1921.
Oil on canvas. 71 x 89 cm.
Tretyakov Gallery, Moscow.

In common with other painters who belonged to the Union of Russian
Artists, Konstantin Yuon (1875–1958) was attracted by the landscape
of Old Russia – particularly by the ancient towns, with their onion-
domed churches [182], monasteries and bustling markets. His urban
landscapes – such as *A Sunny Spring Day in Sergiev Posad* [183] – are
often enlivened by human activity and the movement of birds or ani-
mals. After the Revolution, he produced landscapes such as his famous
Industrial Moscow Morning (1949), which have a poetic quality express-
ing the dynamism of industry and the joy of work.

Detail from:
Konstantin Yuon
183 *A Sunny Spring Day in Sergiev Posad.* 1910.
Oil on canvas. 87 x 131 cm..

Konstantin Yuon
183 *A Sunny Spring Day in Sergiev Posad.* 1910.
Oil on canvas. 87 x 131 cm.
Russian Museum, St Petersburg.

Another of the painters associated with the Union of Russian Artists – and also with the Blue Rose group – was Nikolai Krymov (1884–1958), who played an important role as a teacher of landscape painting in the post-Revolutionary period. Before the Revolution, he experimented with a variety of styles, including a Primitivist phase that resulted in landscapes such as *Windy Day* [184], notable for a pictorial quality and colour range inspired by Russian folk art.

Nikolai Krymov
184 *Windy Day.* 1908.
Oil on board. 70 x 101 cm.
Tretyakov Gallery, Moscow.

Chagall
185 *Over Vitebsk*. 1914. Oil on paper. 73 x 92.5 cm. Collection of Ayala and Sam Zacks, Toronto.

Both landscape and folk art were important to Chagall and Kandinsky. The lovers and other dramatis personae that fly, loom or hover in so many of Chagall's pictures – such as *Over Vitebsk* [185] – do so above unmistakably Russian houses and streets. *The Blue House* (1917–20) features an *isba* (a traditional wooden house) in the foreground and, beyond it, a very Russian view painted in a style derived from Russian folk art. Chagall also painted a number of delightful views from or through windows, some of them realistic [186], others in a more symbolic style.

Marc Chagall
186 *View from the Window, Vitebsk*. 1914. Gouache, oil and pencil on paper mounted on board. 36.3 x 49 cm. Tretyakov Gallery, Moscow.

Vasily Kandinsky
187 *Kochel. c.*1902.
Oil on board. 23.8 x 32.9 cm. Tretyakov Gallery, Moscow.

Kandinsky's early landscapes, such as the one he painted of Kochel in the Bavarian Alps [187], divulge some hints of his future Expressionism. But it was only after he went to live in Murnau – in the mountainous area outside Munich, where he shared a house with Jawlensky – that his move towards abstraction began to emerge, with canvases such as *Boat Trip* [188]. This was painted in 1910, the year before he launched the *Blaue Reiter* (Blue Rider) group together with Franz Marc.

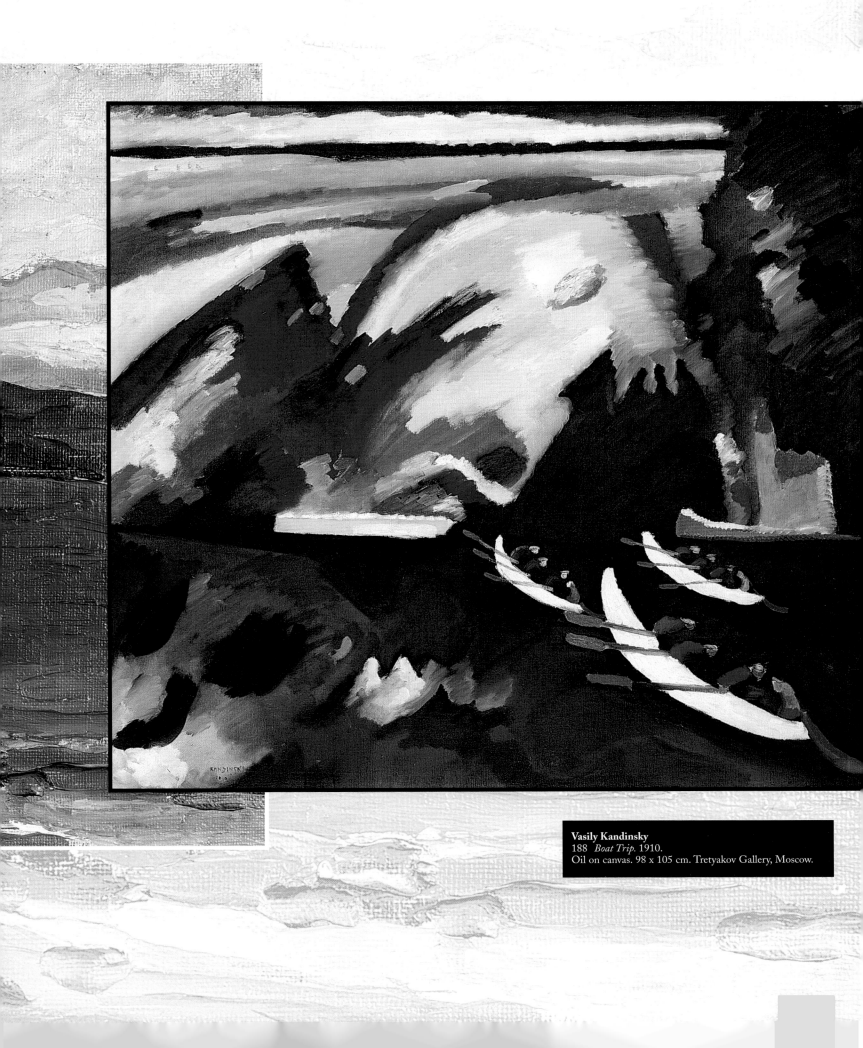

Vasily Kandinsky
188 *Boat Trip*. 1910.
Oil on canvas. 98 x 105 cm. Tretyakov Gallery, Moscow.

Martiros Saryan
190 *Sunrise over Ararat.* 1923.
Oil on canvas pasted on board. 23 x 36 cm.
I. Lunacharskaya collection, Moscow.

Martiros Saryan
189 *Constantinople Street: Midday.* 1910. Tempera on board. 66 x 39 cm. Tretyakov Gallery, Moscow.

"Saryan himself described how the central and southern Caucasus had a special enchantment for him: "There I first saw the sun and experienced intense heat. Caravans of camels with bells, nomads coming down from the mountains with tanned faces, with herds of sheep, cows, buffaloes, horses, donkeys or goats ..."

Martiros Saryan
192 *October in Yerevan*. 1961. Oil on canvas. 79 x 102 cm. Museum of Oriental Art, Moscow.

One of the most spectacular landscape painters of the mid twentieth century was Martiros Saryan. Despite the length of his working life, Saryan's landscapes never lost their feeling of spontaneity and delight in the scenic grandeur of Armenia and the Caucasus. Paintings such as *Constantinople Street: Midday* [189], *Sunrise over Ararat* [190], *Lake Sevan* [191] and *October in Yerevan* [192] show the intensity of his colours and his instinct for dramatic composition. Saryan himself described how the central and southern Caucasus had a special enchantment for him: "There I first saw the sun and experienced intense heat. Caravans of camels with bells, nomads coming down from the mountains with tanned faces, with herds of sheep, cows, buffaloes, horses, donkeys or goats; the bazaars, the street life of the motley crowd; Muslim women slipping silently by in black and pink veils; the big, dark, almond eyes of the Armenian women – it was all that reality of which I had daydreamed back in childhood . . . Nature, many-faced and many-coloured, forged by a great unknown hand is my only teacher."[18]

Opposite page:
Martiros Saryan
191 *Lake Sevan*. 1936.
Oil on canvas. 73 x 53 cm.
I. Koretskaya collection, Moscow.

Historical painting

Alexander Benois
193 *The King's Walk.* 1896.
Pastel and gouache on board. 44 x 62 cm.
Russian Museum, St Petersburg.

One of the strands in the credo of the World of Art movement was "retrospectivism" – a fascination with the past. In the words of Vsevolod Petrov, "The World of Art introduced into history painting innovations totally unlike anything seen before. Neither style, psychological probing nor social issues played any essential part in the creative thinking of Somov, Benois and their associates . . . In their historical subjects they sought to convey the elusive flavour and charm of bygone eras, to express that disenchantment with reality, that nostalgic dream of the irretrievable past which assailed the minds and hearts of their milieu. This retrospective glance served as a romantic protest against the petty bourgeois prosaism of the age."[19]

Alexander Benois
194 *Versailles: By the Statue of Curtius.* 1896.
Gouache on board. 52 x 77 cm.
Private collection, St Petersburg.

Such "retrospectivism" is very much in evidence in the works of Alexander Benois (1870–1960), who started a vogue for "historical landscapes". Many of them depicted places associated with Russian history, including royal palaces and parks, and the architectural and monumental splendours of the past. In addition, Benois was fascinated by Versailles in the time of Louis XIV, which resulted in an extensive series of pictures, painted at intervals between 1897 and 1922, such as *The King's Walk* [193] and *Versailles: By the Statue of Curtius* [194].

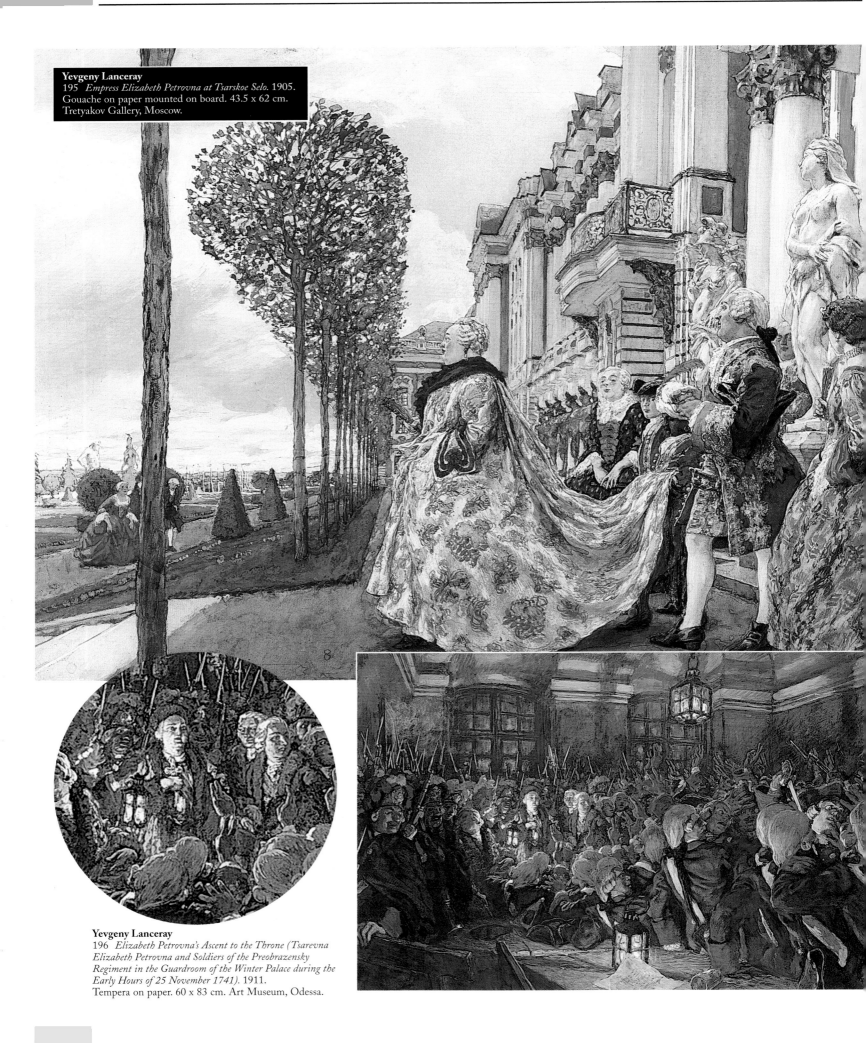

Yevgeny Lanceray
195 *Empress Elizabeth Petrovna at Tsarskoe Selo*. 1905.
Gouache on paper mounted on board. 43.5 x 62 cm.
Tretyakov Gallery, Moscow.

Yevgeny Lanceray
196 *Elizabeth Petrovna's Ascent to the Throne (Tsarevna Elizabeth Petrovna and Soldiers of the Preobrazensky Regiment in the Guardroom of the Winter Palace during the Early Hours of 25 November 1741)*. 1911.
Tempera on paper. 60 x 83 cm. Art Museum, Odessa.

This preoccupation with "the everyday life, intimacy and aesthetic of history"[20] can be seen in scenes such as *Empress Elizabeth Petrovna at Tsarskoe Selo* [195] by Yevgeny Lanceray (1875–1946). Lanceray also produced paintings depicting historical events – such as his tension-charged painting showing Elizabeth Petrovna (younger daughter of Peter the Great) on the night she deposed the infant Ivan VI [196] – and historical landscapes such as *St Petersburg in the Early Eighteenth Century* [197]. Lanceray's penchant for history was encouraged by Benois (his uncle), who took a lively interest in his artistic career.

Yevgeny Lanceray
197 *St Petersburg in the Early Eighteenth Century.*
1906. Tempera on canvas. 58.5 x 111.5 cm.
Russian Museum, St Petersburg.

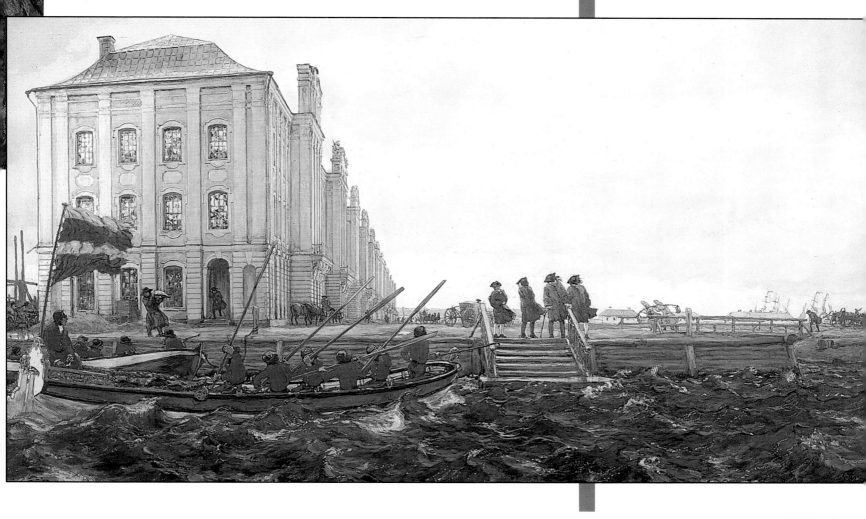

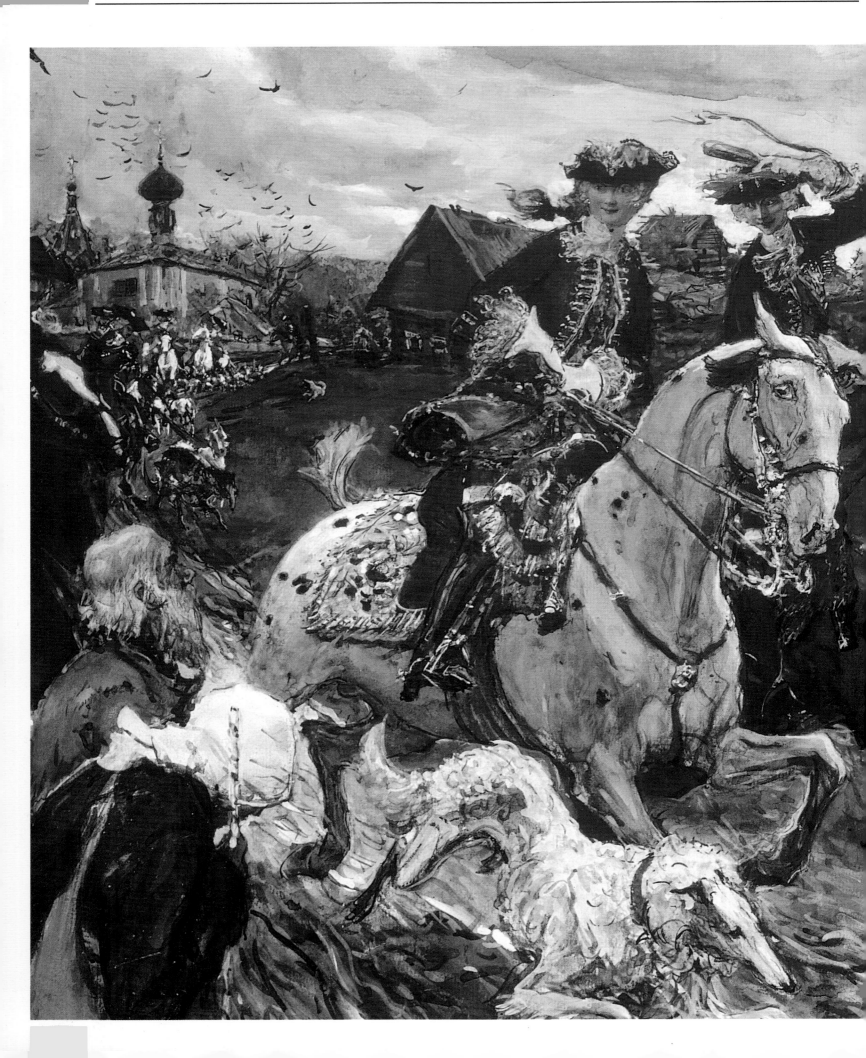

Like Benois and Lanceray, Valentin Serov sought to convey the flavour of bygone eras, particularly the eighteenth century, but he was also intrigued by the character of historical personalities and the psychological nuances of historical scenes. Soon after joining the World of Art society, he received a commission to provide illustrations for Nikolai Kutepov's book *Royal Hunting in Russia* – including *Peter II and Princess Elizabeth Riding to Hounds* [198], notable for the momentum of the galloping horses and the contrast between the finery of the riders and the poverty of the peasants watching them pass.

The World of Art painters tended to favour the decorative texture of tempera, pastel, watercolours or gouache, rather than the richness of oils, and Serov's most remarkable historical work is a relatively small tempera painting bearing the unadorned and unqualified title *Peter the Great* [199]. It shows Peter purposefully striding across the shore of Vasily Island during the building of St Petersburg, while his retinue struggle to keep pace with the impatient tsar.

Valentin Serov
199 *Peter the Great*. 1907. Tempera on board. 68.5 x 88 cm. Tretyakov Gallery, Moscow.

Opposite page:
Valentin Serov
198 *Peter II and Princess Elizabeth Riding to Hounds*. 1900.
Tempera and gouache on paper mounted on board. 41 x 39 cm.
Russian Museum, St Petersburg.

Valentin Serov
200 *"Soldiers, heroes every one of you,
where has your glory gone?"* 1905.
Tempera and charcoal on board. 47.5 x 71.5 cm.
Russian Museum, St Petersburg.

Serov used tempera and charcoal for a
series of poignantly satirical pictures
prompted by the savage suppression of
the Revolution of 1905. On "Bloody
Sunday" (9 January 1905) soldiers
opened fire on a procession of workers
approaching the Winter Palace. Serov's
response was *"Soldiers, heroes every one of
you, where has your glory gone?"* [200],
showing the troops, led by a mounted
officer, advancing on the unarmed
demonstrators.

Two years later, in 1907, Serov visited
Greece together with Léon Bakst
(1866–1924). Their travels inspired Serov
to paint *Ulysses and Nausicaä* and *The
Rape of Europa* [201], both of which are
remarkable for their aura of timelessness,
as well as their adventurous composition
and the modulation of their colours.
Bakst's response to their visit was totally
different. It took the form of a decorative
panel endowed with a vertiginous per-
spective and a nightmarish intensity that
are almost Surrealist. Entitled *Terror
Antiquus* [202], it depicts an ancient
civilization at the moment of destruction.

Above:
Valentin Serov
201 *The Rape of Europe.* 1910.
Tempera on canvas. 71 x 98 cm.
Tretyakov Gallery, Moscow.

Léon Bakst
202 *Terror Antiquus*. 1908.
Decorative panel. Oil on canvas. 250 x 270 cm.
Russian Museum, St Petersburg.

Nikolai Roerich
203 *The Conquest of Kazan*. 1914. Tempera on paper. 78 x 73 cm.
Picture Gallery of Armenia, Yerevan.

Like Bakst, Nikolai Roerich (1874–1947) was an excep-
tionally imaginative stage designer (it was Roerich who
designed the sets for Stravinsky's ballet *The Rite of Spring*).
The scale and decorative possibilities of theatrical design,
coupled with an intense interest in Slavic history, made him
the ideal candidate when it came to commissioning wall
panels for Moscow's new Kazan Railway Station, built in a
resplendent amalgam of styles by the architect Alexei
Shchusev between 1913 and 1926. As with Kustodiev's
proposals for the main ceiling, Roerich's ideas were not
taken beyond the design stage, but his preparatory paint-
ings [203 and 204] indicate how impressive the murals
would have been. During the Second World War Roerich
used his knowledge of history and legend to patriotic effect,
creating works featuring Russian epic heroes and saints.

Detail from: **Nikolai Roerich**
204 *The Battle of Kerzhenets*. 1911. Tempera on cardboard.
52.4 x 70 cm. Russian Museum, St Petersburg.

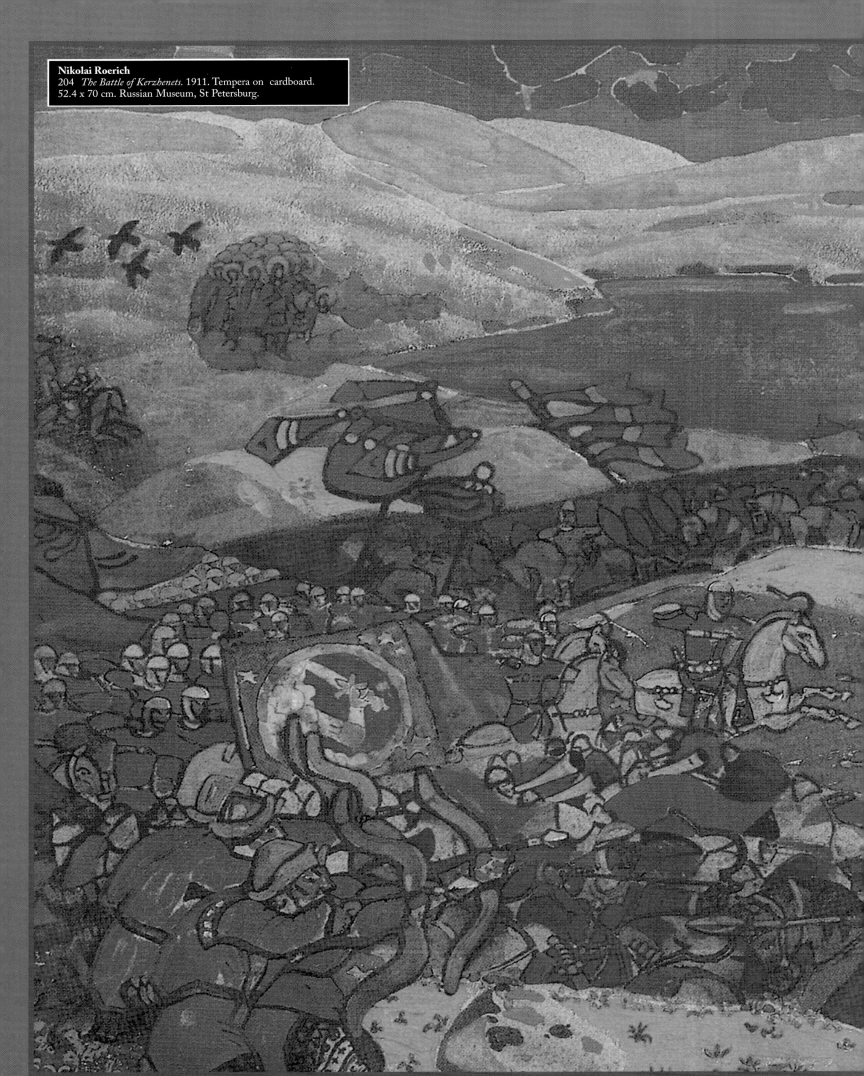

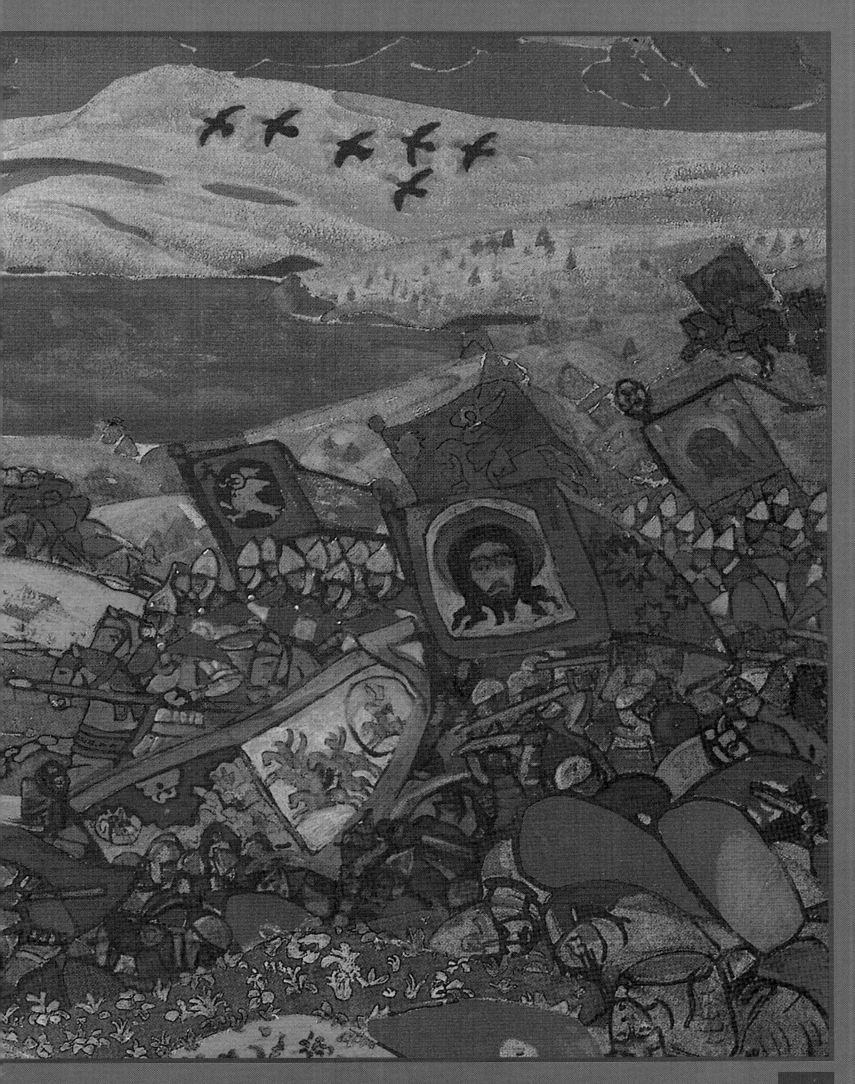

The two World Wars and the Soviet Revolution inspired numerous documentary and commemorative paintings. Many of these, especially after the promulgation of the dogma of Socialist Realism in 1934, were official commissions. In its initial manifesto, published in 1921, the Association of Artists of Revolutionary Russia (AKhRR) stated that its aim was "to capture, through artistic and documentary means, this supreme moment in history" and to portray "the life of the Red Army, the life of the workers, the peasantry, revolutionary activists, and the heroes of labour".[21] Dedicated to the continuation of the historical realism of the Itinerants, it attracted an impressive array of well-known artists, including Arkhipov, Baksheyev, Kasatkin, Kustodiev, Maliutin, Petrov-Vodkin and Yuon. Kustodiev, who possessed an unusual talent for painting crowd scenes, produced a lively record of the mood of celebration outside the Comintern Congress held in Petrograd in 1920 [205]. Petrov-Vodkin's *Death of a Commissar*, painted in 1928, provided a pietà-like memorial to those who died during the Russian Civil War.

Boris Kustodiev
205 *Festivities Marking the Opening of the Second Comintern Congress and Demonstration on Uritsky Square in Petrograd on 19 July 1920*. 1921. Oil on canvas. 133 x 268 cm. Russian Museum, St Petersburg.

Alexander Deineka
206 *The Defence of Petrograd.* 1964. Oil on canvas. 201 x 248.5 cm. Tretyakov Gallery, Moscow.

To satisfy demands for patriotic propaganda, many of the paintings produced during the Second World War were executed in an exaggeratedly heroic style reminiscent of poster art, among them such monumental canvases as *The Defence of Sevastopol* by Alexander Deineka (1899–1969). *The Defence of Petrograd* [206], which Deineka painted in 1964, is no less heroic – but the style is totally different, being in effect a return to, or rather a development of, his style of the 1920s. This later painting starkly presents two contrasting images. In the top half, victims of war wearily make their way across a bridge, while below, as if marching in counterpoint, their comrades rally to the city's defence.

The life of the people

The "life of the workers, the peasantry, and the heroes of labour" was to become the great theme of Soviet art. But it had also been the dominant preoccupation of the Itinerants – especially the "young *peredvizhniki*", such as Abram Arkhipov (1862–1930), Nikolai Kasatkin (1859–1930) and Sergei Ivanov (1864–1910).

The last decade or so of the nineteenth century saw the emergence of what was known as the "eventless genre" – pictures that expressed the underlying significance or nuances of a situation, without any narrative element or the implication of any causative event. Arguably, the ultimate eventless picture was a scene of bored bourgeois domesticity by Baksheyev entitled *The Humdrum of Life* (1893). One of the most famous was Arkhipov's *Down the Oka* (1889) – depicting a group of peasants afloat on a river on a sunny day – which conveys an over-whelming feeling of time standing still.

But the "eventless genre" could express the joys and pains of life, as well as its existential quality. Arkhipov's *Visiting* [207] portrays the simple pleasure of spending time with friends, while the priests demurely savouring an afternoon out in Kustodiev's *Moscow Teahouse* [208] illustrate his satirical vein and his sense of fun.

Abram Arkhipov
207 *Visiting*. 1915.
Oil on canvas. 105 x 154 cm. Russian Museum, St Petersburg.

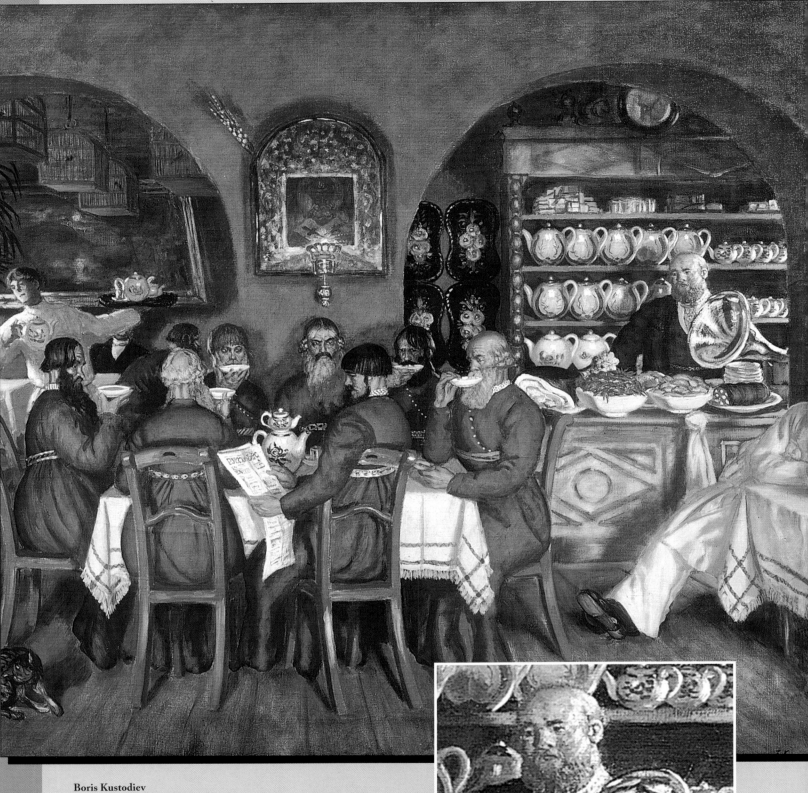

Boris Kustodiev
208 *Moscow Teahouse*. 1916.
Oil on canvas. 99.3 x 129.3 cm.
Tretyakov Gallery, Moscow.

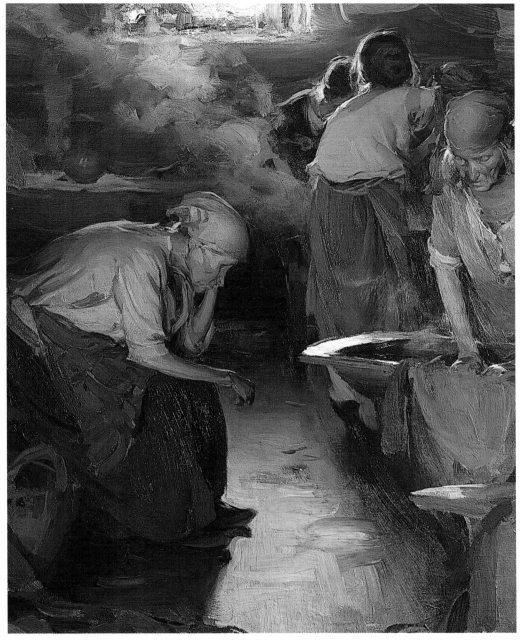

In utter contrast to these, Arkhipov's *Laundresses* [209] is a powerful indictment of the grinding drudgery of sweated labour. Concern at the living and working conditions of peasants and industrial workers was voiced in the works of many of his contemporaries. Kasatkin, for example, lived for several months in a coal-mining region, and many of his pictures depict the rigours of the miners' existence [210]. Sergei Ivanov's *On the Road: The Death of a Migrant Peasant* [211] focused on the plight of agricultural workers in the later part of the nineteenth century. The desperate state of the economy had resulted in thousands of peasants leaving their home villages in search of work. The dead man lying in bright sunshine in the middle of nowhere, his prostrate wife and their bewildered child are powerful symbols of the cruel struggle for survival.

Detail from:
Nikolai Kasatkin
210 *Poor People Collecting Coal in an Abandoned Pit*. 1894.

Abram Arkhipov
209 *Laundresses*. Late 1890s. Oil on canvas. 91 x 70 cm. Russian Museum, St Petersburg.

Detail from:
Sergei Ivanov
211 *On the Road: The Death of a Migrant Peasant*. 1889.

Nikolai Kasatkin
210 *Poor People Collecting Coal in an Abandoned Pit.* 1894.
Oil on canvas. 80.3 x 107 cm. Russian Museum, St Petersburg.

Sergei Ivanov
211 *On the Road: The Death of a Migrant Peasant*. 1889. Oil on canvas. 71 x 122 cm. Tretyakov Gallery, Moscow.

Natalia Goncharova
212 *Fruit-picking*. 1910.
Oil on canvas. 103.5 x 71 cm. Russian Museum, St Petersburg.

The dignity of peasant life, its closeness to nature and its serenity and vigour have been recurring themes in Russian art since the time of Venetsianov. The peasants who feature in the paintings of Serebriakova, Goncharova [212] or Plastov are, in a sense, the descendants of his sowers and reapers. In terms of imagery, among the most remarkable representations of peasant women are Philip Maliavin's dancing peasant girls [213], almost lost amid the frenzied swirls of colour. Maliavin's dancers were, in the words of Dmitri Sarabianov, seen by his contemporaries "as a symbol of the elemental force of the peasantry which exploded at the time of the Revolution".[22] No less memorable are the harmonious, rhythmic colours of *Woman Sleeping in a Sheepfold* [214] by Pavel Kuznetsov (1878–1968), many of whose paintings convey the freedom and fascination of the nomadic world of the steppes.

Detail from:
Pavel Kuznetsov
214 *Woman Sleeping in a Sheepfold*. 1911.

Philip Maliavin
213 *Woman Dancing*. Late 1900s.
Oil on canvas. 210 x 125 cm. Russian Museum, St Petersburg.

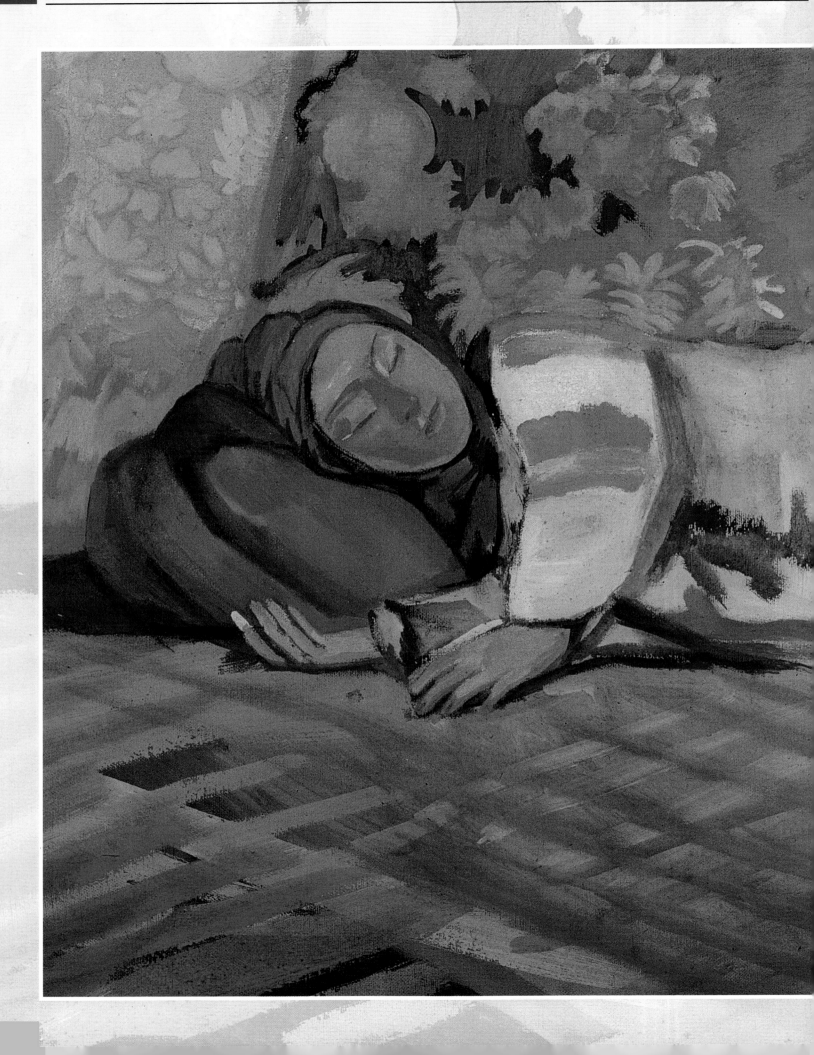

Pavel Kuznetsov
214 *Woman Sleeping in a Sheepfold.* 1911.
Oil on canvas. 66 x 71 cm.
Tretyakov Gallery, Moscow.

Vasily Surikov
215 *The Taking of the Snow Fortress.* 1891.Oil on canvas. 156 x 282 cm. Russian Museum, St Petersburg.

One of the liveliest tableaux of Russian life dates from the 1890s. To help Surikov recover from depression after his wife's death, his brother urged him to paint a picture of the "storming" of a snow fortress [215] – a Cossack tradition, which was still popular in the area around his home town of Krasnoyarsk. Each year, on the last day before the beginning of Lent, a snow fortress would be built, often with considerable skill and imagination. Then a battle would ensue between attackers on horseback, who had to "capture" the fortress, and defenders armed with branches and rattles.[23]

With their violinists, street sweepers, soldiers, newspaper vendors, cattle dealers, rabbis and lovers, Chagall's pictures – including many painted when he lived in Paris – provide affectionate glimpses of village and small-town life in pre-Revolutionary Russia.

In the post-Revolutionary period, industrialization provided a new stimulus for Soviet artists. In 1923 Boris Yakovlev (1890–1972) painted a small picture entitled *Transport Returns to Normal* [216]. In the words of the art historian John Milner, "only the approaching engine's red star communicates the message" in this "hymn to railway transport . . . closely recalling Monet's Gare St-Lazare paintings".[24] If Yakovlev's painting is a hymn to the railways, many of Deineka's works are hymns to industry or to the dynamism of the Soviet people. Nevertheless, a note of ambiguity or paradox is often present.

Boris Yakovlev
216 *Transport Returns to Normal.* 1923. Oil on canvas. 100 x 140 cm. Tretyakov Gallery, Moscow.

In *Female Textile Workers*
[217] there is a lightness
and efficiency about the
workers' movements – but
they are also trancelike and
robotic, and a decidedly
pre-industrial cowherd and
pair of cows are visible
through the window of the
ultra-modern factory.

Alexander Deineka
217 *Female Textile Workers*. 1927.
Oil on canvas. 171 x 195 cm. Russian Museum, St Petersburg.

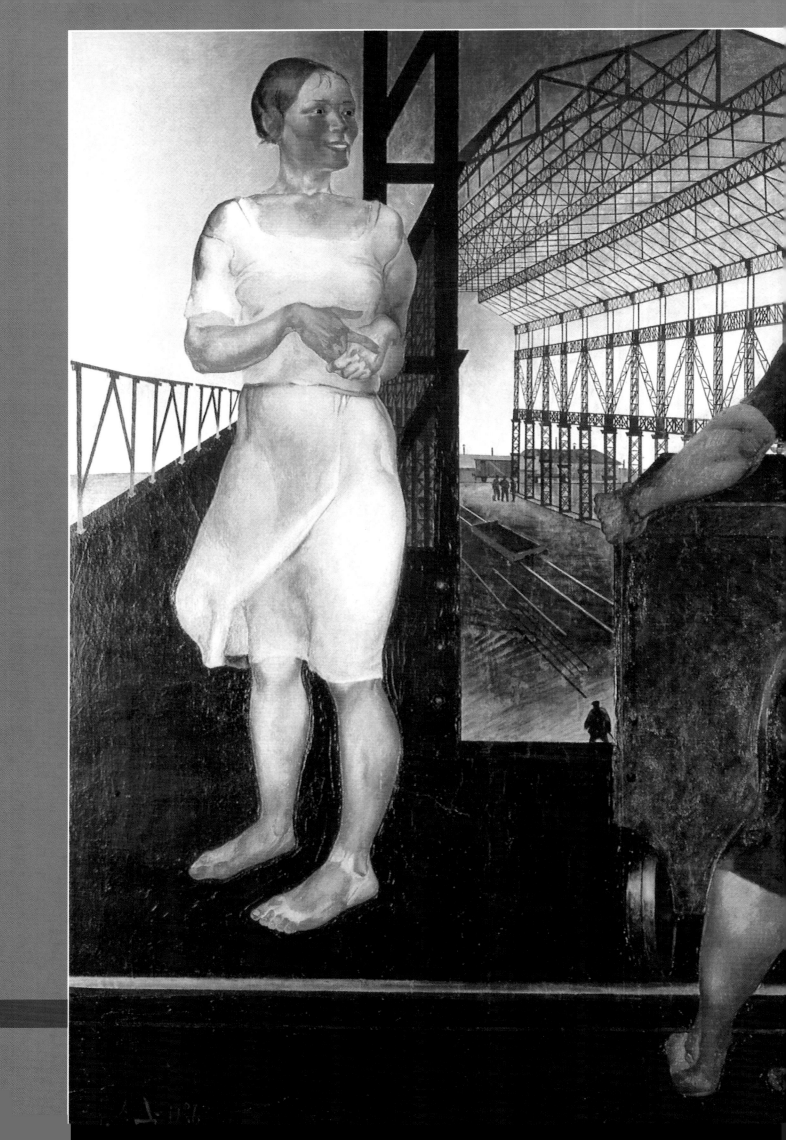

Similarly, in *Building New Factories* [218] the spark of communication between the two women and the athletic twist of their bodies contrast with the geometrical skeleton of lifeless steel girders.

Alexander Deineka
218 *Building New Factories.* 1926.
Oil on canvas. 209 x 200 cm. Tretyakov Gallery, Moscow.

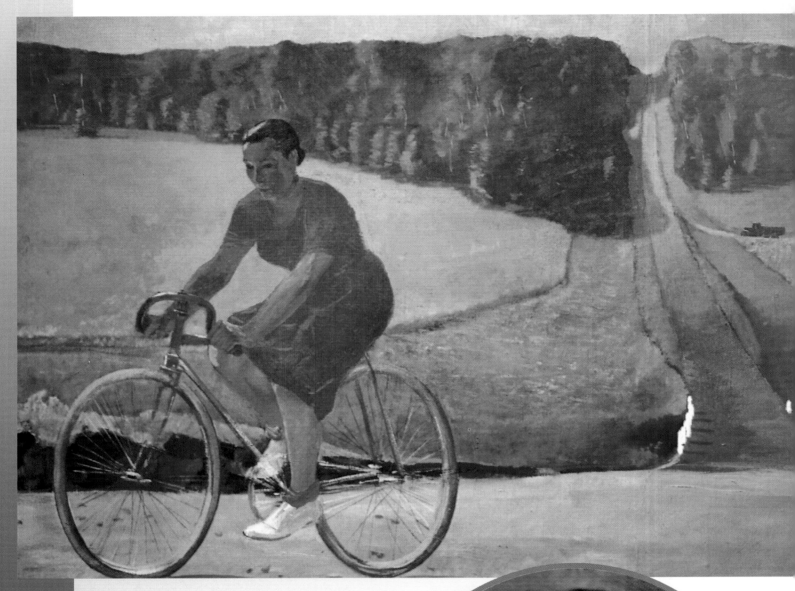

Alexander Deineka
219 *Collective Farm Worker on a Bicycle.* 1935.
Oil on canvas. 120 x 220 cm.
Russian Museum, St Petersburg.

Right, detail from:
Arkady Plastov
221 *Threshing on the Collective Farm.* 1949.

Arkady Plastov
220 *Haymaking.* 1945. Oil on canvas. 193 x 232 cm. Tretyakov Gallery, Moscow.

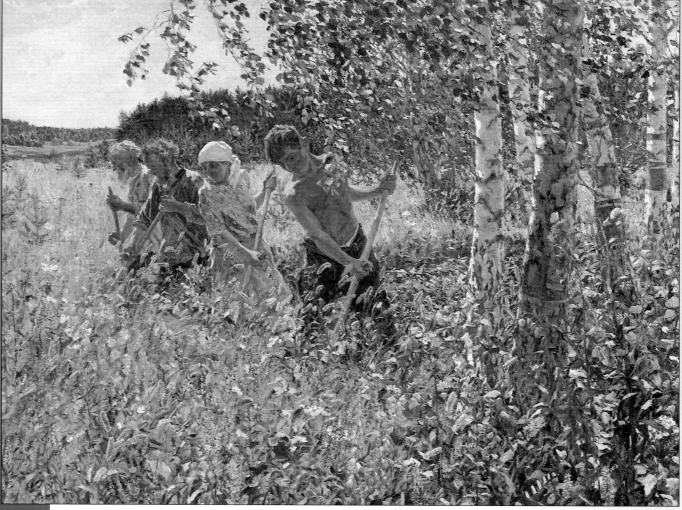

The development of collective farms stimulated some equally memorable images. Deineka's trim 1930s farmworker pedalling through the immaculate countryside on her drop-handled bicycle [219] provided a reassuring symbol of progress (tempered, perhaps, with a barely expressed hint of irony). In the 1930s and after the Second World War, Arkady Plastov (1893–1972) painted farming scenes [220 and 221] full of life and confidence, celebrating the beauty of the Russian countryside and the heroic efforts of the workers engaged in the drive for agricultural regeneration. Huge canvases, intended for public buildings and meant to impress, they have been aptly described as "calls to action, icons of Socialism".[25]

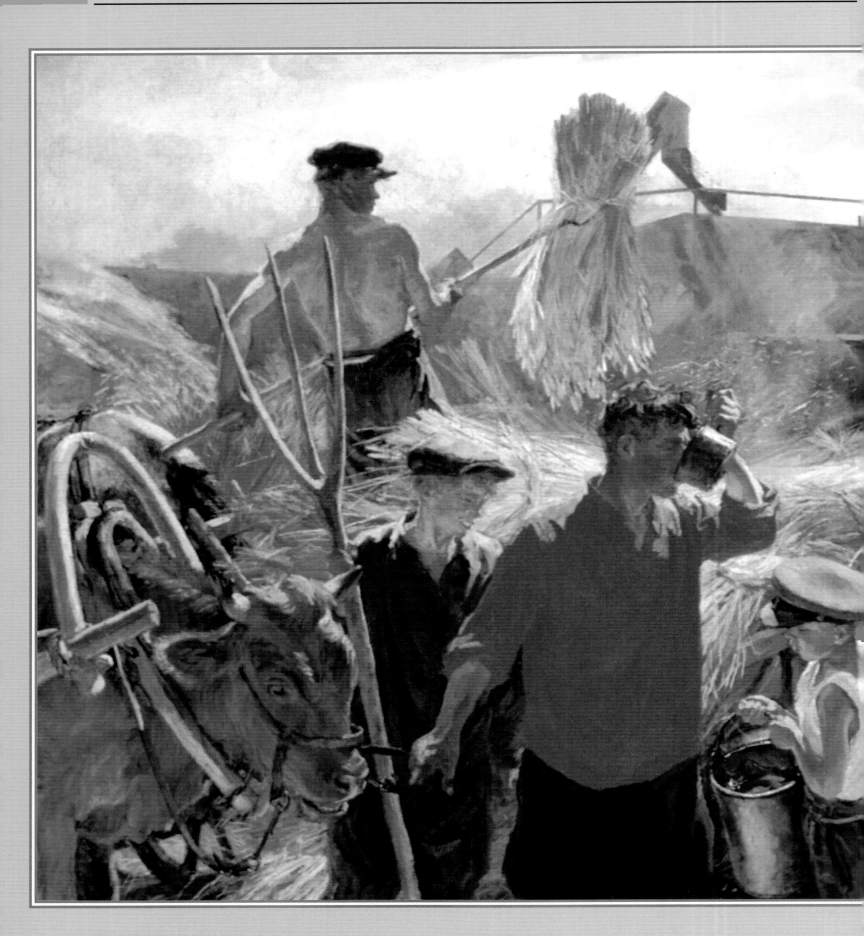

Arkady Plastov
221 *Threshing on the Collective Farm.* 1949. Oil on canvas. 200 x 382 cm. Museum of Russian Art, Kiev.

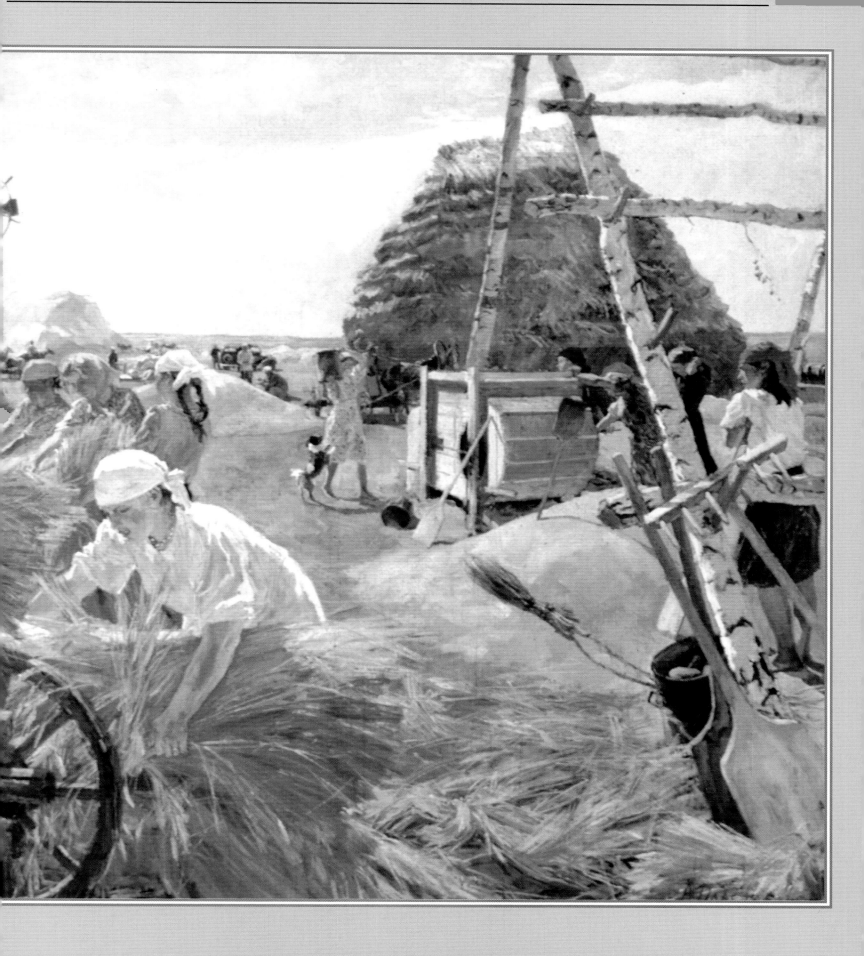

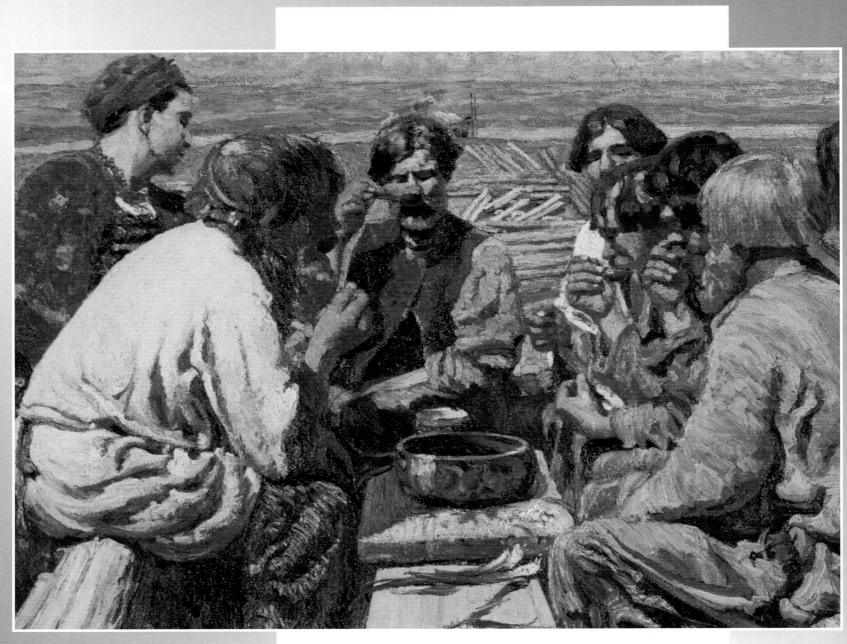

Sergei Maliutin
222 *The Brigade's Lunch*. 1934. Oil on canvas. 123 x 249 cm. Tretyakov Gallery, Moscow.

Some aspects of rural life, however, have altered very little. Sergei Maliutin (1859–1937) – a multi-talented artist who designed several buildings in Moscow incorporating folk-art elements and headed the woodwork studios at Talashkino in the 1890s – painted *The Brigade's Lunch* [222] in 1934. But, as so often with Russian painting, there is a thread of continuity linking the present and the past. The peasant meal of soup and green onions, the lunchers themselves and the riverside setting might have provided subject matter for one of the Itinerants (perhaps Miasoyedov, Arkhipov or Sergei Ivanov) – or even for Mikhail Shibanov, the painter who provoked something of a furore when he exhibited his *Peasant Meal* at the Academy in the eighteenth century.

LIST OF ILLUSTRATIONS

BIBLIOGRAPHY

AUTY, ROBERT AND OBOLENSKY, DIMITRI *An Introduction to Russian Art and Architecture*, Cambridge University Press, 1980

BIRD, ALAN *A History of Russian Painting*, Phaidon, 1987

BOWLT, JOHN *From the Classical to the Romantic: Russian Art of the Late Eighteenth and Early Nineteenth Centuries* (essay originally published in The Art of Russia 1800–1850, University of Minnesota, 1978), reprinted in *Art and Culture in Nineteenth-Century Russia,* edited by Theofanis George Stavrou, Indiana University Press, 1983

FEODOROV-DAVYDOV, ALEXEI *Isaac Levitan*, Parkstone/Aurora, 1995

GRAY, CAMILLA *The Great Experiment: Russian Art 1863–1922*, Thames & Hudson, 1962 (revised and enlarged by Marian Burleigh-Motley, Thames & Hudson, 1986)

GUERMAN, MIKHAIL *Mikhail Vrubel*, Parkstone/Aurora, 1996

GUERMAN, MIKHAIL *Russian Impressionists and Postimpressionists*, Parkstone Press, 1998

GUERMAN, MIKHAIL *Vasily Kandinsky*, Parkstone Press, 1998

GUERMAN, MIKHAIL AND FORESTIER, SYLVIE *Marc Chagall*, Parkstone/Aurora, 1995

HAMILTON, GEORGE HEARD *The Art and Architecture of Russia*, in the *Pelican History of Art* series, Penguin Books, 1954

HARE, RICHARD *The Art and Artists of Russia*, Methuen, 1965

KEMENOV, VLADIMIR *Vasily Surikov*, Parkstone Press, 1997

KOVTUN, YEVGENY *Avant-Garde Art in Russia 1920–1930*, Parkstone/Aurora, 1996

KOVTUN, YEVGENY *Mikhail Larionov*, Parkstone Press, 1998

LEONTYEVA, GALINA *Karl Briullov*, Parkstone/Aurora, 1996

MILNER, JOHN *A Dictionary of Russian and Soviet Artists 1420–1970*, Antique Collectors' Club, 1993

NESTEROVA, YELENA *The Itinerants*, Parkstone/Aurora, 1996

NOVOUSPENSKY, NIKOLAI *Ivan Aivazovsky*, Parkstone/Aurora, 1995

PEROV, S.S. *Russian Art of the First Half of the Nineteenth Century*, essay in *The Art of Russia 1800–1850*, University of Minnesota, 1978–9

PETROV, VSEVOLOD *Russian Art Nouveau*, Parkstone Press, 1997

RAZDOLSKAYA, VERA *Martiros Saryan*, Parkstone Press, 1998

SARABIANOV, D.V. *Russian Art: From Neoclassicism to the Avant-Garde*, Thames & Hudson, 1990

SARABIANOV, D.V. *Valentin Serov*, Parkstone/Aurora 1996

SHUVALOVA, IRINA *Ivan Shishkin*, Parkstone/Aurora, 1996

SMIRNOV, G. *Venetsianov and His School*, Aurora, 1973

STAVROU, THEOFANIS GEORGE (editor) *Art and Culture in Nineteenth-Century Russia*, Indiana University Press, 1983

STERNIN, GRIGORY *Ilya Repin*, Parkstone/Aurora, 1996

TALBOT RICE, TAMARA *A Concise History of Russian Art*, Thames & Hudson, 1963

EXHIBITION CATALOGUE:

The Art of Russia 1800–1850, University of Minnesota, 1978

REFERENCES

Part I

1 G. Smirnov, *Venetsianov and His School*, p. 11.

2 G. Smirnov, *Venetsianov and His School*, p. 8.

3 Quoted in biographical note on Briullov in *The Art of Russia 1800–1850*.

4 Quoted by Galina Leontyeva in *Karl Briullov*, p. 36.

5 See Dmitri Sarabianov, *Russian Art: From Neoclassicism to the Avant-Garde*, p. 65.

6 Quoted by John Bowlt in *The Art of Russia 1800–1850*, p. 26.

7 George Heard Hamilton, *The Art and Architecture of Russia*, p. 371.

Part II

1 Repin, *Correspondence,* quoted by Yelena Nesterova in *The Itinerants*, p. 166.

2 Repin, *Correspondence,* quoted by Grigory Sternin in *Ilya Repin*, p. 23.

3 The critic was Vasily Rozanov, quoted by Grigory Sternin in *Ilya Repin*, p. 63.

4 Dmitri Sarabianov, *Russian Art: From Neoclassicism to the Avant-Garde*, p. 135.

5 Quoted by Grigory Sternin in *Ilya Repin*, p. 64.

6 Quoted by Yelena Nesterova in *The Itinerants*, p. 134.

7 Kramskoi, *Correspondence,* Moscow, 1954, Vol. 2, p. 91.

8 Quoted by Yelena Nesterova in *The Itinerants*, p. 125.

9 Benois, *The History of Russian Painting in the 19th Century,* quoted by Yelena Nesterova in *The Itinerants*, p. 80.

10 *F.M. Dostoyevsky on Art,* quoted by Yelena Nesterova in *The Itinerants*, p. 80.

11 Repin, *Correspondence,* quoted by Yelena Nesterova in *The Itinerants*, p. 68.

Part III

1 Diaghilev's own words, quoted by Vsevolod Petrov in *Russian Art Nouveau*, p. 16.

2 Grabar's description of the project, quoted by Vsevolod Petrov in *Russian Art Nouveau*, p. 90.

3 Quoted by Camilla Gray in *The Great Experiment: Russian Art 1863–1922* (p. 67 in the original edition).

4 Dmitri Sarabianov, *Russian Art: From Neoclassicism to the Avant-Garde*, p. 265.

5 Dmitri Sarabianov, *Russian Art: From Neoclassicism to the Avant-Garde*, p. 278.

6 Camilla Gray, *The Great Experiment: Russian Art 1863–1922* (p. 140 in the original edition).

7 From the article on Symbolism in *The Oxford Companion to Art*, edited by Harold Osborne, Oxford University Press, 1970.

8 Quoted in the article on Symbolism in *The Oxford Companion to Art*, edited by Harold Osborne, Oxford University Press, 1970.

9 Alan Bird, *A History of Russian Painting*, p. 153.

10 John Milner, *A Dictionary of Russian and Soviet Artists 1420–1970*, p. 325.

11 Dmitri Sarabianov, *Russian Art: From Neoclassicism to the Avant-Garde*, p. 272.

12 Yevgeny Kovtun, *Avant-Garde Art in Russia 1920–1930*, p. 133.

13 Yevgeny Kovtun, *Avant-Garde Art in Russia 1920–1930*, p. 125.

14 Quoted by Yelena Nesterova in *The Itinerants*, p. 171.

15 Quoted by Vladimir Kemenov in *Vasily Surikov*, p. 154.

16 Alan Bird, *A History of Russian Painting*, p. 196.

17 Quoted by Yevgeny Kovtun in *Avant-Garde Art in Russia 1920–1930*, p. 113.

18 From "M.S. Saryan" by M. Voloshin (in Russian) in *Apollon*, 1913, No. 9, p. 13, quoted by Vera Razdolskaya in *Martiros Saryan*, p. 29.

19 Vsevolod Petrov, *Russian Art Nouveau*, pp. 42–3.

20 Dmitri Filosov, quoted in *Mir iskusstva* by N. Sokolova, Moscow-Leningrad, 1934, p. 10. Cited by Vsevolod Petrov in *Russian Art Nouveau*, p. 44.

21 Quoted by Yevgeny Kovtun in *Avant-Garde Art in Russia 1920–1930*, p. 250.

22 Dmitri Sarabianov, *Russian Art: From Neoclassicism to the Avant-Garde*, p. 219.

23 Based on a fuller description of the custom given by Vladimir Kemenov in *Vasily Surikov*, p. 95.

24 John Milner, *A Dictionary of Russian and Soviet Artists 1420–1970*, p. 464.

25 Alan Bird, *A History of Russian Painting*, p. 267.